Robert Motherwell
The Formative Years

Studies in the Fine Arts: The Avant-Garde, No. 56

Stephen C. Foster, Series Editor

Professor of Art History
University of Iowa

Other Titles in This Series

Robert Motherwell
The Formative Years

by
Robert Saltonstall Mattison

U·M·I Research Press

Ann Arbor / London

Produced and distributed by
UMI Research Press
an imprint of
University Microfilms, Inc.
Ann Arbor, Michigan 48106

Library of Congress Cataloging in Publication Data

Mattison, Robert Saltonstall.
Robert Motherwell: the formative years.

(Studies in the fine arts. The Avant-garde ; no. 56)
Revision of the author's thesis (Ph.D.—Princeton),
1986.
Bibliography: p.
Includes index.
1. Motherwell, Robert—Criticism and interpretation.
2. Art, American. 3. Art, Modern—20th century—United States.
I. Title. II. Series.
N6537.M67M38 1987 709'.2'4 87-10742
ISBN 0-8357-1810-7 (alk. paper)

British Library CIP data is available

Contents

List of Figures

Introduction

One morning we set forth with thoughts aflame,
O heart o'erladen with desire or shame
And cradle, to the song of surge and breeze
Our own infinity on finite seas.
 Charles Baudelaire, "The Voyage"*

Traditionally, artists' early works do not merit much attention. A novice painter would be attached to the studio of a master and begin as a student of his style. One of the interesting aspects of modernism is the potential freedom of the artist from the very beginning of his career. Even in this context the works made by Robert Motherwell during his first eight years of sustained creativity are remarkable for their exciting experimentation and the insights they yield into his later art.

The years covered in this book, 1941 through 1949, bracket Motherwell's early career. In 1941 he created his first known works in the *Mexican Sketchbook* and had contact with important modern artists who shaped his career. In 1949 he began the celebrated "Elegies to the Spanish Republic," an ongoing series, which was perhaps his most significant statement and propelled him into the 1950s. In all, two hundred works from the forties—paintings, collages, and drawings—have been discovered, and a significant number of these are systematically analyzed in this study.

Abstract Expressionism, of which Motherwell was a leading innovator, has been recognized since the late 1950s as one of the most significant art movements of our century. About fifteen years ago, young scholars began to

*Motherwell greatly admires Baudelaire as a father of modern culture, as I discuss later in this study. The title of Motherwell's 1949 painting *The Voyage* is a tribute to Baudelaire's poem because, in Motherwell's words, it "refers to a sense we had in the 1940s of voyaging on unknown seas...."

explore in depth the roots of that movement during the turbulent 1940s. Their investigations first appeared in doctoral dissertations followed by summary articles which were published in leading art magazines.[1]

In different manners, these studies emphasized the biographical, intellectual, and historical sources of the Abstract Expressionists. They emphasized context and meaning of the works in addition to, or above, the more standard formalist interpretations. As a whole they have greatly enriched our understanding of the artists' accomplishments and the milieu in which they worked. Some of the discoveries about art in the 1940s became apparent to the general public in the popular exhibition Abstract Expressionism: The Formative Years, organized by Robert C. Hobbs and Gail Levin in 1978, which traveled to the Whitney Museum of American Art. In almost all of the dissertations and articles, Motherwell's works were mentioned, and he was interviewed and cited as an authoritative source of information about the period.

As a graduate student, I was aware of this new scholarly work, and discovered that no thorough study of Motherwell's early art and ideas had been undertaken.[2] I had also long been interested in Motherwell's paintings and collages. In addition to his artistic creations, Motherwell had the advantage of having produced a large body of writings about his own art and modern culture which could aid the interpretation of his paintings and collages. Also, Motherwell was centrally involved in many such group projects as founding Subjects of the Artist art school and editing *Possibilities* magazine. A study of his activities during the 1940s necessarily involved all of Abstract Expressionism. Finally, Motherwell was still alive and could provide primary information as well as be consulted about interpretations.

Generously, Motherwell allowed me to spend eight months (1979/80) at his studio. During that time I studied many paintings from the 1940s in his own collection, reviewed his published and unpublished writings, catalogued his extensive library and conducted hours of interviews with him. I also traveled to see Motherwell's paintings in private and public collections. I studied the archives of other artists and interviewed many of Motherwell's contemporaries. Their memories of events enriched and balanced his own.

This book was prepared from those materials, incorporating new information where appropriate. Except for the initial chapter, the book has been organized chronologically. Chapter 1 investigates the philosophical and educational background of Motherwell's art and his aesthetic theory.[3] It is appropriate that this chapter be placed first because Motherwell came to painting from university life, not from studio practice. It is also necessary to explore his intellectual formation first because it underlies Motherwell's art as a whole, rather than being related only to individual paintings at specific dates.

After experimenting with different formats for developing the rest of the book, a chronological arrangement seemed reasonable and coherent. Although works by Motherwell after the 1940s can be organized thematically beginning with the "Elegy" series, Motherwell did not think about his art in that manner during the 1940s. Instead of painting a single closely related theme, he experimented with a wide variety of artistic options simultaneously, keeping a number of expressive forms in operation at the same time.

The chronological schema can best demonstrate and reconstruct the interrelated manners in which Motherwell created his works during the forties. This approach naturally contains within it areas of emphasis that occupied Motherwell during different years. Chapter 2 examines Motherwell's contacts with Surrealism and his influential experiments with automatism in painting, which directly conditioned the effects of immediacy and spontaneity he sought. Covering the year 1942, chapter 3 follows his early discovery of works by Mondrian, Picasso, Matisse and Miró, and his assimilation of their artistic influences. It also deals with the first interaction between Motherwell and the other Abstract Expressionist artists in group meetings organized by Motherwell and Roberto Matta.

During the years 1943 and 1944, Motherwell was almost entirely absorbed with his discovery of collage, whose technical and material effects he combined with a new emotional content in his work. Those years are analyzed in chapter 4. Chapter 5 deals with a testing period in Motherwell's career, the years 1945 and 1946, when his personal problems and professional uncertainties seem to have momentarily clouded his artistic goals and made him excessively dependent on external influences and models.

Between 1947 and 1949 Motherwell's art moved forward energetically, in a period of both significance and consolidation. These years are discussed in the last chapter. For the first time he felt sufficiently confident of his powers to concentrate on large-scale oil paintings. Many of these paintings are dominated by large "personages," whose simultaneous monumentality and vulnerability symbolize the artist's feelings about himself. Spontaneous pictorial incident and a more structured and carefully deliberated painting style, which had formerly coexisted in disjunctive opposition, were now more fully integrated. The ability to combine emotional resonance and animating spontaneity with formal rigor finally culminated in Motherwell's use of the "Elegy" motif.

The art historical viewpoint I have taken in this book can be described as pluralistic, a balance of complementary formal and iconographic perspectives. A great deal of the critical discussion of Abstract Expressionism has been divided between those who primarily view the art as

solutions to formal problems and those who concentrate on such extra-formal issues as personal psychology, myth, and literary association. This critical debate probably originated with the formalist writings of Clement Greenberg's and Harold Rosenberg's more philosophical approach which often ignores the appearance of individual paintings.

For me the individual painting has provided the conclusive evidence of artistic intention and meaning. Obviously, many paintings are also illuminated by such secondary sources as the artist's writings, art theory, world events, and personal events in the painter's life, all of which make up and enrich the complex mosaic finally revealed in the artwork. Motherwell's work is clearly a product of formal sensibility and the relationship between colors, textures, paint application, and other similar elements. Yet those formal relationships are not an end in themselves, nor do they exclude symbolism. The difficult goal which Motherwell undertook was to express abstractly his feelings about himself and his responses to the world around him. During the 1950s Motherwell wrote an unpublished note about the false dichotomy between form and content:

> These matters are not easy to be clear about if one has, in the background of one's mind, the traditional critical distinction between "form" and "content" as a valid necessary distinction. To experience a work of art, as in making love, is to experience human contact: when we speak of form and content, we are speaking of the same experience."[4]

The manner in which Motherwell utilized form and content to develop an original system of signs which express his ideas and emotions will be discussed in this book.

1

Education and Intellectual Background

Before 1940, the date of his earliest known paintings, Motherwell had a rich university life, studying and reading broadly in the history of modern culture. From 1932 to 1937, he attended Stanford University where he majored in philosophy. Then in 1937 he enrolled for a year as a graduate student in the Department of Philosophy at Harvard University, and, finally, in 1940 he spent one year in the Department of Art at Columbia University working with Meyer Schapiro, who became a formative influence.

This intellectual background distinguishes Motherwell from the other Abstract Expressionist painters including Gorky, de Kooning, Pollock, and Rothko, all of whom came to their studios with an art school training. Motherwell's emphasis in the early forties on his intellectual development as roots for his paintings was established in a 1941 letter to William Carlos Williams. In the somewhat inflated language of youth, he wrote:

> I am a Californian who graduated from Stanford University in philosophy (instrumentalism) in 1936; . . . I was then in the graduate school of philosophy at Harvard; and the late D.W. Prall and Arthur Lovejoy sent me abroad to finish a book on Delacroix which I had written. . . . At the beginning of the war I returned to assist Prall at Harvard, but took a lectureship in painting at the University of Oregon instead because I wanted to look at rural America, and because the job offered me a transition from philosophy to painting as a profession. The contract was for one year, when it expired Prall was dead, and Harvard no longer interested me, so I came to New York to study with Meyer Schapiro. . . . [1]

It is a difficult task to determine which of Motherwell's extensive readings were most influential on his art at this time. But significant clues are found in his published and unpublished writings. Important information is also yielded by the contents of his library, particularly the books he acquired or owned during the 1940s and in which he made notations. Three major areas of interest emerge in philosophy, Symbolist literature, and psychology. Within

these areas, Motherwell's interests can be divided more precisely. At Stanford Motherwell had become preoccupied with empiricist, or instrumentalist philosophy, and he has indicated that he was particularly interested in the writings of John Dewey. Then at Harvard, Motherwell's advisor was the aesthetician David Prall, who left a lasting impression on him. Alfred North Whitehead was still lecturing at the time and he also influenced Motherwell. In reading Symbolist literature for its insights into modernism, Motherwell took a strong interest in Baudelaire, and in Paul Valéry. His psychological interests were focused on Freud's cultural and psychoanalytical ideas, rather than on Jung's.

Motherwell's artistic theories were not empty verbiage added to the paintings after they were finished. Rather, the theories provided an important intellectual framework for the type of work he created, and the experience of the work in turn suggested intellectual interests. Of course his theories had to be accompanied by concrete experience in painting and the study of other artists, or the ideas would be irrelevant.

Philosophy

Motherwell began reading the works of John Dewey while he was at Stanford. He has said, "I realize that I was full of Dewey during the forties, and he remains one of the really significant, subconscious forces in my art today."[2] John Dewey was one of the founders of American Empiricist (also called Instrumentalist or Pragmatist) philosophy, a viewpoint that connects existence to personal actions: we learn through doing. Dewey anticipated the life-centered philosophy of Existentialism when he stated that only "in acting—confronted with obstacles, compelled to make choices, and concerned to give *form* to *experience*—is man's being realized and discovered."[3]

John Dewey linked his theories to art in the book *Art as Experience,* which Motherwell has called "one of my early bibles."[4] The artistic experience was defined by Dewey as creative activity during which the artist responded spontaneously to life situations and his own impulses under tension.[5] Dewey's close connection between actual physical activity and mental energy was later translated by Motherwell into a conscious rationale for painterly activity, which Motherwell expressed as a mode of thinking. In his writings, throughout the forties, Motherwell referred to painting as the activity of the "body-mind," a term he had borrowed from Dewey.[6] In a 1951 lecture he summarized his views of Dewey, "Everyone knows that modern art is experimental, and it is in regard to the experimental that first-rate minds become eloquent with commitment. John Dewey's whole philosophy, 'radical empiricism' is just another name for experimentalism."[7]

Motherwell's belief that art is a fundamental experiment with a

potentially revolutionary impact upon personality profoundly affected the entire direction of his work from his willingness to begin a painting with spontaneous gestures, to his constant search for inventive new forms. Even the rough, unfinished character of many of his early paintings can be related to Dewey's experimentalism and desire to be emancipated from formal stereotypes. However, the specific painterly methods that Motherwell employed depended upon his interaction with the Surrealists, and study of works by Picasso, Miró, and Matisse. These will be discussed in subsequent chapters.

Because Dewey emphasized artistic creation as immediate experience, he found the formulation of representational images in a painting a secondary concern. In this regard, he cited the writings of Albert Barnes to whom *Art as Experience* was dedicated:

> The solution to the matter of expressiveness and meaning in "abstract" art is found, I think in the following statement of Dr. Barnes. "Reference to the real world does not disappear from art as its forms cease to be those of actually existing things. . . . When one can not find in a picture representation of any particular objects, what it represents may be the qualities all particular objects share, such as color extensity, solidity, movement, rhythm, etc. All particular things have these qualities, hence what serves, so to speak, as a paradigm of visible essence of all things may hold in solution the emotions which the individualized things provoked in a more specialized way."[8]

Dewey concluded that it was the interaction of shapes and colors that gave the work of art its dynamic energy, not representational subject matter. Dewey thus became one source for Motherwell's early understanding of art as a process of abstract relationships which communicate emotions. Motherwell has said of Dewey, "I owe Dewey part of my sense of process. He demonstrated philosophically that abstract rhythms, immediately felt, could be an expression of the inner self."[9]

In 1969 Motherwell stated, "But by far the most important influence on me was an aesthetician named D.W. Prall."[10] As noted earlier, Prall was Motherwell's academic advisor and close friend in the year the artist spent at Harvard. Motherwell has gone so far as to call Prall's 1936 book *Aesthetic Analysis,* "one of the most important statements on aesthetics since Kant's writing on that subject."[11] In his library Motherwell still has his original copy of Prall's book inscribed, "Harvard University, September, 1937," and it contains the artist's own underlining and commentary on the text.

Like Dewey, Prall discussed aesthetics primarily in the context of abstract pictorial elements rather than recognizable subject matter. In his copy of Prall's text, Motherwell underlined twice for emphasis one of the author's clearest statements which provided another rationale for the abstraction that would later appear in Motherwell's work:

Any one who has ever been absorbed in looking at a tree in a picture has been occupied discriminating lines, shapes, color variations, and just those shapes and color variations which go together to make out this particular picture. Thus, it is the picture itself which is exciting. And obviously this is not due to the fact that it is a picture of a tree. Recognizing so familiar an object as a tree is not exciting at all.[12]

Motherwell wrote next to this statement by Prall, "This is why there is not form and content. They are one and the same. Content is just the form involved and form is just the content involved." Prall's statement, indeed, united the traditional dichotomy between form and content. His thesis was that the significant content of the work derived from such formal elements as "lines, shapes and color variations." Motherwell's note is one of the earliest intimations of his lifelong belief that the forms in a work of art need not imitate any other objects, but that their presence alone can be expressive of the artist's feelings. In unpublished notes written during the fifties on form and content, Motherwell expanded his commentary on Prall's book:

That modern art is somehow remote from real life, in being all "form" and no "content," so to speak, is plainly false. Certain abstract artists, notably Kandinsky and Arp, have wanted to be called "concrete" artists instead, because they know very well that their work is not all "form" and no "content." On the contrary it is their "form" that gives their "content" concrete existence: with other "forms" they would *ipso facto* be expressing other "contents." From this point of view it is the realistic painters who use the same relational structure—which is what "form" is—no matter what order of human being is being expressed.[13]

The important difference between Motherwell and Prall is that Motherwell connected the philosophical theory with specific modernist painters and with concrete painterly experience. Indeed, without this connection the philosophy would be useless for him.

While John Dewey supposed that art was based upon an immediate experience, Prall, in contrast, believed that artistic creation contained two distinct stages. The first was an immediate response to stimuli, and the second was a logical analysis and refinement of those immediate impressions. The notion that art depended on both instinct and logical analysis became important for Motherwell's developing ideas. In the early 1940s, he attempted to reconcile Surrealist automatism and severe Mondrian-inspired grids within the same paintings, an opposition few contemporaries seemed willing to confront so boldly.

Prall based his first stage of the creative process upon the ideas taken from Dewey, as he readily acknowledged:

Mr. Dewey, in fact, calls this aesthetic surface the quality of process. He tells us that what differentiates the aesthetic is what marks off an experience from experience in

general ... When the heightening is emphatic; when the aim of the experiencing activity is felt to be achieved in a vital process of receiving; when, to use Mr. Dewey's terms, our doing has its own felt consummation ... [14]

In addition to defining art as an instinctive, spontaneous activity, however, Prall argued for a second, more intellectual response in the unfolding of artistic creativity. In this second process, the artist, whether poet, musician or painter, refined and organized his initial response. He did so by directing his attention first to one part of the work and then to another, consciously balancing the parts against each other in order to achieve an optimum order. According to Prall each one of such elements as color and texture in painting, or meter and rhyme in poetry, was organically dependent on the others. Thus, change in one element altered all others decisively. Prall argued:

To show that one kind of relation is dependent on another all we need to do is exhibit variation in pattern constituted by this type of relation, while the pattern constituted by another type of relation must vary accordingly. [15]

Probably during the late 1930s, Motherwell wrote in Prall's text next to this passage, "The perfect work of art then is one in which a term can not be changed without affecting all the systems of relations." Prall's idea about a second stage that entails consciously balancing abstract characteristics is an important source for what Motherwell has repeatedly called his "relational structures." [16] Later in his career Motherwell spoke about viewing the artwork as a product of complex internal relationships which made abstraction a viable style in his work:

I have continually been aware that in painting I am always dealing with, and never not, a relational structure. Which in turn makes "permission" to be "abstract" no problem at all. ... So that I could apprehend, for example, at first sight my first abstract art. For painters with either literary or art school backgrounds, at least in my time, to make the transition from figuration to abstraction was a threatening problem. I was able to be an abstract painter right off the bat, if I chose. Which I did.

I understood that meaning was a product of relations among elements, so I never had the common anxiety as to whether abstract painting had a given meaning. [17]

This method of balancing and adjusting dependent abstract elements after the initial suggestions of form, placement, and interaction have been made through spontaneous paint marks is precisely the procedure that Motherwell used to create many of his paintings.

Prall never explained how instinctive creative activity and selective analysis would finally resolve themselves, and whether in favor of rational structure or spontaneous effusion. Rather, *Aesthetic Analysis* leaves the reader with a sense of the two systems competing with each other. Similarly,

as we shall see, a conflict between immediate gesture and a careful process of balanced relationships remains unresolved in Motherwell's art at times. The conflict provides some of the vitality and the tension in his work.

While Prall's discussion provided a theoretical framework, it gave no hint to Motherwell of the actual process of painting that might yield specific pictorial results. Motherwell found his style in the context of assimilating such modernists as Mondrian, Picasso, Matisse and Miró, from whom he borrowed a variety of formal devices in shaping his own art.

When Motherwell attended Harvard, Alfred North Whitehead had just retired, but the eminent philosopher gave a series of lectures at Wellesley College which Motherwell still remembers vividly and describes as a profound intellectual experience. Of all the references Motherwell makes in his writings, those to Whitehead may be the most frequent. He presently has seven books by Whitehead in his library, four of which he acquired while he attended Harvard.

Like Dewey and Prall, Whitehead believed that the first source of knowledge was immediate experience which was beyond verbal explanation. He wrote:

> I contend that the notion of mere knowledge is a high abstraction, and that conscious discrimination itself is a variable factor only present in the more elaborate examples of occasions of experience....An occasion of experience is an *activity,* a mode of functioning which jointly constitutes its process of becoming.[18]

Motherwell would have been sympathetic to Whitehead's idea of basic knowledge gained through spontaneous activity, and organically connected to experience rather than *a priori* thought. Much as he did in adopting ideas from Dewey and Prall, Motherwell sorted through Whitehead's complex writings and translated his ideas into tangible painterly experience. In a 1954 lecture at Hunter College Motherwell stated, "In this sense one can only think *in* painting while holding the brush before the canvas...." He then referred to Whitehead:

> As Whitehead wrote, we suffer from a "deficiency" of language. We can see variations in meaning, although we can not verbalize them in any decisive, handy manner. Thus we can not weave into a train of thought *what we apprehend in flashes.*[19]

Whitehead believed, however, that the sources of man's immediate experience were beyond his analysis. Instead, he concentrated on how man organized and systematized those experiences. This type of analysis is related to Prall's second stage of organization in creating the art object. In Whitehead's view, man structured his thoughts by moving toward essentials and eliminating trivia. He wrote, "Importance generates interest. Interest

leads to discrimination. In this way the two factors stimulate each other."[20] This constant process of selection and refinement of stimuli did not make one's thought process hermetic or isolated from the surrounding world. Rather, discrimination allowed greater expression of feelings and the emphasis on salient elements in response to concrete experience. As one focused attention on essentials, more feelings could be focused on shaping the remaining elements.

Motherwell has frequently cited Whitehead as a philosophical source for conceiving of art as a process of selection which leads to more centralized, organized, and powerful expression. In a 1951 lecture at Harvard University, he said:

> The most complete and exact treatment that I have seen of the nature of abstraction is one of the last essays by the late Alfred North Whitehead called "Mathematics and the Good.". . . But it is certain of Whitehead's asides that concern us here, for, in talking about mathematics as a way of thinking about pattern, he points out that mathematics is thinking about certain patterns in concrete reality and ignoring others, and is consequently a form of abstraction—thought in this sense, he insists, is a form of emphasis. And so with art. All art is abstract in that it presents certain things and omits others from the fullness of man's experience: . . . Modern art is more abstract than any preceding art, because it rejects more around it than any other art.[21]

Thus we find that Whitehead complemented and enlarged the ideas which Motherwell had already absorbed from Dewey and Prall.

Motherwell's philosophical speculations were essential to his early understanding of the creative process. The study of philosophy accustomed him to thinking in a conceptual mode. All three philosophers believed that thought and art were based upon immediate experience, and that ideas should be concretized. The nature of aesthetic experience was characterized for them, not by describing objects in the outer world, but by giving a fresh reality to abstract concepts such as activity, unity, and disunity, and the transactions between self and the world. For each, the creative experience affirmed the spontaneous vitality of life. Prall and Whitehead also argued for a second stage of artistic consciousness in the selection and adjustment of perceptions after the initial shock of raw energy. This philosophical background allowed Motherwell to approach his paintings during the 1940s in terms of the feelings evoked by shape and color rather than representational subjects. Motherwell's interest in philosophy helped him to reduce the fantastic imagery of Surrealism and to concentrate on its "creative principle" of automatism, when he first came in contact with that movement. It also enabled him to understand the universal values sought by Mondrian in a geometric model, at a time when few other Americans appreciated the Dutch painter's ideas. Through the example of these antithetical Surrealist and

Constructivist artists, Motherwell translated the philosophical questions of his youth into plastic terms that directly influenced the concrete process of painting.

Symbolist Literature

When he was at Stanford University from 1932 till 1937, Motherwell began to read extensively in French Symbolist literature, inspired by the avant-garde poet Yvor Winters, who taught him. Motherwell recalls, "I think I read everything I could get my hands on by Rimbaud, Mallarmé, Verlaine and Gide, but I believe the theoretical ideas of Baudelaire and his 20th century heir Paul Valéry affected me most profoundly."[22]

Motherwell believes that Symbolism was the first literature to discuss the problems of modern art. He has said, "In order to find out what modern art is, the greatest existing body of literature on the subject was the nineteenth and early twentieth century symbolist poets theorizing on what the nature of poetry was."[23] From Symbolist theories of poetic creativity, Motherwell gained essential insights into the individual consciousness, the psychology of creative moment, and Baudelaire's celebrated theory of "correspondences." He also assimilated another view of the relationship between spontaneous invention and structured composition, and further support for the value of suggestive rather than descriptive forms.

Motherwell recalls that his fascination with Symbolist art theory was unusual among the Abstract Expressionists. It was echoed only in William Baziotes, whom he met in 1941 partly because of this common interest.[24] Motherwell recalls discussing Baudelaire extensively with Baziotes. In Baziotes's vague atmospheric paintings with monstrous figures, he derived quite different meanings of a fantastic nature from Symbolism, however.[25] Although Motherwell does not recall that any other New York School artist was interested specifically in Symbolist literature, he believes Symbolist ideas did influence Abstract Expressionism indirectly through the role they played in the later formation of Surrealist ideas and practices.[26]

In Motherwell's opinion the best critical discussion of Symbolism is Marcel Raymond's *From Baudelaire to Surrealism*.[27] He was the editor of the 1950 English translation of that text in the Documents of Modern Art series, though he knew and appreciated the book during the late 1930s and 1940s, in the original French.

In 1948 Motherwell wrote of Baudelaire's role in the history of modernism, "The history of Modern art can be conceived of as a military campaign, as a civil war that has lasted more than a hundred years—if movements of the spirit can be dated—since Baudelaire first requested a painting that was to be specifically modern in subject and style."[28] During the

1940s Motherwell owned *Intimate Journals* which was given to him by his wife Maria in 1944, a translation of *The Flowers of Evil,* and a translation of Baudelaire's essays on Edgar Allan Poe.

Motherwell derived three major ideas from Baudelaire's writings, the concept of "purity" of poetic language (and thus, for Motherwell, potentially of painting), the theory of "correspondences," and emphasis on artistic freedom and individuality. For Baudelaire "purity" meant that poetry must be based on the internal characteristics of language. Everything that detracted from the direct communication of emotions and a sense of the poet shaping his medium must be eliminated. Motherwell commented on this matter: "All intelligent works of modern French poetry (since Baudelaire) have spent pages on the concept of 'purity.' . . . I should perhaps add as a historical note that I do not know of another American painter who shares my interest in French poetry, but that I have spoken of it often, over 20 years in our gregarious milieu."[29]

Paul Valéry, whose theoretical writings Motherwell read extensively, best analyzed Baudelaire's concept of purity as expressed in his *The Flowers of Evil:*

> If we now look at *Les Fleurs du Mal* as a whole and take the trouble to compare this collection with other poetic works of the same period, we shall not be surprised to find that Baudelaire's work is remarkably pure. . . . *Les Fleurs du Mal* contains neither historical nor legendary poems; nothing depends on narrative. There are no philosophical orations. Politics makes no appearance. Descriptions are rare, and yet always *relevant.* But all is enchantment, music, powerful yet abstract sensuality.[30]

We have already mentioned the process of refinement and elimination that Alfred North Whitehead discussed, and its impact on Motherwell's thought and art. The results of a reductive procedure by the philosopher and the poet are quite different. While Whitehead's selections led him to a structural system of relationships stripped of superficial detail, Baudelaire's led to deeper and more powerfully self-interrogating moods. Baudelaire used sentence fragments, broken meter, strange juxtapositions of words, and unusual sound combinations to communicate a melancholy personality. For Baudelaire, "purity" meant emotions communicated directly through language structure, syntax, and the incantatory music of poetic diction. Motherwell is indebted to both Whitehead and Baudelaire. Yet, he is perhaps closer in spirit to Baudelaire, because his elimination of certain subjects and the organization of forms in his work are ultimately directed at communicating feelings, never simply pictorial logic for its own sake.

Baudelaire's theory of "correspondences" might seem to conflict with his insistence on poetic purity. According to Marcel Raymond, the theory of correspondences is a device which enlarges the "poet's ability to perceive

analogies, metaphors, symbols and comparisons."[31] While purity is based on reduction, correspondences are freely expansive. The poet uses words and presents ideas which encourage a chain of free association. Yet, purity and correspondence are complementary rather than contradictory ideas. Words are musical and thus "pure," but inescapably connotative as well. Both are opposed to the use of detailed description and anecdote. They encourage a deep emotional response. Establishing mood is important, not telling a story. The correspondences that Baudelaire prefers are those which have multilevel association. In his poetry a phrase can evoke scent, color, and sound. At the same time, poetic image and diction reveal the creative process, and most importantly also evoke deep psychological states. Baudelaire called this wide variety of associations "indirection."[32] By indirection he meant that the analogies were suggested, not explicitly stated, so that a wide latitude for imaginative interpretation was left open.

In his poem "The Voyage," which Motherwell adored, Baudelaire wrote, "These treasures, this furniture, this luxury, this order, these perfumes, these miraculous flowers, are you."[33] On one level the words refer to sense impressions, but do so without describing specific objects. Secondly, the straightforward juxtaposition of words makes the creative process evident, since they suggest the mind's uncontrolled chain of associations. It may even be argued that the specific words are analogies for the artist shaping his medium. Furniture may equal the structure of the composition and perfumes its elusive meaning. Finally, Baudelaire concluded all these associations with "are you." In the words of Raymond, the final meaning of the poem is a "mental landscape."[34]

Motherwell also found no contradiction in his art between the reductive process of abstraction and the free associations possible with his system of analogies or correspondences. He advocated both perspectives to reach an understanding of his complex art. Motherwell has said, "One might truthfully say that abstract art is an art stripped bare of other things in order to intensify its rhythms, spacial intervals, and color structure." In another article during the same period Motherwell wrote in contrast, "The 'pure' red of which certain abstractionists speak does not exist, no matter how one shifts its physical contexts. Any red is rooted in blood, glass, wine, hunter's caps, and a thousand other concrete phenomena. Otherwise we should have no feeling toward red or its relations, and it would be useless as an artistic element."[35]

Motherwell has spoken specifically of Baudelaire's theory of correspondences. He said, "The idea that appears in Baudelaire again and again ... is the idea of nature being analogies—that is, nature is essentially a system of equivalences that any given thing can be a corresponding metaphor for something else."[36] Motherwell also believed in Baudelaire's obliqueness, his theory of "indirection." He found that the suggestion of feelings rather

than description of an object allowed a powerful range of associations, a kind of psychological reverberation. Borrowing from Mallarmé's famous statement, he wrote, "The intention of Symbolist poetry is not to represent the thing but the effect of the thing. That is it works by indirection. . . . In that sense Bill [Baziotes] and I were in accord that the modern art that on the whole interested us was always an indirect statement, but nevertheless had a genuine subject."[37] In the same vein, Motherwell has said, "I do think there are references [in my art]. I do think the so-called 'abstractness' of modern art is not really that it is about abstract things, but that it is really an art in the tradition of French Symbolist poetry, which is to say, an art that refuses to spell everything out. It's a kind of shorthand where a great deal is simply assumed."[38]

Baudelaire was also obsessed with the idea of artistic individuality, an issue not discussed by philosophers in whom Motherwell was most interested. Motherwell was given a copy of Baudelaire's *Intimate Journals* by his first wife Maria in 1944.[39] In the *Intimate Journals,* Baudelaire's central preoccupation was the nature of the individual in an increasingly anonymous society. His conclusion was that the individual can only "become what he wills; he must have a self determined history."[40] For Baudelaire, the "Dandy" was the heroic individual who stood in the face of society's conventions. He was a man who dared to exaggerate his individuality.[41] During the 1940s, Motherwell was similarly concerned with artistic individuality in relation to a society that he perceived as having few convictions. In 1944 he wrote:

> The social condition of the modern world which gives every experience its form is the spiritual breakdown which followed the collapse of religion. This condition has led to the isolation of the artist from the rest of society. The modern artist's social history is that of a spiritual being in a property-loving world. No synthesized view of reality has replaced religion. Science is not a view, but a method. The consequence is that the modern artist tends to become the last spiritual being in the great world.[42]

Motherwell's use of automatic painting techniques, which will be discussed in the next chapter in detail, was intended to reveal precisely what was original in each artistic personality.[43] His various automatic procedures led him to develop at the early stages of his career a group of individual shapes and colors which were distinctive and could be readily identified as his own. These include the vertical stripe, ovoid egg, stick figure, black, lemon yellow, and ochre. In works after the 1940s, Motherwell even more systematically investigated his *own* personal images in extended series of paintings such as the "Elegies" and "Opens." In Motherwell's art and theory throughout the 1940s, self-definition is one of the most important artistic motivations. He has written, "I suppose every work of mine is a symbolic self-portrait; it rarely occurred to me to do anything in daily life except feel my own presence."[44]

Paul Valéry has been recognized as a late Symbolist heir of Baudelaire's ideas on creativity. Perceptively, Motherwell recognized Valéry's importance at a young age. In 1939, he acquired Valéry's *Collected Essays*. It contains the French poet's most important writings on aesthetics, including his first essay on a painter, "The Method of Leonardo." Motherwell commented in an interview for the Archives of American Art, "When I was young I read Paul Valéry a lot because he was a big help to me in trying to formulate some of the ideas about abstract art I was developing in the 1940s and 1950s."[45] Motherwell has also said, "The art of painting and 'what is creativity' are the two obsessions of my life. Paul Valéry is one of the most precise thinkers about what creativity is."[46]

Like Baudelaire, Valéry advocated purity of language for poetry. Poetry functioned for him through repetition, contrasts of sound and metaphor rather than narrative description. During the 1940s, Motherwell cited Valéry's abstract view of language in connection with Mondrian, who was to play a major role in the development of his early paintings: "It is the nature of such art to value above all the external, the 'pure', the 'objective.' Thus Mondrian used to speak of the 'universal.' Thus the notion of 'pure form' among non-figurative painters, and Valéry's idea of the 'pure self.' "[47] Although Baudelaire did not relate his ideas about the purity of poetic language to abstraction in the visual arts, Valéry did in his essay upon Leonardo of 1894. Motherwell has said of that essay, "I was very moved in my early career by Valéry's 'The Method of Leonardo.' "[48] Valéry approached Leonardo's paintings and drawings with an eye to the immediately felt responses caused by their shapes and colors:

> I believe, on the contrary, that the surest method of judging a picture is to identify nothing at first, but, step by step, to make a series of inductions demanded by the simultaneous presence of colored masses in a definite area; then one can rise from metaphor to metaphor, from supposition to supposition, and so attain in the end, knowledge of the subject.[49]

Valéry's suggestive views about the creative process are based upon an interaction between incipient psychological states, instinct, and conscious rationalization. We have already seen how the philosophers Motherwell studied closely dealt with similar issues, and how Baudelaire touched upon the relationship between intuition and creativity. Later, we will investigate the method by which Motherwell made this process evident in many of his early paintings. Valéry wrote in the beginning of his 1895 essay "The Creation of Art," a passage underlined by Motherwell in his copy, "Writing someone in connection with the composition of Tristan and Isolde, Richard Wagner said roughly this... 'I composed *Tristan* under the stress of a great passion and *after several months of theoretical meditation.*' ... Nothing has given me

more food for thought than this brief sentence."[50] Later in the same essay, Valéry expanded on this central idea in his thought:

> The first phase belongs, on the whole, to general psychology. The events that take place in it, though essential to creation whose general substance they supply—in the form of emotional elements, of particularly striking or powerful associations—are far from sufficient for the production of the organized work, which implies a very different order of mental activity. Here the author, whether he expects it or not, takes an entirely new attitude. At the start he looked only within and saw only himself; but no sooner does he think of producing *a work* than he starts to calculate outward effect.[51]

The first stage of creation discussed by Valéry shares many characteristics with the ideas that Motherwell developed about spontaneity and passion in painting. According to Valéry, the instinctive first step in creation is not an uncontrolled outburst, but one deliberately induced by the artist. He wrote, "In this case, we endeavor to put ourselves into such a state that our decision becomes *automatic; we* try to arrive at a kind of tropism."[52] For Valéry, these induced states of passion reveal characteristics of the artist's personality which would otherwise be suppressed by the conventions of society. He wrote, "The true artist is one who comes, though not exactly in the way I have described, to possess self-knowledge so considerable that his personality, his *originality,* comes to be applied and practiced automatically."[53]

Similarly during the 1940s Motherwell, under the spell of Surrealist automatism, began to induce states of mind in which he could spontaneously make marks upon the canvas. Like Valéry, he believed that these gestures revealed individual personality. These marks and paint passages were not wild, uncontrolled, or compulsive. Instead, they were almost a calculated device and adhered to certain dicta of modernism, such as flatness, and sensitivity to the material medium.

Of all the New York School artists during the 1940s, Motherwell was probably the most intensely involved with literature. From Symbolist poetry he assimilated a new sense of the creative process, adopting its methods in a manner unique to the visual arts. Thus Motherwell used Symbolist writings and theory to confirm his own painterly direction which he had already embarked upon. Motherwell summarized long-held views upon Symbolist literature in his preface for Raymond's *From Baudelaire to Surrealism* in 1950:

> A weakness of modern painting nowadays, especially prevalent in the "constructivist" tradition, is inherent in the taking over or inventing of abstract forms insufficiently rooted in the concrete, in the world of feeling where art originates, and of which modern French poetry is an expression. Modernist painting has not evolved merely in relation to the internal structure of painting; it is not only legitimate but necessary to include, among the documents of modern art reference to French poetry from Baudelaire to

surrealism.... True painters disdain "literature" in painting. It is an error to disdain literature itself. Plainly, painting's structure is sufficiently expressive of feelings, of feelings far more subtle and "true" to our being than those representing or reinforcing anecdotes; but true poetry is no more anecdotal than painting. Both have sought in modern times to recover the primitive, magical and bold force in their mediums and to bring it into relation to the complexities of modern felt attitudes and knowledge.... Perhaps the "plasticity" that we painters so admire is no less than the poetry of visual relations.[54]

Psychology

In addition to philosophy and Symbolist literature, Motherwell's third dominant interest as a young man was psychology. While an undergraduate at Stanford University, Motherwell took two introductory courses in psychology. He became so involved in the discipline that he wrote his senior thesis on a psychoanalytical interpretation of Eugene O'Neill's plays, a paper now unfortunately lost.[55] In the course of his studies, Motherwell was introduced to both the theories of Freud and Jung. The textbook for one of his courses was Arthur Healy and Augusta Bronner's *The Structure and Meaning of Psychoanalysis*, inscribed by the artist "Robert Burns Motherwell, Stanford University, 12 December 1934." It contains a comparative analysis of Freudian and Jungian psychological theories. In addition, Motherwell still owns copies of *The Basic Writings of Sigmund Freud* and Jung's *Contributions to Analytic Psychology* which date to his undergraduate days.

In a 1944 statement about the painting *The Spanish Prison*, Motherwell clearly identified psychology with the types of shapes he used in his art and its overall meaning. He wrote in Sidney Janis's *Abstract and Surrealist Art in America*:

> The *Spanish Prison*, like all my work, consists of a dialectic between the conscious (straight lines, designed shapes, weighted color, abstract language) and the unconscious (soft lines, obscured shapes, *automatism*). The hidden Spanish prisoner must represent the anxieties of modern life, the intense Spanish-Indian color, splendor of any life.[56]

An essential feature of Motherwell's psychological concerns during the forties was his strong Freudian orientation. This direction is surprising in light of the recent emphasis that has been placed on Jungian psychological theory in relationship to the origins of Abstract Expressionism. The Jungian connection was first emphasized by Dore Ashton in her *The New York School: A Cultural Reckoning*. Ashton believes that Jung's theory of the "collective unconscious" is more compatible with the ideas of the Abstract Expressionists than Freud's more psychiatric analysis of art.[57] She also guessed that Motherwell was one of the artists most thoroughly acquainted with Jungian theory, though she cited as evidence only his training in philosophy.[58] In response to my recent questioning about Jungian ideas and

Abstract Expressionism, Motherwell would only comment, "Do not underestimate the influence of Freud upon my work and the entire era."[59]

Motherwell's incisive statement about the *Spanish Prison* contains within it the primary reason for his Freudian rather than Jungian orientation. For Jung the mark of psychic health, and aesthetic value, was unity.[60] In contrast Freud proposed a division of the psyche into three parts the id, ego and superego. The three levels of the psyche have a dynamic and conflicting relationship with each other. In Motherwell's art, spontaneous, individual discoveries, "soft lines, obscure shapes, *automatism*," and rational structure, "straight lines, designed shapes, weighted color, abstract language," often conflict with each other. This duality and struggle is essential to Motherwell's art and lends it energy and meaning.

Later in his 1944 article, "The Modern Painter's World," Motherwell elaborated upon the analogy he found between the Freudian psyche and his artistic theory. Although he referred to his analysis in terms of "Freud's fictions," the length and detail of his discussion reveals his belief in its efficacy. In this article he equated the uncontrollable, primal drives of the id with the Surrealists, and thus explained their childish, sadistic, and sexual themes:

> With the content of the super-ego gone, the Surrealists are driven to the animal drives of the id. From hence the Surrealist admiration for men who have shattered the social content of the super-ego, for Lautréamont and the Marquis de Sade, for children and the insane. This is the sadistic strand. It is from this direction that Surrealism tended to become predominantly sexual. Yet it is plainly impossible for cultivated men to live on the plane of animal drives.[61]

At that time, Motherwell wished to differentiate a variety of spontaneous creation from the Surrealists. He thus suggested that this type of intuitive creation was like Freud's concept of the ego, which draws upon all aspects of the internal world and which is the essence of one's individuality. He wrote:

> Empty of all save fugitive relations with other men, there are increased demands upon the individual's own ego for the content of experience. We say that the individual withdraws into himself. Rather he must draw from himself. If the external world does not provide experiences' content, then the ego must.[62]

At a later date, Motherwell expanded his assertion that spontaneous techniques of creation, or automatism, entailed a kind of free play, but were not uncontrolled:

> The problem with automatism is that one equates it with the "unconscious" as if one is stone drunk or asleep, not knowing what one is doing. The truth is that the unconscious [id] is inaccessible to the will by definition; that which is reached is the fluid and free "fringes of the mind" called the "pre-conscious," [ego] and consciousness [super-ego] constantly intervenes in the process.[63]

In chapters 3 and 4 we will see that Motherwell was using controlled periods of free invention in his paintings and collages at the same time he made these theoretical statements.

In "The Modern Painter's World," Motherwell further equated purely geometric, formalist painting with the superego, control and logic to the exclusion of all else. He also wished to differentiate himself from the followers of that tendency in its purest form. He suggested indirectly that formalism, which sought universal communication, (the superego) had to be balanced by an individual style (the ego) arrived at through spontaneous paint handling. He wrote:

> Lissitsky's [sic, Malevich's] white square upon a white ground combines the logic of the aesthetic position in its most implacable form. The power of this position must not be underestimated. It has produced some of the greatest creations of modern art. But the fundamental criticism of the purely formalist position is how it reduces the individual's ego, how much he must renounce. No wonder there is such an interest among the formalists in perfection, and with perfection it must replace so much else.[64]

The parallel categories that Motherwell drew between psychology and his art did not determine the visual appearance of particular paintings. For that concentrated painting experience was necessary, as well as contact with contemporary painters and the study of modern masterpieces by Picasso, Mondrian, Miró, and others. But neither was his psychological interest simply a rationalization for his art after the fact. Rather, it began before he started to paint intensively, and it provided needed confirmation for his art in one of the greatest fields of twentieth-century exploration, man's psyche. It further convinced Motherwell that his art was concerned with the expression of internal states, not the mimicry of objects in the outside world.

In summary, Motherwell adopted five basic ideas from the intellectual sources he investigated. He came to believe in painting as an activity or a process during which discoveries were made, rather than a statement of already completed ideas. This process involved two stages: spontaneous conception alternated with more considered reorganization of those immediate responses. Even the spontaneity was not "wild," but a device used for self-discovery. The writers whom Motherwell studied further stressed the mutual dependence of form and content, and Whitehead wrote of abstraction as a process of simplification which reveals underlying truths. Finally, Baudelaire's correspondences indicated that art functioned not by literal description, but by expansive suggestion and analogy. As significant as these ideas were, they were only important to Motherwell when applied in conjunction with the painting experience he would acquire over the next several years.

Having absorbed concepts from three important areas of modern culture, philosophy, literature and psychology, Motherwell passed through one other important intellectual influence before beginning his career as a painter. He briefly took art history courses from Meyer Schapiro at Columbia University.

In the fall of 1940 Motherwell began the Ph.D. program in art history at Columbia University, and there he attended courses given by Meyer Schapiro. Motherwell has recalled:

> During that year (1939–40) I met the composer Arthur Berger, who advised me to go to New York and study with Meyer Schapiro at Columbia, while making up my mind [whether to pursue an academic career or become a painter]. New York he thought—and quite rightly—was much more the center of art than other places I had been. So I wrote Columbia. They pointed out that I was unqualified technically to be in the graduate school of art history, but they were willing to take me on probation.[65]

While at Columbia Motherwell took Schapiro's course on medieval manuscripts and his introduction to modern art. Four decades later, Motherwell's memory of Schapiro's influence is general. It may be summarized by his statement, "His specific suggestions were not as important to me as his overall feeling for modern civilization. He had a very large ego and insisted on comparing everything to the history of modern culture. Sometimes I found this idea debilitating and at other times inspiring. In terms of specific modern artists, he seemed most interested in Picasso, who was the real focus of his modern art course."[66] Schapiro's emphasis on Picasso probably influenced Motherwell's strong interest in the Spanish master, which will be discussed in the following chapters. First it is important to examine what effect Schapiro's overall ideas on art may have had on Motherwell's developing art theory.

As Motherwell has indicated, Schapiro was particularly interested in the relationship between art and modern culture. Between 1936 and 1937, Schapiro expanded his understanding of modern art to include abstraction. He had come to believe that abstract art could contain profound personal meaning. Schapiro found that the artist must turn inward to his own subjective feelings. Although these personal feelings were alien to traditional social institutions, such as church and state, they could relate to other similar fields in modern culture, such as literature and philosophy. These ideas have a remarkable similarity to Motherwell's own developing thoughts.

Schapiro began to develop these ideas in 1936. In a speech of that year, he tentatively proposed that the abstract artist's very rejection of social institutions was significant. He said, "If modern art seems to have no social

necessity, it is because the social has been so narrowly identified with the collective as the anti-individual, and with repressive institutions and beliefs, like church or state or morality, to which most individuals must submit."[67] In 1937 Schapiro expanded this point of view in his important article "The Nature of Abstract Art." It was a response to Alfred Barr's book *Cubism and Abstract Art,* accompanying Barr's exhibition of that year. The significance of that article for Motherwell is witnessed by the fact that Motherwell kept a copy of it in the front of Barr's book which he acquired in New York in 1942.[68]

In "The Nature of Abstract Art," Schapiro criticized Barr on two major issues. He found that Barr discussed abstract art as formal relations without reference to the artist's feelings, "an art of pure form without content."[69] He also objected to Barr's view of abstract art as essentially "unhistorical." In contrast, Schapiro looked for the types of emotions that abstract art could express and the areas of modern thought to which it could be connected.

After citing many examples, including Kandinsky's interest in primitivism and theosophy, Schapiro concluded:

> Besides the movement of abstract art is too comprehensive and long prepared, too closely related to similar movements in *literature* and *philosophy,* which have quite other technical conditions, and finally too varied to be considered a self-contained development issuing by a kind of internal logic directly from aesthetic problems. It bears within itself at almost every point the mark of changing material and psychological conditions of modern culture.[70]

Like Schapiro, Motherwell believed that art was essentially a subjective expression. Yet also like Schapiro, Motherwell held that this subjective form of expression had a broad cultural basis in other modern disciplines, and these parallel currents of thought could enrich and illuminate the complex meanings of modern art.

In his writings and lectures Schapiro's broad cultural conception of modern art must have provided an important stimulus for Motherwell as he turned his attention directly to painting. The ideas that Motherwell culled from philosophy, literature, and psychology were the background for his creative experiments and, in many instances, provided their rationale.

Meyer Schapiro had another specific influence upon Motherwell. He introduced the young painter to the Surrealists who were exiled in New York during the war years. Motherwell remembers: "One day he [Schapiro] suggested that what I really needed was to know some other artists . . . and I said I didn't know any I really liked or wanted to meet. And then he said, what about the Parisian Surrealists (who were most of them in New York in exile)?"[71]

2

First Contact with the Surrealists

From January until June 1941, through Schapiro's introduction, Motherwell attended Kurt Seligmann's studio two days per week.[1] Schapiro had apparently recommended Seligmann to Motherwell, not because of his art, but because he was a calm fatherly figure, spoke excellent English, and had the theoretical sort of mind that Schapiro thought would be suitable to Motherwell's artistic outlook.[2] Motherwell recalls that his contact with Seligmann involved primarily watching studio life rather than obtaining formal instruction in art. He already disliked Seligmann's meticulously defined and explicit Surrealist drawings of creatures with machine and monster body parts, though he did appreciate "a few more geometric etchings after which I made several drawings, now lost."[3] Seligmann had two other students, Barbara Reis, daughter of Bernard Reis, attorney, collector and patron of many exiled European artists, and Monica O'Flaherty, daughter of the experimental film producer. The most important occurrence for Motherwell at Seligmann's studio was briefly meeting the Surrealists, Breton, Duchamp, Ernst, Tanguy, and especially Roberto Matta Echaurren with whom he began a friendship of several years.

With the intensification of the war in Europe and the fall of Paris in 1940, many of the most important European artists, the Surrealists among them, fled to America. Matta and Tanguy arrived in 1939; Mondrian, Léger, Seligmann, Ernst, and Breton in 1941, and Masson in 1942.[4] Thus, through the war, New York became the international art capital. In New York the Surrealists remained a close-knit group and had less contact with the Americans than is commonly thought. As an indication, Breton and Masson never bothered to learn English, and Masson and Tanguy lived in relative isolation in Connecticut. The Surrealists had their own uptown dealers, primarily Julian Levy and Pierre Matisse, and their own periodical in 1941, *V.V.V.* The only American artists with ready access to the Surrealists in the forties were Motherwell, William Baziotes, David Hare, Isamu Noguchi, and the lesser-known painters Peter Busa and Gerome Kamrowski.

Coinciding with the arrival of the Surrealists in America, a change in direction took place in the movement which has not been fully noted by historians. The first pictorial manifestations of Surrealism were largely abstract. In 1924 André Breton officially began the movement with his first Surrealist manifesto:

> Surrealism. Noun, masculine. Pure psychic automatism by which one intends to express verbally, in writing or by any other method, the real functioning of the mind. Dictation of thought in absence of any control exercised by reason, and beyond aesthetic and moral preoccupation.[5]

The year Breton wrote the manifesto he met Joan Miró and André Masson. They interpreted the Surrealist literary program in terms of visual "automatism" or spontaneous creativity. Automatism emboldened them to loosen somewhat the rigorous structure of Cubism in favor of a more improvisational art. In the case of Miró, this meant that between 1925 and 1927 he broke away from the multiple tiny creatures and rectilinear organization of works like his *Catalan Landscape*. Instead, he began to execute canvases allowing the brush to wander freely, only later picking up clues for the composition which would lock the picture together formally. Miró explained, "Rather than setting out to paint something, I begin to paint and as I paint the picture begins to assert itself under my brush. The form becomes a sign for a woman or a bird as I work. . . . The first stage is free, unconscious."[6] Of course, automatism was not pure in Miró's art. Pure automatism like pure accident is inimical to coherent formal structure, and it is noteworthy that Miró qualified the description of his procedure by adding, "the second stage is carefully calculated."

The ascendency of abstract Surrealism was evident in the first 1925 exhibition at Galerie Pierre in France, which contained works by Miró, Ernst, Arp, and Masson. In 1929, however, Surrealism went through a crisis that was motivated in Breton's thinking by its lack of political activity and concentration on "pure aesthetics." Thus, among the artists he excommunicated from the movement were Miró, Masson, and Ernst, whose work had been notably improvisatory and automatic. Breton then turned his favor to Dali, Magritte, and the illusionistic wing of the movement. The Surrealist group arrived in America in this philosophically divided state, and the continuing decline of Breton's influence was hastened in the new environment of New York.

By chance, most of the artists who emigrated to the United States, Masson, Ernst, Tanguy, and Matta, were associated with the more abstract wing of Surrealism, and continued to maintain those values in their art. In America these artists reaffirmed the importance of both the formal nature of their art and its poetic content.

André Masson said in an interview in the *Museum of Modern Art Bulletin,* "The surrealist movement is essentially a literary movement.... In literature the surrealists are as insistent as Boileau; but when it comes to painting they are very liberal in matters of structure. The spiritual directors of surrealism are not of the profession.... The admirable achievement of Seurat, Matisse and the Cubists was counted as nothing. Their exalted concept of space and their discovery of essentially pictorial means were treated as a burdensome legacy which had to be thrown overboard."[7] Breton, himself, observed this change in the first article he wrote for *Minotaure* after arriving in the United States. There he noted the decline of interest in Dali, and the increased influence of psychic automatism in painting.

This general redirection in Surrealism became important to Motherwell and the other Abstract Expressionist painters because of their transformation of Breton's psychological theories into more plastic and formal pictorial expressions. I have already mentioned that Motherwell's early study of Freudian thought, and his theoretical distinction between the ego and the id oriented him toward work that was both spontaneous and controlled. It led him away from the sexual and infantile fantasies of which the imagistic Surrealists were particularly fond.

Motherwell's contact with the Surrealists centered around two figures, Matta and Wolfgang Paalen. Motherwell met Matta at Seligmann's studio in February of 1941, and was soon visiting him several times per week. Matta has stated that he was fascinated by Motherwell's "theoretical bent of mind."[8] Although Motherwell had no formal artistic training, his extensive knowledge of philosophy, aesthetics, literature, and psychology appealed to Matta's speculative intellect. In June of 1941 Matta, Motherwell, and Barbara Reis traveled to Mexico. Motherwell and Matta remained in the mountainous artists' colony of Taxco until August. It was during this summer that Motherwell executed his first works that are known and preserved today.

Around 1940 Matta challenged Breton's bias toward imagistic painting on the grounds that Breton himself had established in his first Surrealist manifesto of 1924, the theory of "psychic automatism." Motherwell remembers that he first learned of the manifesto and this definition from Matta early in 1941.[9] On one level, Matta took automatism to mean releasing the creativity of the mind through rapid, scarcely controlled paint application. In a 1944 *Art News* interview he said of his painting of 1939 till 1941, "I took up painting, plunging into and mastering its technique in a wave of creative energy, 'pure automatism.' Where artists once tried to tell you what it feels like to be a tree, I express what modern life feels like."[10] Later in his career Matta again remembered this early period, "I was trying to be as free, as close to the real feeling as possible, with a minimum of control. No time to compose."[11] The relationship of Matta's theory of automatism to its practical

expression can be seen in the painterly spontaneity of a work such as *Prescience* of 1939 (fig. 1). There, all the forms are painted in thin, rapidly applied pigment, and thus remain amorphous with many layers of paint overlapping. The thinness of the paint at the same time gives the illusion of deep indeterminate space. In the center of the painting accidental drips from the rapid application of pigment can be seen, and the upper right is dominated by thin washes bleeding into one another with no identifiable shapes. James Thrall Soby, a longtime friend of the artist, wrote in 1947 of the spontaneity of these early paintings, "His technique was spontaneous to the point of being careless. In some of the paintings [1938–40] and a later period, for example, he allowed pigment to spill and run in certain sections, creating its own accidental patterns."[12] This technique influenced the rapid and emotional execution of Motherwell's first drawings and watercolors.

Matta, however, accompanied his rapid handling of the medium with two other concepts which did not have a long-term influence on Motherwell's art. The translucent washes of pigment Matta used suggested an infinite spatial depth in which he found a metaphor for the recesses of the mind. Thus Matta called his works "inscapes," a term invented by the poet Gerard Manley Hopkins, by which Matta meant internal landscapes or vistas of the mind.[13] Matta further encouraged the illusion of infinite depth, which denied the emphasis on the flat picture plane, a basis of modern painting, by drawing receding perspective lines and thus establishing visible schema for spatial depth.

Matta also developed the concept of "morphology," which he emphasized as essential to his art. For him morphology was "following a form through its evolution."[14] Thus many of his shapes appear to be hybrids between mineral, liquid, and gaseous substances in a condition of flux. His morphological and spatial expression denied other assumptions of modernist painting which were embraced by Motherwell, the insistence on flatness, edge, silhouette, and the clarity of form.

Motherwell's first works in Mexico were small ink drawings dated between July 17 and July 25, 1941 (figs. 2, 3, 4, and 5). He made them in a 9 × 11-inch notebook which was later called *Mexican Sketchbook*. *Mexican Sketchbook* was subsequently buried amid the artist's papers and did not come to light again until 1979. The drawings in it have not been adequately discussed in the Motherwell literature, and are extremely important. They exhibit a remarkable degree of maturity and look forward to many of the artistic concerns which dominated Motherwell's later art.

Ten drawings in *Mexican Sketchbook* exhibit rapid linear scribbling, portions of which were filled in with solid, black inked shapes suggested by the scribbling. Motherwell's sketches should be compared to Matta's pencil and crayon drawings of the early forties. Motherwell has said of Matta's

drawings, "I found them among the most beautiful works of that decade."[15] Yet a comparison of *Mexican Sketchbook*'s page A, dated July 17, to Matta's *Endless Nude* (1941) reveals important differences (fig. 6). In Matta's drawing various plantlike shapes are clearly evoked, and diagonal lines in the lower left indicate recessional depth. Motherwell's drawing is more abstract; he does not stop to elaborate bone or plant "morphologies." Rather, long segments of his line are connected, indicating that he executed it in looping rhythms without hesitating for conscious evaluation. This method of execution led to the greater spontaneity of his work, and its higher degree of abstraction. Also Motherwell's line adheres to the picture surface with no indication of spatial recession.

After the spontaneous, preconscious scribbling on page A, Motherwell more deliberately filled in some of the contours, roughly defined by the lines, with black ink. While Matta's light crayon rubbing suggests atmosphere and three dimensional forms, Motherwell's shapes are flat, emphasizing edge and contour. They are neither shaded to indicate volume nor shaped so as to suggest recession. Yet on the two-dimensional picture surface, Motherwell's forms have a much more lively interaction than Matta's. They push against, or withdraw from each other, and fit into adjoining contours. For instance, the comma shape in the lower right seems to gesture toward a curved contour which is the negative of its outline. There is a playful spirit evoked in these early sketches. The plastic activity brings the shapes alive without the necessity of defining a specific narrative context or creating an illusionistic dream world.

Motherwell's earliest drawing embodies several tendencies which remain critical to his mature art. Rapid abstract drawing is related to a spontaneous conception of artistic process, and represents the artist's application of the theory of automatism. His drawing method produces solid but irregular, vaguely organic forms which emphasize edge and silhouette without depth. Finally, there is an interest in the dramatic contrast of black and white without mediating grey tones. In fact, the early drawings in *Mexican Sketchbook* are surprising precursors to Motherwell's most famous painting motif, "The Elegies to the Spanish Republic," discovered at the end of the decade. Many of these formal devices relate directly to the abstract procedures of spontaneity and structure in philosophy and Symbolist literature which Motherwell had already absorbed.

The dating of *Mexican Sketchbook* is based on three dated drawings, A, C, and H, and the stylistic affinities between these and the other drawings in the book. The only exception is J, a watercolor, which appears closer in date to other watercolors executed later that year. The book, one should remember, covers probably only nine days of activity, and indicates that Motherwell's initial and natural tendency toward creative freedom and

abstraction was temporarily overcome by the illusionistic aspects of Matta's art. Drawing G , near the end of the series, shows a craggy landscape in detail through converging perspective lines similar to those used by Matta (fig. 5). The landscape, which contains schematic mountains, a lake and even a bird, also resembles a free adaptation of traditional artists' perspective drawings. This work was probably influenced, in addition, by the vacant landscapes of Yves Tanguy. Motherwell had met Tanguy at Seligmann's studio. He could have known the French Surrealist's work from a variety of other sources including reproductions, the two examples of his paintings which hung at The Museum of Modern Art, and a May 1941 Tanguy exhibition held at the Julian Levy Gallery, when Motherwell was still in New York.

Falling between early and late drawings in *Mexican Sketchbook*, drawings D and E show a degree of abstraction and spontaneity which recovers the spirit of drawing A. In drawing D the areas of black ink prevent the linear patterns from coalescing into a visible landscape image. Drawing F is more representational. Heavy black brush-drawing divides the paper into compartments. At the lower right, a schematic insect is trapped. This creature shows that Motherwell was not yet immune to the fantastic monsters of Surrealist visions, as well as being susceptible to their theatrical space.

This tendency toward a more imagistic Surrealism, shown in the final drawings of *Mexican Sketchbook,* was abruptly reversed by Motherwell later in 1941. This change was due in part to his contact with the Surrealist painter and writer Wolfgang Paalen, whom he met in August of that year. When Matta left Mexico at the end of August, Motherwell stayed near Mexico City until early November of 1941. He did so in order to continue his liaison with Maria Emilia Ferreira y Moyers, who would later become his wife, and to "work near Paalen."[16] He has recalled, "I received my post-graduate education in surrealism from Wolfgang Paalen."[17]

Although Paalen was painting in an imagistic Surrealist manner in 1939, he radically shifted both his artistic theory and painting style by 1940.[18] (Later in his career, he marked 1940 as the year of his break from the Surrealists.[19]) Like Matta, Paalen found automatism to be an important source for artistic creativity, and to a greater extent than Matta opposed imagistic Surrealism. In an article translated by Motherwell for *Dyn* magazine, which Paalen had founded and edited, the Surrealist painter remarked:

> Salvador Dali has never made a painting which could be qualified as automatic. This point has to be clearly established, because his defenders pretend that his academic style does not matter since he uses it as a means to relate automatically experienced images of dreams. . . . But it is precisely for this reason that his painting instead of being automatic is simply an academic copy of a previously terminated psychological experience. . . . [T]he true value of the artistic experience does not depend on its capacity to *represent*, but on its capacity to *prefigure*, i.e. on its capacity to express a potentially new order of things.[20]

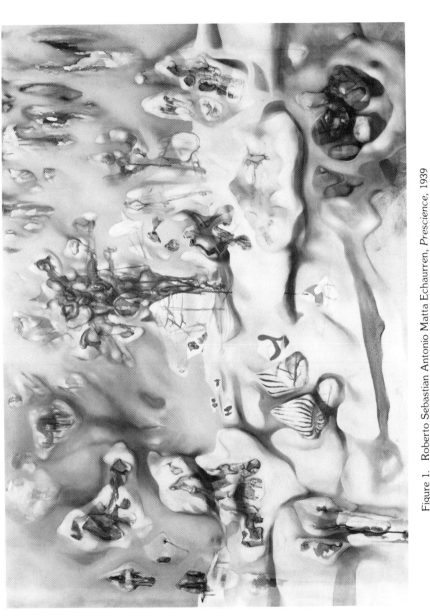

Figure 1. Roberto Sebastian Antonio Matta Echaurren, *Prescience*, 1939
Oil on canvas, 36 × 52 1/16"
(*Collection Wadsworth Atheneum, Hartford. The Ella Gallup Sumner and
Mary Catlin Sumner Collection*)

Figure 2. Robert Motherwell, *Mexican Sketchbook* (A), July 17, 1941
Ink on paper, 9 × 11 1/2"
(Collection Robert Motherwell)

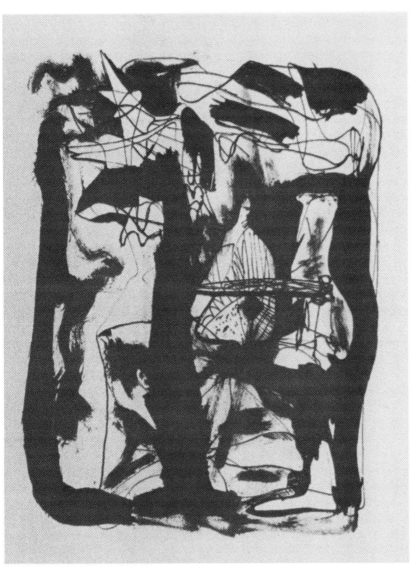

Figure 3. Robert Motherwell, *Mexican Sketchbook (D)*, 1941
Ink on paper, 9 × 11 1/2"
(Collection Robert Motherwell)

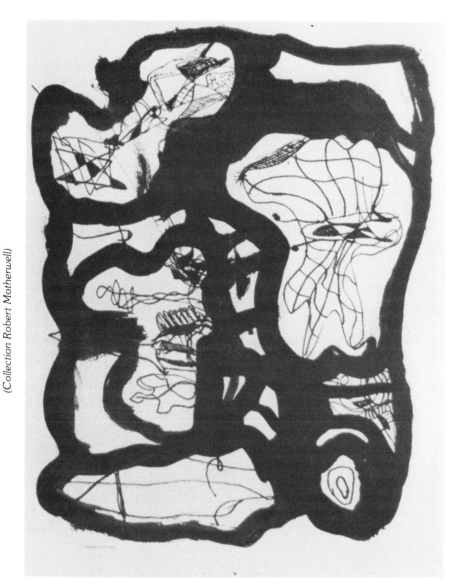

Figure 4. Robert Motherwell, *Mexican Sketchbook* (F), 1941
Ink on paper, 9 × 11 1/2"
(*Collection Robert Motherwell*)

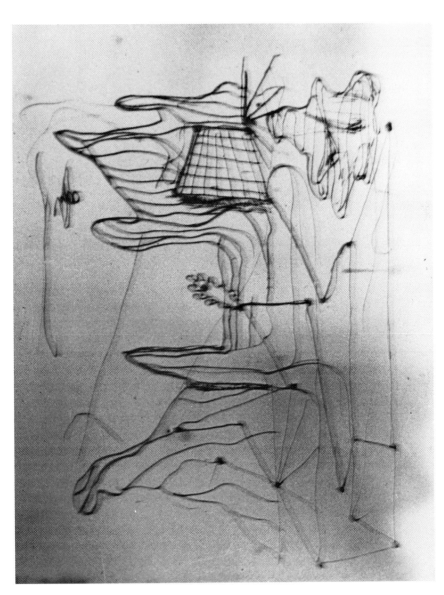

Figure 5. Robert Motherwell, *Mexican Sketchbook (G)*, 1941
Ink on paper, 9 × 11 1/2"
(Collection Robert Motherwell)

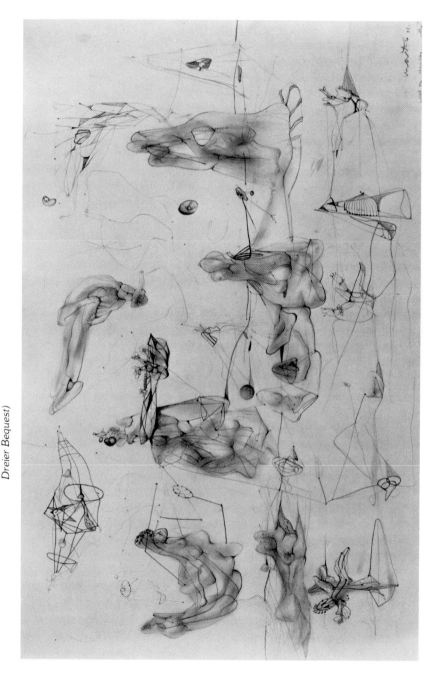

Figure 6. Roberto Sebastian Antonio Matta Echaurren, *Endless Nude*, 1938
Crayon and pencil on paper, 12 3/4 × 19 1/2"
*(Collection, The Museum of Modern Art, New York City, Katherine S.
Dreier Bequest)*

Figure 7. Wolfgang Paalen, *Untitled*, 1938
Ink on paper, 21 3/4 × 28 1/2"
(*Collection, The Museum of Modern Art, New York City. Gift of Mrs. Milton Weill*)

Paalen thus did not consider art an imitation of psychological experiences. He regarded it as an evolving experiment in the course of which psychological experiences were actually discovered, or in his words "prefigured." We will see that throughout Motherwell's career, he similarly discovered states of mind while engaged in the *act* of painting.

Paalen placed even more emphasis than Matta on abstraction as the necessary direction for automatism. In contrast to Matta's anthropomorphic forms, Paalen proposed in both his art theory and through the example of his paintings that forms arrived at through automatism be expressive without reference to known or existing objects. He wrote:

> The true value of the image, through which artistic activity is connected with human development lies in its capacity to project a new representation which does not have to be referred for its meaning *to any object already existing.* This point will appear clearly below: however it may already be considered as established by the fact that the symbolic value of a sign, in certain cases, does not depend on its possibility of being identified with any concrete reality. . . . The sign is usually used with a one way symbolic meaning with a practical end in view. "V" for "Victory" for instance, and other such signs are not identified with actual objects. Instead they operate as visual symbols whose function it is to bring about behavior conducive to the material realization of ideas which are so signified.[21]

Although Paalen had thoughts about a more abstract and spontaneous art before Motherwell met him, Motherwell made important contributions to the development of those ideas, which the artists worked out together. Specifically, he recalls introducing Paalen to the philosophy of John Dewey.[22] Paalen cited Dewey's *Art as Experience*, discussed in chapter 1, several times in his essays. He also wrote a letter to Motherwell about sending a copy of his book *Form and Sense* to Dewey.[23] For Paalen as for Motherwell, Dewey provided a philosophical parallel for the view of painting as an *activity* of direct contact between the artist and his medium, an encounter which could be signified by nonrepresentational paint marks upon the canvas. Later, this idea would be called "action painting" by Harold Rosenberg, the important critic of Abstract Expressionism.

Paalen's paintings of 1938–44 parallel his art theory by showing totally abstract rhythms of paint. They can be divided into two categories. One is a group of ink drawings such as *Untitled* in which colored inks are randomly splashed upon the paper (fig. 7). Their experimental freedom directly influenced Motherwell's contemporary watercolors, which will be discussed in the following pages. The spontaneity of Paalen's ink drawings is also echoed in his work throughout the forties. In collages such as *Pancho Villa, Dead and Alive* and in *In Blue with China Ink* we find thinned paint splashed upon the paper in a similar gesture. Much later in the 1960s, Motherwell's "Beside the Sea" paintings show a type of spontaneous decision making and a use of chance which look back to these early works by Paalen.

The second category of works by Paalen consisted of oil paintings. In these works Paalen intended more controlled vortexlike patterns of paint strokes to represent what he described as the "swirling energy of my ideas."[24] He felt that in these paintings he had discovered a new multidimensional space in which colored surfaces and lines expanded freely in all directions. The influence of these rhythmic abstract paintings on the other Abstract Expressionists, particularly Jackson Pollock, still needs to be investigated.[25]

Under some influence from Paalen, Motherwell's work returned to his natural inclination for spontaneity and abstraction. A new group of five small watercolor and ink drawings, dated in the fall and winter of 1941 just before Motherwell returned to New York, represent the significant change. The first of these works is *Landscape of the Inner Mind,* titled and dated "17 Sept. 41," on the verso (fig. 8). The title is extremely important. As noted, Paalen had written that his work reflected mental rhythms, and Matta had called his paintings "Inscapes." Influenced by these antecedents and with his knowledge of psychology, discussed in the previous chapter, Motherwell came to view his own art as abstract representations of states of mind and passionate feelings. The title of this little watercolor is the first conclusive evidence in his works of the forties of that viewpoint.

Landscape of the Inner Mind is transitional in style. While the left side depicts a landscape close to those executed in July, the right side shows a different view of the "inner mind." It consists of thicker washes which inhibit reading into depth. Two ovals, one containing roughly concentric circles, and the other, placed within a divided square, are depicted. These forms relate loosely to each other across the surface of the paper rather than encouraging an illusionistic reading of spatial depth. The concentric circles seem to be a metaphor for penetrating ever deeper layers of thought. They remind us of the vortex patterns in Paalen's paintings, but unlike Paalen's works they are relatively flat. The oval trapped within a grid looks forward to the contrasts between organic and more geometric shapes, visual equivalents for emotional and intellectualized experiences, which dominate so much of Motherwell's later work.

The right side of *Landscape of the Inner Mind* may be compared to four similar watercolors, including *For Pajarita,* which show thinly rubbed watercolor pigment and ink lines scribbled on paper (fig. 9). These works are remarkable for their freedom and spontaneous invention. In *For Pajarita* the watercolor is washed across the surface of the paper with no regard for creating representational forms. The tendency of brown watercolor to read like a mountainous landscape is frustrated by the green oval area suspended in the center of the paper. This green area and the red circle within it provide the only focal point for the work. Both shapes are outlined with thick black contours which emphasize flatness and surface. Perhaps Motherwell intuitively felt that the contrast of green and red, complementary colors,

added to the visual energy of the work. Similarly, the spiral pattern to the lower left shows Motherwell's attempt to draw energetically and yet avoid representation. Paalen had used the spiral form as a sign of energetic and emotional thinking. Rapid ink scribbles are evident throughout *For Pajarita*. The recessional lines to the upper and lower left are summarily broken rather than allowed to converge and thus indicate depth as they did in the later *Mexican Sketchbook* drawings. Motherwell was clearly influenced by the painterly freedom advocated by Matta and Paalen, but I know of no work by them which is so uninhibited in execution as this little watercolor by Motherwell.

Other watercolors, dating from the fall of 1941, are similar in style to *For Pajarita* (fig. 10). All show jagged linear marks and energetically drawn spiral lines. Thin washes of watercolor are splashed on the paper with little regard for the contours formed by the rapid ink drawing. In none of them is description of locale or objects important. Rather, maximum tension and emotion are sought through painterly means exclusively. The works exhibit a quality of reckless energy unprecedented in Motherwell's experiments to that date. Only one watercolor in *Mexican Sketchbook*, page J, appears to date from this period because of similarity in medium and degree of abstraction (fig. 11). Perhaps Motherwell had the last page of the sketchbook empty when he took it to Mexico City in late 1941, and filled it there sometime in November. Page J is reminiscent of *For Pajarita*, but it is quite different in the type of feelings expressed. Rather than the linear energy of those watercolors, J exhibits soft, floating, organic forms set on a more evenly washed background. In fact, these forms resemble the aquatic shapes of Mark Rothko's Surrealist watercolors of 1941 through 1946, although neither artist knew of the other's work at this time. The background of page J contains areas of yellow, brown, and red which bleed gently into one another. Page J shows Motherwell's increasing ability to convey a variety of feelings through abstract devices and spontaneous creation. Seldom will we see this intuitive side of Motherwell's art so fully exposed as in these watercolors. In later works he covered over most of this initial, free painting with more structured and considered compositions. Yet the emotional, spontaneous style of painting remains under the surfaces in most of his later works. It is never entirely overpainted. In many of Motherwell's important early paintings the traces of spontaneous style and improvisatory energies can be seen in isolated areas of the canvas, or "windows," and the interaction with structure is deliberately made visible, so that complementary modes of creation can be clearly read.

Motherwell created an important oil painting while in Mexico, which has not been sufficiently discussed in the literature on him, *La Belle Mexicaine* (fig. 12). The painting shows a shift in his artistic direction which places it as the last work of that trip. *La Belle Mexicaine* began with a type of free

automatist paint mark that dominated Motherwell's watercolors. This initial scribbling in oil paint can be seen throughout the left side of the figure's torso. In fact, the thin soft washes of oil paint in red, yellow, grey, and white markedly resemble those in page J of *Mexican Sketchbook*. The bulging contours of the figure's upper body, and especially her apron, resemble the contours of the black organic shapes in J. It is probable that a work similar to watercolor J originally covered the entire surface of *La Belle Mexicaine*. For a female portrait, which Motherwell later identified as his wife-to-be Maria, it was appropriate that the artist used the more gentle and organic of his recently developed, spontaneous painting styles. Rather than watercolor, the oil paint was probably poured on the canvas and then loosely intermixed with brushes and sticks. No attempt was made at that stage to define specific objects. The oil paint sits on the surface of the canvas, as opposed to watercolor which soaks into the paper and thereby creates some degree of spatial illusion.

Referring to *La Belle Mexicaine,* as well as to much of his work during the forties, Motherwell described his working methods in an unpublished interview: "What actually happened in my work was that I began pictures automatically—the automatism consisting of dabs of paint scraped across the surface of the canvas with brushes or sticks or spatulas—the kind doctors stick down your throat. . . ." Motherwell then found in these abstract paint marks, made by intuition, suggestions from which he could construct the figure. He continued, "But then in my efforts to resolve the picture a great deal of the canvas would slowly be covered with a more formal, architectonic surface. Actually in the portrait of Maria [*La Belle Mexicaine*], done in Mexico, the primary automatism is largely covered with a portrait of its own structure. But the portrait would have had a different figuration if it were not being worked out in relation to the primary automatism."[26] This statement is very significant. The combination of spontaneity and architectonic structure, sensuality and rationality, will be played out again and again in his work.

The "structure" of *La Belle Mexicaine* diverges radically from the art of Matta and Paalen. It is the first example in Motherwell's art that demonstrates his interest in Picasso. The painting might be compared to any one of Picasso's seated females which he executed largely between the late 1920s and late 1930s. Perhaps Motherwell was specifically recalling Picasso's *Seated Woman,* which was exhibited during the 1940s at The Museum of Modern Art (fig. 13). In this comparison the differences between Picasso's and Motherwell's works are also immediately evident. The automatist methods Motherwell depended upon to stimulate his creative involvement clearly show in his painting. The process of creating the work thus remains graphically visible from spontaneous conception to the final finished structure, and both modes take on a symbolic value for different stages in the creative act.

Picasso's *Seated Woman* is based on the ambiguities of form which can be traced back to Cubism and which remained central to his art. Three simultaneous views of the face are evident; the right shoulder melts into the breast, and the background wall patterns are fractured. In *La Belle Mexicaine,* the background is flat, though rich and painterly in its mixture of grey and white brushstrokes. Motherwell's figure is outlined and fixed with a thick line which prevents the spatial metamorphosis and ambiguities Picasso intended. Yet that line also gives Motherwell's figure a softer, more organic character than Picasso's hard modeled volumes. The face of Motherwell's figure is partially obliterated with softening brushwork, rather than expressing the convulsive divisions of Picasso's facial features. While the thin stripes in the lower skirt of Picasso's figure play optical tricks, Motherwell fills in his stripes so as to create strong, but painterly, brushstrokes parallel to the picture's edges. These stripes anticipate the dominating vertical patterns of *The Little Spanish Prison,* and appear in different contexts throughout Motherwell's later career.

In summary, Motherwell sought to resolve his intuitive paint handling within a two-dimensional structure. His figure is more concrete and less ambiguous than Picasso's because of its flatness and the powerfully defining black lines. Yet Motherwell's female is also softer and more humane than Picasso's. Motherwell's oblique portrait is a commanding presence yet it conveys an impression of softness and sensuality. This is close to the manner in which Motherwell has remembered Maria.[27] The fact that the automatist painting passages are at the center of the figure speaks perhaps of an opening to the preconscious, here shown more literally than Motherwell would in his later paintings.

This dialectic between sensual, spontaneous marks and clear direct pictorial structure remains an essential characteristic of Motherwell's art. The artist has said, "My continuing struggle during the twenty odd years of my painting life has been to find equilibrium between the automatic and formal beauty that is the end result of an emerging process, in the sense of a dialectic evolution."[28] Motherwell discovered this characteristic plastic formula in Mexico in contact with Matta and Paalen. Yet, *La Belle Mexicaine* is atypical for Motherwell in its degree of naturalistic representation. It is significant that Motherwell spoke of the painting as begun "automatically" and resolved in an "architectonic surface." Motherwell was to be occupied in his next phase with canvases, executed shortly after his return to New York, whose emotion arose directly through paint handling and the invention of abstract shapes rather than the human figuration.

Another important aspect of Motherwell's trip to Mexico must first be discussed here, and that was the impact of popular Mexican culture upon his art. In Mexico, Motherwell became fascinated by the peasant life and forms of

popular art. From his young, romantic viewpoint, they were a class of people who expressed their feelings directly, unself-consciously and in a straightforward visual manner. He found their attitude close to the values he sought in his own art.

One visual expression of the vitality and earthiness of the peasants was their folk art. Motherwell remembers that he was extremely interested in this popular art. In contrast, neither he nor Matta paid any attention to the ancient or modern art of Mexico. Motherwell has said:

> Of course, I can not speak for Matta, but my impression was that he, no more than I, was interested in Mexican modern art or in pre-Columbian art. In those days he used to say, "North Americans have made the error of painting Indians. The thing to do is paint as though you were an Indian." Matta loved Mexican *art populaire*.[29]

He added:

> About popular art, if I may continue for a moment: I think that Mexico has the most beautiful of these kinds of objects, of any place: skulls in spun sugar and *papier mâché* bulls that are filled with firecrackers, *papier mâché* masks of all kinds—actually some of those masks had a most specific visual effect on me.[30]

The Mexican folk objects were frequently painted ochre and bright alkaline colors of orange, lemon yellow, and green. Motherwell came to equate these colors in his art with vitality and intense feelings.[31] We will see them used with this meaning in works like *The Little Spanish Prison* and *Spanish Prison*. Motherwell has recalled, "I didn't have the slightest interest in modern Mexican painting or in pre-Columbian art. But I loved the Indian market places, I loved Mexican-Indian folk art color: magenta, bright lemon yellow, lime green, indigo, vermillion, orange, deep ultramarine blue, black and white, and purple, lots of purple, and nobody else uses it, (no metalic colors which I detest), beautiful intense greens."[32]

Also, the folk objects and native fabrics were often designed in freely painted geometric patterns. In the early forties Motherwell adopted a freehand geometry in his art. The loose geometry in such paintings as *Spanish Picture with Window* and *Sentinel* is derived, on the one hand, from great modern masters like Matisse, Picasso, and Mondrian. However, the deliberately irregular adaptation of geometric form by Motherwell represented an effort to deepen the humanity of his art by reconciling it with folk art models.

Motherwell was also moved emotionally by the rough white stucco walls that he saw in Mexico (fig. 14). He remembers, "Huge stucco walls dominated my impression of the city [Mexico City]. These walls were meant as protection; they also had a strong sense of materiality in their rough surfaces.

Their tops were covered with broken glass to keep intruders out. Anyone trying to climb over would have been cut to pieces."[33] For Motherwell the idea of these stucco walls merged, in the manner of a Baudelaire's "correspondence," with the flat painterly surfaces of modernist art. They came to represent for him at different times security and frustrating entrapment. References to walls appear throughout Motherwell's work, and are particularly important in *Spanish Picture with Window* and *Wall Painting with Stripes.*

Motherwell also "became passionately interested in the Mexican Revolution,"[34] which provided him with an early sense of popular, but futile, humanitarian struggle. He equated this event with his efforts to humanize modern art. He would later enlarge this concern by his interest in the personal feelings provoked by the Spanish Civil War. Many of Motherwell's early works embody feelings which are equivalent to the humane struggle in the Mexican Revolution. These include *Pancho Villa, Dead and Alive* and *Three Personages Shot.*

Finally the cruel violence and bloodshed of the Mexican Revolution, as well as the general attitude of the peasants, convinced Motherwell that the various feelings generated by death were a theme he must explore in his art. He has recalled his experiences there:

> All my life, I've been obsessed with death and was profoundly moved by the continual presence of sudden death in Mexico (I've never seen a people so heedless of life)! The presence everywhere of death iconography: coffins, black glass-enclosed horse drawn hearses, sigao sculls, figures of death, corpses of priests in glass cases . . . women in black, cyprus trees in cemeteries, burning candles, black edged death notices and death announcements . . . All this seized my imagination.[35]

Motherwell's obsession with death may also be the unconscious result of his asthmatic condition and health anxieties as a child. He still remembers the struggle to breathe, and that "there was a great celebration when I reached my sixteenth birthday because nobody expected me to live." In any case, these feelings were reinforced by his experiences in Mexico, subsequent loneliness in New York, and personal response to World War II. The theme of death appears in such intensely personal, early works such as *Surprise and Inspiration, Personage* and *Pancho Villa, Dead and Alive,* and later more publicly in the "Spanish Elegies."

During the 1940s and throughout his career, Motherwell's imaginative involvement with Mexican and Spanish society was a personal variation upon the interest in primitivism experienced by such painters as Adolph Gottlieb, Barnett Newman, Jackson Pollock, and Mark Rothko. For the other artists, oblique references in their writings and paintings to "primitive" cultures, particularly the Northwest Coast Indians, satisfied a need for common

symbolism and basic emotions in their art. Motherwell was too interested in modern Western culture for such primitive yearnings.[36] In this regard, Mexico and Spain appeared to him modern societies which were partly preindustrialized and more humanistic. Thus,they provided an outlet for his romantic feelings.

In retrospect Motherwell has realized that all these feelings about Mexican life were absorbed subliminally, and took years to resurface in his art. He has noticed, "For some reason that I do not know, painting-wise I am often affected by places *after* I leave them . . . and as I remember, Mexico for a time became dominant in my painting after I returned to the U.S.A."[37] Indeed, when Motherwell returned to America the vivid, unsettling memories of the Mexican trip were combined with many new discoveries made about modern art in New York.

Figure 8. Robert Motherwell, *Landscape of the Inner Mind*, September 17, 1941
Ink and watercolor on paper, 9 × 12″
(Formerly collection Robert Miller Gallery, New York City)

Figure 9. Robert Motherwell, *For Pajarita*, 1941
Ink and watercolor on paper, 7 1/2 × 9 1/2"
(*Private collection*)

Figure 10. Robert Motherwell, *Automatic Drawing II*, November 1941
Ink and watercolor on paper, 8 × 10″
(Collection unknown)

Figure 11. Robert Motherwell, *Mexican Sketchbook* (J), 1941
Ink on paper, 9 × 11 1/2″
(*Collection Robert Motherwell*)

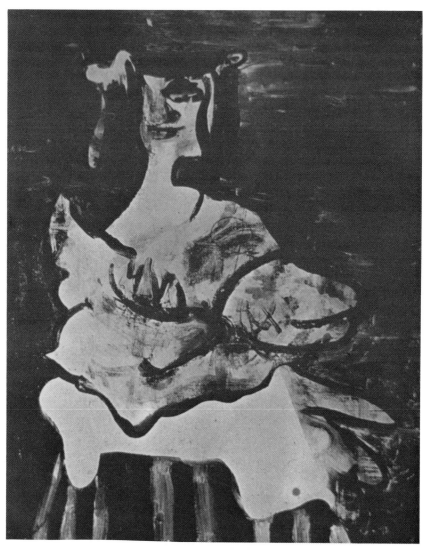

Figure 12. Robert Motherwell, *La Belle Mexicaine,* 1941
Oil on canvas, 29 1/2 × 23 3/4″
(Collection Robert Motherwell)

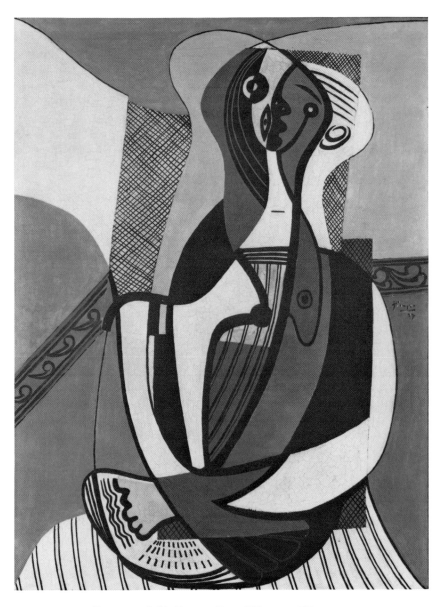

Figure 13. Pablo Picasso, *Seated Woman*, 1927
Oil on canvas, 51 1/2 × 38 1/2″
(Collection Art Gallery of Ontario, Toronto)

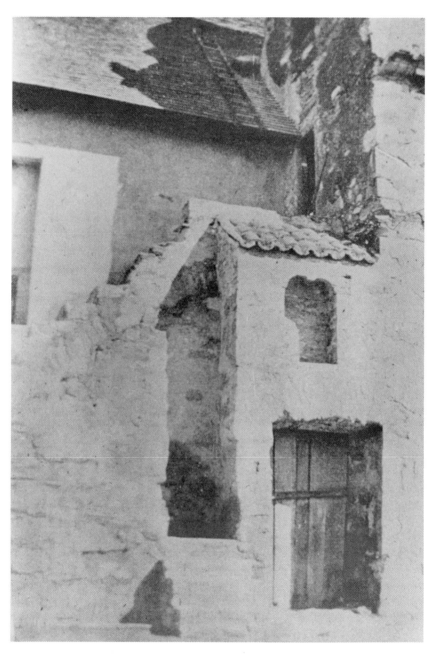

Figure 14. Wall in Mexico City

3

New York and the Modernist Tradition

Motherwell returned from Mexico with Maria in early November of 1941 and settled into an apartment on Perry Street, New York City. While he had created a promising group of watercolors and drawings in Mexico, they could hardly be described as sophisticated modernist paintings. His most ambitious effort, *La Belle Mexicaine,* found Motherwell striving toward originality combined with greater understanding of the modernist idiom, as it was embodied in Picasso's work of the late twenties. In New York, Motherwell was exposed to a much wider variety of modern paintings. He was convinced of the importance of the art scene in New York during the forties: "At that time, no where else in the world was there such a great collection of modern masterpieces."[1] A careful assimilation of contemporary painting was particularly important to Motherwell because he has always felt himself closely linked to the modernist tradition which he regards as extending from Baudelaire through Symbolism, Fauvism, Cubism, and Surrealism. The individual works of art in New York that he studied most intensely require some comment, for they profoundly shaped his art through the decade.

Motherwell remembers frequent visits to The Museum of Modern Art and the A.E. Gallatin Collection at New York University. At The Museum of Modern Art, he recalls that he was most struck by Picasso's *The Studio* of 1927–28, which he has called "the most important modern painting in America" (fig. 15). He also admired Matisse's *Piano Lesson* (1916) and the *Moroccans,* which hung in the museum. Motherwell frequently visited the Pierre Matisse Gallery, which during 1942 had exhibitions of Matta, Tanguy, Calder, and Miró.[2] The paintings he best remembers at Pierre Matisse were Henri Matisse's great *Bathers by the River* (1911–17) which hung in the lobby throughout the forties, and his *Goldfish* which was shown by the Gallery six times during the decade (fig. 16).[3] One of the most significant gallery exhibitions of 1942 for Motherwell was the first one-man show of Piet Mondrian at Curt Valentin's Gallery.

The single most important gallery for Motherwell, however, was Art of This Century which Peggy Guggenheim, then the wife of Max Ernst, organized. Ms. Guggenheim, the niece of Solomon R. Guggenheim and self-described "enfant terrible" of her family, first planned to open a modern art museum in London. Furnished with a list by Herbert Read of modern masters, she traveled to Paris in 1938 as the war hung over Europe. Once in Paris, Guggenheim decided to buy the works she had only intended to borrow. She recalled, "I put myself on a regime to buy one work of art a day."[4] Aided by Petra van Doesberg and Howard Putzel, Guggenheim found that Parisians, expecting the invasion, were happy to sell. Herbert Read's wide-ranging and eclectic interest in modern art influenced Guggenheim's collecting habit which was equally broad. Her collection included figures representing a wide scope of modern expressions, and contained works by Jean Arp, Giacomo Balla, Georges Braque, Salvador Dali, Marcel Duchamp, Paul Klee, René Magritte, Kasimir Malevich, Joan Miró, Pablo Picasso, and Yves Tanguy. As war overtook Europe, Guggenheim and Ernst dramatically escaped to America with her collection in 1941.

Equipped with these modern masterpieces, Guggenheim commissioned the Surrealist architect Fredrick Kiesler to design an art gallery called Art of This Century. The collection was divided into two tendencies, abstract art and Surrealism, which were housed in opposite wings of the gallery. Between these wings she operated a temporary exhibition space. The opening of the gallery was considered an event by such newspapers as the *World Telegram*, *New York Times* and *Chicago Sun*. The reviewer for *Art Digest* described the sensational impact of Art of This Century upon a public unaccustomed to avant-garde collections shown in a fantastic and bizarre setting:

> The installation, certainly the most spectacular in town, all but floored the critics. Designed by Columbia University's Fredrick J. Kiesler, the installation uses in the abstract gallery curving walls of blue canvas drawn taut by rope lacing to the ceiling and floor. Canvases jut out from the wall with neither visible means of support or frames. The surrealism gallery has concave walls of unfinished wood and a tricky lighting system that alternately lights up and darkens down certain sets of exhibits. In one corner a large wheel may be turned to bring into view successive works by Marcel Duchamp, in another a whirling electric motor brings a series of small Klees into view for precisely ten seconds each.[5]

Art of This Century soon became the focal point for both emigré artists and the new generation of emerging New York School painters. It remained an important center of vanguard activities until Guggenheim returned to Europe in 1947. Drawing on the advice of Ernst, Duchamp, Howard Putzel, Alfred Barr, and James Johnson Sweeney, Guggenheim organized a series of historical and influential one-man shows for Pollock (1943), Baziotes (1944), Motherwell (1944), Rothko (1945), Still (1945), in each case his first in New

York. (The specifics of Motherwell's exhibition will be discussed later.) In addition to these one-man shows, Guggenheim held an international collage exhibition in 1943, which will also be discussed later, and offered spring salons each year for promising young artists.

The division of Art of This Century into two major tendencies, abstraction and Surrealism, had a very important effect on the young New York School artists, who bridged the antithetical styles and resolved them into a variety of inventive painting modes. Their works were shown in the exhibition space between the two installations, and certainly for Motherwell the polarization of styles suggested the need for synthesis. Recently, he eagerly drew a diagram of the gallery and said, "The first time I saw the two wings, I realized the two directions abstraction and surrealism had to be joined."[6]

Motherwell's intention of identifying and synthesizing the two artistic modes is documented by his own 1942 checklist of Guggenheim's collection. On that checklist he marked individual works with either an "A" for abstract or an "S" for Surrealist. (Sculptures were marked with an "O" for objective.) For instance Braque, Delaunay, van Doesberg, Gris, Kandinsky, Malevich, and Mondrian were marked as abstractionists. Arp, Duchamp, Hayter, Klee, Masson, Miró, and Tanguy were listed as Surrealists. The only artist identified as both an abstractionist and Surrealist by Motherwell was Picasso. The fact that Motherwell regarded Picasso as combining abstraction and Surrealism was a factor in his careful study of Picasso's art. A clear instance of Picasso's direct influence is the relationship between Picasso's *Studio,* and *Pancho Villa, Dead and Alive.*

Elaborating further on his response to Guggenheim's collection, Motherwell has said, "Certainly Peggy Guggenheim's collection was one place where I was seeing good abstract pictures; it was the gallery I frequented the most, and it had several excellent exhibitions. I felt the full impact of Mondrian for the first time very deeply, I realize now. [Peggy Guggenheim owned two 1913 "plus and minus" works and the 1939 *Composition* (fig. 17).] I think I felt this influence more than I was consciously aware, . . . but my favorite picture in the whole Guggenheim collection was the white Picasso [*Studio,* 1928] which she told me Max Ernst had persuaded her to buy [fig. 18]. I also loved the beautiful brown Miró [*Painting,* 1925]."[7] Each one of these paintings had an important effect on the development of Motherwell's art.

The first important influence on Motherwell after his return to New York was Mondrian. Recently Motherwell has stated that the first Mondrian paintings he saw immediately after his return from Mexico were the four compositions exhibited at Gallatin's Museum of Living Art. Later he studied the Mondrians owned by Peggy Guggenheim, and saw Mondrian's exhibition

at the Valentin Gallery in March of 1942. He has remembered, "I visited the exhibition nearly a dozen times, almost against my will. I couldn't get away from him."[8] Motherwell then wrote a review of the Mondrian show for the Surrealist periodical *V.V.V.* stating that Mondrian represented the farthest direction to which abstraction had been pushed. Yet he also expressed his reservations about the severity of Mondrian's art, fearing it might entail a loss of contact with human emotions. Motherwell wrote:

> Moreover as Meyer Schapiro had remarked of modern art in general, Mondrian's work has the value of a *demonstration*. He brought abstract art into being at the moment when its nature was the object of much speculation, based on the unsatisfactory data of trying to view representational art of the past abstractly. His work has the value like that of an experimental scientist, *whether it is successful or not*, of showing us with permanent subjectivity what lies in a certain direction. But seizing the laboratory freedom of a scientist Mondrian has fallen into a natural trap—loss of contact with historical reality: . . . he created a rational art when art was the only place men could find irrational sensual release. . . .[9]

Motherwell's ambivalence about Mondrian expressed the essential conflict between instinct and intellect in his own art. Motherwell desired an art that was at once spontaneous and rational. The degree to which this conflict existed is a distinctive feature of Motherwell's work. Having executed watercolors during the fall in Mexico which are most notable for their careless freedom, it is remarkable that in March he could admire one of the most rational and reductive painters then practicing. Motherwell's first oil paintings executed in New York attempted to reconcile these two influences through the invention of an "emotive" geometry.

At this point in his career, Motherwell saw Mondrian's painting primarily as a way of clarifying his own art, rather than as a moral or aesthetic cause. He viewed Mondrian's art as a rational experiment, almost scientific in nature, which defined the extremes of one of the two major tendencies in modern art, abstraction, carried to its farthest point. Motherwell felt intuitively that he must incorporate that tendency in his art, though he also believed that he had simultaneously to humanize it. Mondrian's rational reductions were intellectually supported by his admiration for the logical systems in philosophy he had studied under Whitehead. Then, in 1944–45 Motherwell had a deeper encounter with Mondrian's art theory when he edited *Plastic and Pure Plastic Art* for the Documents of Modern Art series. At that time he realized that Mondrian's style also represented a moral position involving such concepts as goodness, originality, and order. This realization led Motherwell to reconsider Mondrian in broader cultural terms. The reevaluation was a contributing factor in the blossoming of Motherwell's art at the end of the decade.

Motherwell's early interest in Mondrian distinguished him from many of his New York School colleagues. Although Mondrian had devoted followers in the American Abstract Artists group, Motherwell recalls that he knew few artists in the New York School vanguard who accorded Mondrian great importance. He has said, "No more than ten artists I knew well even thought that Mondrian was above the second rank of painters."[10] Tony Smith, who was then close to the Mondrian circle, confirmed Motherwell's recollection, "None of the Abstract Expressionists were really interested in Mondrian at all."[11]

Although some of the New York School artists, particularly de Kooning and Gorky, did know members of the A.A.A. in the 1930s, there was little contact between the two groups during the 1940s. In 1940 the A.A.A. suffered a schism which ended the dominant role it had played in American art of the 1930s. That year the geometric abstractionists, led by G.L.K. Morris, attempted to narrow the goals of the A.A.A. so as to exclude more expressionistic abstraction.[12] This divisiveness halted the influential regular schedule of exhibitions of the group. As a consequence of the separation, the geometric painters became dryer and harder in their forms and colors. Many of those practicing expressionistic abstraction, who might have become linked to the Abstract Expressionists, turned back to figuration. They include George McNeil, Byron Browne, and Carl Holty. At the same time, many of the emerging Abstract Expressionists, such as de Kooning, Gorky, Gottlieb, and Rothko were moving in an opposite direction from a figural mode to abstraction. Harry Holtzmann remembers that Motherwell had no contact with the A.A.A. members, and how surprised he was when Motherwell, whom he had thought of as totally involved with the Surrealists, came to him in 1945, and revealed his long-standing interest in Mondrian, in connection with his decision to edit Mondrian's writings.[13]

Indeed the only other Abstract Expressionist who discussed positively the influence of Mondrian was Adolph Gottlieb.[14] The relationship between Gottlieb's grids, in which he inserted pictographic images, and Mondrian's art was far more schematic than Motherwell's absorption of Mondrian's style and ideas.

Motherwell's rapid assimilation of abstract principles in art can partly be accounted for by his early interest in Mondrian. From Mondrian's art, he learned the importance of surface and adherence to the picture plane of his shapes. The power and clarity of structures attained from alignment of forms to the picture edges also became apparent to him in Mondrian's paintings. Like Mondrian, Motherwell began to balance vertical and horizontal planes rather than weighting his forms gravitationally. He later understood that by extending these interlocking planes to the edges of the canvas he could infer extension of the pattern beyond the frame. This assumption was confirmed

by Motherwell's 1944 visit to Mondrian's studio, and it led to the increased scale of his paintings that year. Motherwell has said of Mondrian's art generally, "Once these structures were *driven home* by Mondrian, I saw how clearly evident they were in certain Picassos and Matisses."[15] Indeed, through Mondrian's constructivist influence, Motherwell was attracted to the more structured works by Picasso and Matisse. These were Matisse's 1914–17 paintings and Picasso's works of the later 1920s. It may be argued that Motherwell's early appreciation of Mondrian conditioned many of his later artistic interests.

The first four paintings Motherwell executed after his return to New York immediately showed the influence of Mondrian. They are *Recuerdo de Coyoacan, Spanish Picture with Window, The Little Spanish Prison,* and *Mexican Night* (figs. 19, 20, and 21). He began these paintings with thinned pigment poured upon the canvas in a manner similar to the automatist passages of *La Belle Mexicaine* (fig. 12).[16] The abstract, spontaneous underpainting, which began these works intuitively, can be seen in the "window" to the right center of *Recuerdo de Coyoacan.* As Motherwell explained in regard to *La Belle Mexicaine,* this intuitive and emotional beginning suggested and altered the structure of the painting subsequently derived from it.

In *Recuerdo de Coyoacan,* the vertical direction of the dripping pigment suggested the red vertical stripes in the canvas. These thin red stripes can be seen through the brown, black, and white pigment to have once dominated the entire composition. Unlike *La Belle Mexicaine,* the structure built over this automatism was not figurative, but geometric abstraction.

Motherwell's concern for clear structure based on stripes and flat, frontal forms was already hinted at in *La Belle Mexicaine,* particularly in the skirt of the figure. Yet, *Recuerdo de Coyoacan* consists entirely of straight-edged, interlocking planes. The style is clearly dependent on Mondrian's discoveries. As Motherwell indicated in his article on Mondrian, he felt the need to humanize the Dutch painter's art. This humanization took place first through showing the initial automatism in the "window." In fact, the pigment throughout is deliberately thin so that pentimenti and layers of revisions, human errors and corrections, are visible. The planes overlap, changing the color tones of each other as they do. This relatively active and imperfect relationship also differs from Mondrian's purer grids. Most important for the emotional expression of *Recuerdo de Coyoacan* are its dark, forbidding colors, black, brown, deep green, and dark vermilion red. These colors are certainly opposed to Mondrian's pristine use of primaries. Later in his career, Motherwell wrote of Mondrian's colors:

Despite the fact that Mondrian is one of the few painters to go beyond the aesthetic to a mystical vision, one notion of his used to annoy me namely that certain primary colors are the only "pure" colors and consequently only a pure painter ought to use. I found it ridiculous to equate pure with unmixed, for me the brown of burnt sienna is as pure as yellow.[17]

Motherwell's dark colors are more emotional and subjectively charged than Mondrian's. In fact, Motherwell has identified the overall feeling of *Recuerdo de Coyoacan* as "anxiety."[18]

The title of *Recuerdo de Coyoacan* refers to Motherwell's Mexican trip. Coyoacan is a section of Mexico City near Paalen's home. While the painting depicts nothing in the city, it evokes Mexico through its Mexican colors. The tones used and their ominous character are particularly close to the more frantic *For Pajarita* (fig. 9). The expression of "anxiety" in *Recuerdo de Coyoacan* resulted from emotions having been reined in, and the conflict between two painting modes as different as automatism and Mondrian's grid structure. Motherwell has referred to the window showing splashed paint in the work as "all the confusion I could stand in the painting."[19] The sublimation of these chaotic impulses through a controlling intellectual will, and the resulting anxiety also points out the importance for Motherwell of Freud's analysis of the repression of instinct. The painting acts out in a concrete manner the inhibiting, yet socializing influence of the superego upon the ego. Freud often described the result of this relationship as "anxiety."

Importantly, *Recuerdo de Coyoacan* epitomizes the dichotomy in Motherwell's work between order, which he associated with the intellect, and painterly freedom, which he linked to feeling and to Surrealist automatism. His later paintings more freely integrate these extremes. The fact that Motherwell remembered the stark juxtaposition of planar structure and automatism in this painting as resulting in a sense of "anxiety" shows the early date at which purely abstract forms provoked emotional states in him.

At first glance, *Spanish Picture with Window* also resembles Mondrian's work, particularly the nearly monochromatic *Composition* owned by Peggy Guggenheim (figs. 20 and 17). As in *Recuerdo de Coyoacan,* Motherwell has employed a flat geometric structure of interlocking planes. The edges of the planes consist of broken, uneven lines in red, yellow, and black. Unlike those of either Mondrian or his own earlier *Recuerdo de Coyoacan,* they are obviously hand-drawn and often fade away randomly in the midst of defining a shape. The lush, painterly white pigment of *Spanish Picture with Window* is also different from either the purity of Mondrian or the depressing tones of *Recuerdo de Coyoacan.* In *Spanish Picture with Window* shadowy layers of yellow and black pentimenti can be seen beneath the white. Motherwell again

deliberately made the evolving, uncertain process through which the work was created evident by retaining its surface marks. These underlying colors indicate that the lines in the canvas roughly define the edges of differently colored planes existing in the first stages of the painting, a style close to *Recuerdo de Coyoacan.*

The painterliness of *Spanish Picture with Window* is, in fact, much closer to Picasso's *The Studio,* which was also in the Peggy Guggenheim collection (fig. 18). As noted earlier, Motherwell had indicated on the collection checklist that Picasso was both "S" Surrealist and "A" abstract. Motherwell's codification referred both to ideas of emotion and order, or painterly freedom and geometric rigor. The resemblance between the Picasso and the Motherwell lies first in the creamy white ground with accents of red and yellow, although Motherwell limits those color notes to the upper left area of his canvas. Picasso basically drew his flat geometric figures in strong outlines derived from his Synthetic Cubist style. The supporting network of lines is far freer than Mondrian's gridlike schemes. The lines in the lower left area of *The Studio,* in particular, are unevenly drawn and thinly applied. Thus, they resemble Motherwell's linear methods in *Spanish Picture with Window.* From Picasso's paint handling, Motherwell perhaps derived his own deliberately rough and self-consciously handmade surfaces. We will see that throughout the forties Motherwell repeatedly referred for guidance to Picasso's works of the later 1920s and early 1930s that combine structure and free painterly handling.

The most important difference between the two works is that Motherwell eliminated Picasso's figural references to a sculpture bust and a schematic stick figure. In *Spanish Picture with Window,* Motherwell was able to release the emotional constraint he found in Mondrian through painterliness and hand-drawn lines, for which he discovered a precedent in Picasso. Unlike Picasso, he did so without recourse to figuration.

Motherwell recalls that the rectangle with red, yellow, and black stripes to the upper left of *Spanish Picture with Window* was originally a "window" showing freer underpainting like that in *Recuerdo de Coyoacan.*[20] This recollection led to the contemporary title that Motherwell gave the work. Its original name is unknown. In *Spanish Picture with Window* the artist covered over this automatist area with a colorful geometric design. I would suggest that such a window showing the original automatism was unnecessary in this painting because the intuitive quality that Motherwell sought had already been incorporated in the freer lines and painterly surface of the work, thereby relieving the mood of "anxiety" expressed in *Recuerdo de Coyoacan.*

Motherwell noted in a recent conversation about *Spanish Picture with Window* that it was his first work to call forth correspondences between a modern painting and the walls he saw in Mexico.[21] The textured white surface

of the painting particularly resembles stucco. The graffiti drawn on these rough Mexican walls had the sort of careless, uneven character that Motherwell gave the lines in *Spanish Picture with Window* (fig. 14). For Motherwell the wall could be a symbol of protection. In its emphasis on the picture plane and surface painterliness, *Spanish Picture with Window* has a more confident painterly and emotional tenor than the dark, anxiety-ridden *Recuerdo de Coyoacan.*

The Little Spanish Prison is perhaps the most famous of Motherwell's early canvases before 1944, and the artist considers it one of the most important paintings of his career (fig. 21).[22] The painting can not be called a turning point, however, because it took Motherwell many years of experimentation to realize the full implications of the seemingly simple discoveries he made in it. The work features undulating bands of lemon and white broken in the upper left by a small rectangle of magenta. The stripes of *The Little Spanish Prison* are flat, unmodeled and parallel to the side edges, emphasizing the frontal plane. Motherwell was almost obsessively aware of painting on the two-dimensional surface. In this regard, the yellow stripes were not painted on a white ground, but rather the yellow and white ribbons of paint abut with neither overlapping the other. Both the lemon and white stripes seem to have been painted over vertical stained areas in dark tones, perhaps black and burgundy. Motherwell has recalled that the magenta bar was originally a "window" revealing spontaneous underpainting. As was the case with *Spanish Picture with Window,* Motherwell found that the rippling surface contained so much energy and feeling that exhibiting the more spontaneous underpainting was unnecessary. A reminiscence of the darker colors of a preliminary stage was only retained in the tone of the magenta bar. The final lemon and white hues, however, are vibrant and cheerful. They relate to the bright colors of the folk art Motherwell saw in Mexico.

Rather than balancing horizontal and vertical planes of color as in *Recuerdo de Coyoacan* and *Spanish Picture with Window, The Little Spanish Prison* marks the beginning of verticality as a dominant theme in Motherwell's work. Premonitions of this interest appeared in the vertical drips of *Recuerdo de Coyoacan* and the solid vertical stripes in the small window to the upper left of *Spanish Picture with Window.* The vertical stripes in *The Little Spanish Prison* prevent it from being freely associated with a landscape. Our natural tendency is to infer horizons in nature from the use of horizontal lines, a problem that intruded upon the abstract qualities of Motherwell's Mexican ink drawings and watercolors.

The vertical orientation of forms in Motherwell's art continued throughout the forties and found its most consistent expression in his "Elegies to the Spanish Republic" in which ovals are pressed between

Figure 15. Pablo Picasso, *The Studio*, 1927–28
Oil on canvas, 59 × 91″
(Collection, The Museum of Modern Art, New York City. Gift of Walter P. Chrysler, Jr.)

Figure 16. Henri Matisse, *Bathers by the River,* 1911–17
Oil on canvas, 103 × 154″

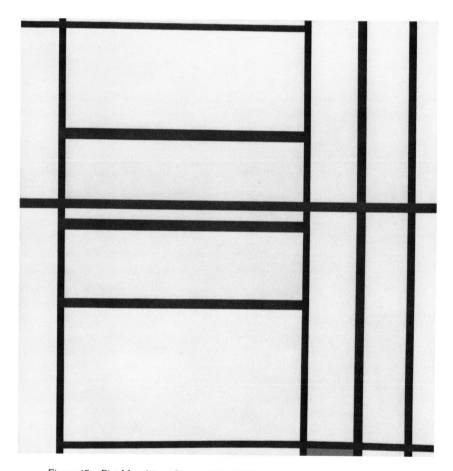

Figure 17. Piet Mondrian, *Composition*, 1939
Oil on canvas mounted on board, 41 7/16 × 40 5/16″
(The Peggy Guggenheim Collection, Venice; The Solomon R.
Guggenheim Foundation, New York City. Photo: Robert E. Mates)

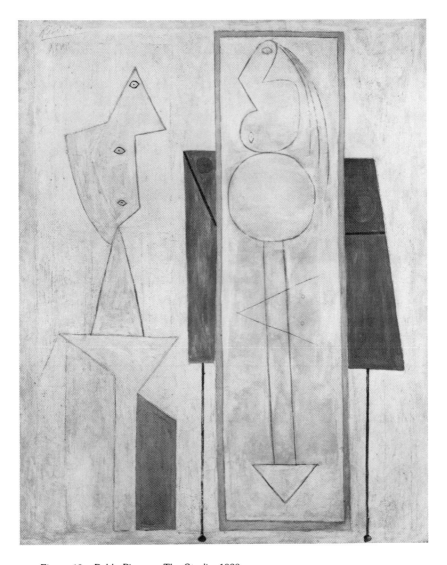

Figure 18. Pablo Picasso, *The Studio*, 1928
Oil on canvas, 64 × 51 1/2″
*(The Peggy Guggenheim Collection, Venice; The Solomon R.
Guggenheim Foundation, New York City. Photo: Robert E. Mates)*

Figure 19. Robert Motherwell, *Recuerdo de Coyoacan*, 1941
Oil on canvas, 42 × 34″
(Collection Robert Motherwell)

Figure 20. Robert Motherwell, *Spanish Picture with Window*, 1941
Oil on canvas, 42 × 34″
(Collection unknown)

Figure 21. Robert Motherwell, *The Little Spanish Prison,* 1941
Oil on canvas, 27 1/8 × 17″
(Collection Robert Motherwell)

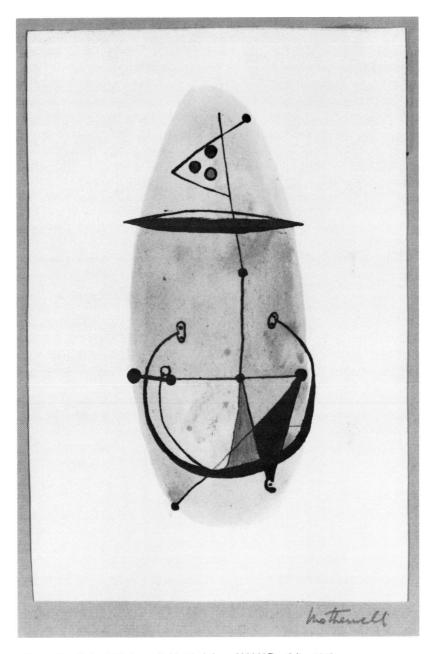

Figure 22. Robert Motherwell, *Untitled,* from *V. V. V.* Portfolio, 1942
 Black and colored inks on paper, 8 3/4 × 6″
 (Courtesy, Museum of Fine Arts, Boston. Bequest of W.G. Russell Allen)

elongated vertical slabs. In *The Little Spanish Prison* these rising and descending vertical stripes convey the feeling of organic life and growth without being specific to natural phenomena in their references. Although the stripes imply growth, they can also be associated with confinement, a reference confirmed by the work's title. This character arises from the irregularity of edge and the tension between the bands as they seem to press and pull against each other with more vigor than the lines in Motherwell's other canvases of that year. Each band of color seems to hold the other back from expansion. Motherwell has described the mixture of emotions he felt in *The Little Spanish Prison*, "The basic feeling is oppressive, compassionate, and yet the picture displays a certain assertiveness."[23]

According to Motherwell, his use of stripes was probably related to the stripes in such Picasso paintings as *The Seated Woman* (fig. 13). Also the schematic yellow picture edges on a white ground depicted in Picasso's *The Studio* seem a likely source (fig. 18). Yet, to remove these shapes from the partially representational context in which Picasso used them, and to have them embody the entire feeling of the painting is a radical innovation. The repetition of the stripes and their slight variation in the width, curvature, edge, and implicit motion combine assertive structural design and organic variety. Motherwell's stated objective of combining intuitive sensitivity and rational organization was achieved more completely in *The Little Spanish Prison* than in his earlier paintings. Motherwell has said of the painting, "The geometry is deliberately freehand emphasizing sensibility."[24]

Two years later Motherwell applied the principle of repetition with slight variations in shape and scale to a wider range of shapes. Ovals, stripes, and triangles interact in such different works as *Collage in Beige and Black* and *Mallarmé's Swan*. Although *The Little Spanish Prison* is a small painting (27 × 17 inches) the repetition of stripes infers continuation beyond the edges of the canvas, like ripples from a cast pebble that extend into a force field. This impression is enforced by the diminution in breadth of the outermost bands, suggesting that they may continue to expand beyond the confines of the canvas. This potential for increased scale was first realized by Motherwell in his large *Wall Painting with Stripes* of 1944. Heroic scale became a hallmark of Abstract Expressionism and later characterized a major segment of Motherwell's artistic production.

The title *The Little Spanish Prison* is the first indication during the forties of Motherwell's concern with the Spanish Civil War. The theme reappeared in his art throughout the decade and was ultimately expressed in the varied "Elegies to the Spanish Republic." Motherwell has been careful to point out that his paintings with Spanish Civil War themes are not objective records of the war.[25] Rather they embody personal and emotional responses which are often tied closely to his painting problems at that time.

Because Motherwell was completely isolated from the day-to-day horrors of the war, it became for him a symbolic struggle of the individual, or the sensitive man, against the forces of oppression. These broader symbolic and romantic implications permitted Motherwell to merge the peasant struggle in Mexico, taking place four decades earlier, with a more contemporary issue in the struggle of the "people" in Spain against the Fascist regime. For Motherwell the whole Spanish-speaking world became a place where feelings dominated, and impersonal mechanization had not yet taken over. In 1944 he wrote an important *précis* of his concern with Mexican and Spanish culture: "It is in the unindustrialized Spanish-speaking countries of the occident that this humanism, in a far more popular form still persists. . . . The Spaniards Picasso and Miró are especially loved, just as in the political sphere it is the Spanish Civil War and the Mexican efforts that strike our hearts."[26]

Of course, during the late thirties and early forties, Motherwell was only one of numerous artists and writers concerned with issues of freedom and oppression in the Spanish Civil War. Dore Ashton summarized the intellectual ambience in America during this period, "It would have been hard to find a writer or a painter who was not profoundly disturbed by the reports from Spain, and who did not have at least one friend who volunteered for the International Brigade. Spain loomed large in everyone's thoughts, all the larger because it seemed so far away."[27] The more allegorical view of the Spanish Republican cause was popularized in this country by André Malraux. Motherwell heard Malraux speak about the civil war while in California in 1937, and owned his influential novel about the conflict *Man's Hope*. Malraux saw in the Spanish Civil War a conflict between individual will and collective restraints. He supported this interpretation by vividly portraying individual citizens, often artists, caught in the struggle against a faceless enemy.[28] He also argued that regardless of the outcome of the war, the will and vitality of the Spanish people would continue to grow.

Motherwell's painting *The Little Spanish Prison* embodies similar beliefs. The vertical stripes are meant to suggest prison bars. By the time the work was executed, Franco had made Spain into a prison. Yet a tension is established between our ideas about a prison as a stable enclosure and the undulating stripes of the composition. The bars also suggest growing, organic forms. Similarly the bright yellow and white Mexican-Spanish colors do not suggest incarceration. Instead, they speak of vitality and life-force. The power of *The Little Spanish Prison* lies in its ability to contain contrasting emotions within the same forms. It carries us from one end on the emotional spectrum to the other, from joyful freedom to depressing confinement. In Motherwell's words, the painting contains "compassion, oppression and assertiveness," a multivalent content accomplished with the most direct and simplified painterly methods.

Motherwell's individual painting discoveries occurred at the time of increased contact between the Abstract Expressionist artists, which resulted in a cross-fertilization of ideas. During the early spring of 1942, Motherwell and Matta initiated some important gatherings of these artists. At that time according to Motherwell, Matta developed the idea that he wanted "to show the Surrealists up by making a manifestation counter to theirs."[29] He and Motherwell accordingly planned a series of meetings during which a group of young artists would experiment with various types of automatism. Motherwell remembers, "Matta said—quite properly—if we are going to make a manifesto against surrealists, the work has to have some group point, something more than simply personal talent. Then I said, you and I have talked for a year constantly about surrealist theories of automatism and we believe they can be carried much further."[30]

Because neither Matta nor Motherwell knew many American artists, they approached William Baziotes, to whom Matta had introduced Motherwell in 1941, and asked him to recruit artists he knew from the W.P.A. (Works Progress Administration) to join them. Baziotes tentatively selected Pollock, de Kooning, Peter Busa, and Gerome Kamrowski.[31] Over the next six weeks Motherwell and Baziotes visited these artists. Peter Busa remembers, "Bill introduced us, while Bob acted as the theoretician."[32] Busa recalls that Motherwell explained automatism as drawing rapidly without conscious thought, and that he emphasized the greatest value of this method was that "one could not help but be original."[33]

Pollock, Busa, and Kamrowski exhibited a great deal of enthusiasm for the automatist group. De Kooning was not interested in the proposal. In 1942 he had already developed an autographic style of fluid, though heavily painted organic shapes in both his figurative and abstract canvases. He was then struggling with the problem of "finish," and automatism offered little help with this problem. De Kooning also had developed a strong underground reputation in New York, and probably resented the suggestions of lesser-known artists.

Motherwell believes today that Pollock's interest in the automatist group was due primarily to his desire to establish a relationship with Peggy Guggenheim's Art of This Century. Yet, Motherwell also remembers that Pollock "was already convinced of the role of the unconscious in art" when they met.[34] Pollock had undergone several years of Jungian analysis by 1942, and probably found Motherwell's descriptions of automatism related to some of his own ideas for finding mythic symbols in the unconscious. Despite his dislike of group activities, Pollock did attend the automatist gatherings.

Before the actual meetings, Pollock met informally with Motherwell, Lee Krasner, and Ethel and William Baziotes at Motherwell's apartment on several evenings during the early spring of 1942. They experimented together

in writing automatist poetry, emulating the Surrealist "exquisite corpse" game.[35] Ethel Baziotes has described the experiments: "Each guest wrote a sentence on a common piece of paper, which was then folded to cover the phrase and passed to the next person. Finally the whole poem was read aloud."[36] Another game involved the spontaneous responses of each participant to a given word. The results were recorded by Motherwell in a notebook which has since been lost. These Surrealist games generally encouraged spontaneity and demonstrated the value of irrational associations. With his background in psychology and literature, Motherwell was particularly attuned to these experiments. The automatist poetry evenings may have had some bearing on Pollock's use of written symbols in paintings like *Stenographic Figure* of 1942, and Motherwell used words in his two *Viva* paintings of 1945–46, and later in numerous works. The difference is that Pollock utilized a multitude of cryptic signs in his painting which relate to his later complex, dripped webs, while Motherwell utilized the letters as bold shapes to proclaim his renewed creative vitality in late 1945.

The group meetings with Matta during the spring of 1942 were more structured. At these meetings, Matta suggested themes such as "male and female, natural elements, life and death, and the hours of the day."[37] These themes differed from the typical Surrealists' subjects in their breadth and less fantastic associations. Rather than calling for specific myths, they left open a wide range of creative options, including the possibility of abstract shapes. Throughout the 1940s, Motherwell used abstract shapes to express the feelings generated by similarly broad and universal human concerns. As an example, the emotional differences between male and female were summarized in his stick figures through works like *Three Important Personages* and *Jeune Fille*. Motherwell suggested his personal response to natural elements in such paintings as *Western Air,* and the "still life" paintings of 1947. The theme of life and death began to appear in his work in *The Joy of Living, Surprise and Inspiration,* and *Pancho Villa, Dead and Alive.*

While Matta's subjects may have appealed to the young New York artists, his insistence that they be incorporated into the illusionistic, pictorial context of his current work alienated their sympathies. Matta has described his impressions of the automatist meetings, "Everyone brought samples of their work. I felt we had to keep a degree of reference to reality, and a sense of the possibility of the deep space in the picture. It couldn't be all explosion, you know."[38] Disagreements broke out in the group almost immediately, and the participants disbanded after some six meetings. Baziotes reported that Pollock disliked the organized methods which reminded him of "school homework assignments." Busa remembers that Motherwell and Matta were at odds because "Bob believed so strongly in Picasso and Matisse and their discoveries."[39]

Indeed, nearly one year earlier Motherwell had built on Matta's discoveries of emotional, spontaneous drawing and paint handling in Mexico, subordinating his own intuitive feeling for a more two-dimensional and abstract pictorial organization. In New York, however, his awareness of pictorial structure inspired by Mondrian and Picasso, became more urgent. Motherwell recalls, "Matta always consciously took the position that the message is everything in art: colors, forms, etc., are sugar coating to get people to dig the message that reality is more important than art. Matta thought of abstract art as being formalism."[40] Motherwell believed that Surrealist automatism must be made compatible with two-dimensionality, strong pictorial structure, and other standards of modernist art.

Although no works have been conclusively identified by the participants of any of these automatist group meetings, certain suppositions based on stylistic evidence can be made. Baziotes's paintings of 1942 are clearly dependent on Matta. Those works exhibit amorphous objects and bright mineral colors typical of Matta's morphological forms. Baziotes would retain these thin, glowing washes throughout most of his career. Later he monumentalized his forms, and his mature canvases allude to vague creaturelike presences rather than the landscape associations of Matta.

Baziotes's artistic method makes an interesting contrast with Motherwell's, and underlines the differing content in the work of each artist. Like Motherwell Baziotes apparently began his paintings by working "automatically" in abstract color areas. He has said:

> Each painting has its own way of evolving. One may start with a few color areas on the canvas; another with a myriad of lines and perhaps another with a profusion of colors. Each begins to suggest something. . . . The suggestion becomes a phantom which must be caught and made real. As I work or when the painting is finished the subject reveals itself.[41]

Baziotes remained much closer to the spirit and technique of Surrealism, however, by then evolving dreamlike and nightmare images from these spontaneous marks. Regarding other works related to the automatist meetings, David Rubin has suggested that a series of drawings by Pollock dated from circa 1939–42, representing male and female types, resulted from Matta's assignment of that theme.[42] Their graphic intensity and violence differs radically from either Matta or the other members of the group.

The one work that Motherwell remembers from these gatherings points to the growing differences between his work and Matta's. Motherwell's major study executed for the subject "times of the day" was a painting with yellow and white vertical stripes very much like *The Little Spanish Prison*.[43] The artist has said that he intended the bright tones to be a nonnarrative metaphor for the feelings evoked by midday sunlight. The painting was

unusual in that he painted on both sides of the canvas and mounted it on a rotating pivot, so it would act as a turnstyle for those entering a planned, but never staged, exhibition.

In contrast to Motherwell's integration of poetic metaphor and abstract painting, Matta had begun to deemphasize the painterly aspects evident in his 1939–41 works (see chapter 2). He exchanged these for a narrative iconography with science fiction overtones, as seen in his *Portrait of Breton* (1943), holding a futuristic ray gun. Matta has said of that period:

> I wasn't in the war. I felt I should participate, but being terrifically anti-militaristic, I went through a ferocious crisis, so to speak. And then I passed in my work to these anthropomorphic things. . . . It created a very definite divorce. Especially Motherwell when he came to visit me he would say, you are coming back to the figure. . . . I became the sort of fellow who wasn't accepted. They were happy as long as my work expressed cosmic violence and whirlpools.[44]

A break between Matta and the young Abstract Expressionist artists occurred at this point, as he embraced an explicit subject matter.

Motherwell spent the summer of 1942 in East Hampton. Although he saw a good deal of Max Ernst and Peggy Guggenheim, he does not believe that Ernst's art affected him at all. Ernst's paintings depicting primal rain forests had become increasingly detailed and imagistic since his arrival in America. (Motherwell's respect for Ernst's achievement, as well as his aesthetic distance from it, was expressed in his 1948 preface for Ernst's *Beyond Painting*.)

Despite Motherwell's increased theoretical ability to differentiate his artistic goals from the Surrealists and such surprising inventions as *The Little Spanish Prison,* Motherwell's paintings during the summer and fall of 1942 remained experimental and unresolved. His development during the 1940s was not a steady progression toward a single goal. For the young artist, painting was an experimental procedure which embodied the development of his entire personality. Discoveries were often made with brush in hand. This attitude meant that exciting innovations were sometimes made suddenly. At other times, ground that had been mastered already, was painfully retraced. For instance, two untitled "black" paintings, one of which is dated on the back September 1942, show several areas of vaguely organic forms created in thinly scumbled pigment. They resemble some of the shapes in his 1941 watercolors. These suggested organisms were partly covered by black paint which was then divided by a lattice of white lines in complicated and rather uncertain geometric patterns. With less assurance than *Recuerdo de Coyoacan,* these two somber little paintings show the agonizing difficulty

Motherwell sometimes had in resolving his spontaneous impulses and coherent pictorial structure.

Despite his ambivalent relationship with the Surrealists, Motherwell was invited together with Baziotes, Joseph Cornell, and David Hare to show at the First Papers of Surrealism exhibition organized by Breton and held at the Whitelaw-Reid mansion in October 1942. Duchamp created a truly enigmatic atmosphere by erecting a six mile web of string in criss-cross patterns in the room between the spectators and the exhibited works. Motherwell's entry, not previously known, has now been identified by the artist as the work to the right foreground in a popular photograph of the exhibition.[45] This painting, whose location is unknown, is one of the artist's most severely geometric and rationalized early works. It could only have been intended as a direct challenge to the fantastic and narrative imagery of the Surrealists.

For another Surrealist project Motherwell continued to search hard for means of expression which would vary the types of feelings possible within the abstract mode. In the fall of 1942 he was asked to submit works to a portfolio of prints issued by the Surrealist magazine *V.V.V.* in 1943. The portfolio contained works by Matta, Breton, Seligmann, Masson, Ernst, Calder, and Tanguy, among others.

V.V.V. had been conceived in the spring of 1942 as an American rival for the Surrealist magazine *Minotaure* published in Paris. It included articles on magic, fetishes, and such new Surrealist discoveries as Haitian witchcraft and science fiction. Motherwell was asked to be the American editor, but after accepting the position he resigned almost immediately.[46] This is another indication of his disenchantment with orthodox Surrealist ideology. While briefly working on *V.V.V.* Motherwell wrote to William Carlos Williams, asking Williams to be the American literary editor. In this unpublished letter, Motherwell affirmed his faith in creativity in terms that both avoid Surrealist imagery and that stress tangible painterly possibilities. He wrote:

> Through him [Schapiro] I came in contact with the Surrealists—against whom I had many philosophical prejudices—but they seemed to understand empirically the solution to those problems of how to free the imagination in concrete terms, which are so baffling to the Americans. . . . Now I have taken a partisan stand, in the creative sense that surrealist automatism is the basis of my painting.[47]

It is noteworthy that Motherwell limited his interest in Surrealism to the creative principle of automatism. He also reinforced this principle with reference to his background in empirical philosophy, discussed in chapter 1, and hinted at the concrete painterly means he would use to embody these theories. Motherwell was replaced for the two-year life of the periodical by David Hare. He did, however, contribute his article on Mondrian to the

magazine. Perhaps not surprisingly, the only American artists whose works were illustrated in the periodical were Hare and Cornell.

Despite these theoretical disputes, Motherwell contributed to the *V.V.V.* portfolio. Because he knew nothing about printmaking at that time, he executed fifty slightly different watercolors for it. Of these works, five have been located and three more are known through photographs. These watercolors were begun in 1942 as is indicated by a dated notebook, containing two of them, which was only recently found in Motherwell's studio. All of the watercolors are in an oval format. They have more playful organic lines than the paintings of the period, and several contain drawings of pennants or flags (fig. 22). Both the oval formats and the meandering lines suggest Motherwell's desire to modify the severe grid structure which had dominated most of his paintings. The oval criss-crossed by freer lines may have been suggested by Mondrian's looser "plus minus" and "pier and ocean" compositions, two of which belonged to Peggy Guggenheim.

However, Motherwell's curvilinear, playful lines ending in dots and drawn on a bright ground also suggest his first response to Joan Miró's art. These lines may be compared to similar devices in Miró works such as *Composition* (1927), then in the Pierre Matisse Gallery, and shown regularly in the early forties.[48] In fact, the hornlike configuration at the bottom of several watercolors may have been taken from similar shapes in this painting by Miró or others like it. The striped pennants in several of Motherwell's watercolors may also have been suggested by the whimsical little French and Catalan flags in the upper left corner of Miró's *Catalan Landscape* at The Museum of Modern Art. The flag is a flat emblematic shape, which nevertheless has emotional associations. Thus it suited Motherwell's aesthetic inclinations. Motherwell apparently was using the free play of the hand and conscious wit in these small, less significant works to break through the constricting formalized geometries that limited his gestural inventiveness in some of the paintings of 1941–42.

Despite the tentative nature of these little watercolors, they signal an experimental variety in medium, format, line, color and most importantly mood at the end of 1942. In 1943 Motherwell carried on this experimentation in a more fruitful manner in his first collages. The collages dominated his art for two years, and he found original solutions to many of the difficulties that plagued his early oil paintings, while simultaneously advancing some of the strongest formal and emotional elements of those works.

4

The Collages: 1943–44

Motherwell was motivated to experiment with collage by Peggy Guggenheim's invitation to send works to an international collage exhibition she was planning.[1] She broached the idea in February of 1943 and the exhibition was held from April to mid-May of that year. It included collages by Calder, Duchamp, Braque, Ernst, Gris, and only two Americans besides Motherwell, Pollock and Baziotes.

Motherwell came to collage through an external suggestion rather than through a prolonged search, and perhaps for that reason he feels that he reacted more directly to the expressive possibilities of the medium and was less influenced by its past masters. He has recalled:

> The one thing you have to remember is that in the forties up to the mid-fifties collage was being used very little anywhere in the world. Or when it was being used it was much more likely in a photomontage way, as in Ernst or Heartfield. But no one was doing plastic collages or ones in the original cubist spirit. I don't mean cubist structure, but primarily plastic with poetic overtones.[2]

However, during the 1940s, there was a small, but classic, group of collages available for study in New York. Some of these works also profoundly affected Motherwell's development in the medium. By 1943 The Museum of Modern Art owned one Picasso collage *Man with a Hat* (fig. 23), three Schwitters collages, Arp's *Collage Arranged According to the Laws of Chance,* and three Ernst photomontages. At that time, the museum had no Braque, Gris, or Miró collages. Peggy Guggenheim's collection contained Picasso's 1914 *Lacerbe,* two collages by Schwitters, and several photomontages by Ernst. The Gallatin collection had only one collage by Picasso *Guitar with Wine Glass,* and one by Gris, but it also contained six important torn paper collages by Arp.

Motherwell and Pollock decided to make their first experiments in collage at Pollock's studio since it was larger and better equipped. Even today Motherwell vividly remembers with some evident shock how Pollock worked

on his collages with increasing violence. "He began pasting, tearing, and pouring paint. He burned the edges of the paper and even spit on them."[3] On the basis of Motherwell's description, at least one of Pollock's collages for the exhibition may be identified as *Untitled* (ca. 1942). One of Pollock's few collages, it contains rivulets of poured paint as well as burnt paper edges.

Motherwell made two small collages for the Guggenheim show on that day with Pollock. One of these has since been lost, and there is no visual record of it. The other was formerly in the collection of the architect and friend of Motherwell, Pierre Chareau (fig. 24). It consists of a piece of rectangular Japanese rice paper pasted on artists' board. The paper was rubbed and splashed quickly with grey pigment, and then two cutout paper forms, one with a yellow circle painted on it and the other colored vermilion, were pasted to the rice paper. Lines of white paint, applied directly from the tube, were added, and finally Pollock "contributed" a glass bead at the left to complete the work.[4]

Although so different in technique, the collage embraces a dialectic present in Motherwell's earlier paintings. He began it with an incisive, emotional gesture in the painterly grey area. This area of splashed paint used elements of chance liberally. It avoided both a horizon line and gravitational weighting, creating a sort of personal world. Motherwell then sought to resolve this intuitive paint application through larger, solid areas of paper glued onto the support and through organizational lines. The solidly colored paper with a yellow circle was placed dead center in the composition as a focal point, while the vermilion rectangular fragment was lined up above it. The two white lines in the upper half of the composition run roughly parallel to the picture edges, and the curved line, squeezed from the paint tube, to the lower right carefully enclosed the contour of the splashed pigment within its arc.

Much like his earlier oil paintings, Motherwell relied in this work on a process of suggestion and revision. Bypassing the lengthy drying time required by oil paint, he discovered that collage allowed him to add cut and torn papers immediately, and then to move them around freely, experimenting with various configurations. The flexibility seemed to enhance the freshness of his conception. Using cut out papers also encouraged Motherwell to enlarge and simplify his shapes.

Further, by adding papers to the plane of the composition, Motherwell reasserted the importance of the material surface, and diminished the role of illusionistic devices. The bead contributed by Pollock, however, seemed to intrude upon the flatness of the work. It added a note of Surrealist ambiguity to the collage creating an unforeseen tension between the paint surface and a translucent, manufactured object. For Motherwell, who was primarily interested in expressing his feelings through physically apprehended form, color and texture on the surface of the painting or collage, this bright glittering

object added an unwelcome note of optical confusion. For this reason, Motherwell has not used any three-dimensional objects in his collages after this first work.

Perhaps more than any work we have yet seen, this little collage poetically reveals the creative process and the development of a personal artistic universe. Motherwell began with the empty paper representing the void. This was followed by creating a chaos of stains and spots. As he looked at these marks, they suggested other forms to him. He saw the need to loosely organize the confusion of his preconscious with a bright, clear artistic sensibility. That sensibility is embodied by the yellow circle and vermilion rectangle, which are suspended in front of the splashed areas of paint, thus lending order to an improvisational beginning. In Motherwell's words the collage is "plastic" but retains "poetic overtones."

Motherwell's first collage has two artistic reference points. The first of these is Picasso's 1913 *Man with a Hat* in The Museum of Modern Art (fig. 23). The similarity between the two works lies in the simple, central placement of the collaged papers, and the use of curving and straight lines to connect the *papiers collés* with the picture edges. The major differences between the two works are Motherwell's more insistent abstraction, and his freer use of paint squeezed from the tube in a palpable line. When Motherwell adopted structural hints from Picasso, he went instinctively to Picasso's simplified collages of the 1913-14 period. As in his earlier reference to Picasso's *Seated Woman*, for *La Belle Mexicaine*, Motherwell avoided works by Picasso that encouraged complex, multiple viewpoints of objects. Thus he never showed interest in the collage *Lacerbe* owned by Peggy Guggenheim. He felt Picasso's ambiguities undermined the clear and direct statement he sought in his own art.[5] In his collages throughout the forties, Motherwell also deliberately avoided the Cubist use of newspaper fragments which make intellectual puns and pose questions about the double meanings of objects as verbal and visual signs.

The other reference for Motherwell's first collage is Miró's 1925 *Composition* then owned by Pierre Matisse Gallery. This work by Miró was just mentioned as a source for Motherwell's watercolors for the *V.V.V.* portfolio. Although Miró's *Composition* is not a collage, the thin background washes of a single color, the central white trapezoid with a circle painted in it, and the straight but loosely organized lines resemble Motherwell's collage. Motherwell used Miró's painterliness and compositional freedom as a counterweight to the geometric rigidity of Cubist structure, as he did more hesitantly in the *V.V.V.* watercolors.

Motherwell remembers that the first Miró works that he knew were the more representational and complexly organized works, among them the *Dog Barking at the Moon* at The Museum of Modern Art and early detailed *The*

Farm, which was frequently reproduced because Ernest Hemingway owned it. Around 1942 he saw his first of Miró's sparse 1924-29 compositions, including the one that Peggy Guggenheim purchased that year, and was immediately struck by them. He said of this discovery:

> Miró had both a *thingness* and an *airiness* which has always been essential to my work. I have always felt, as different as our work is, that Miró and I were exposed to approximately the same thing. Liking cubism as painting but being very influenced by the surrealist milieu, we arrived at approximately the same conclusions—to keep the work plastic but to keep, in quotes, the poetry too.[6]

Interestingly Motherwell's little collage is closest in feeling to Miró's *Birth of the World* (1925), though Motherwell could not have known that work which was sequestered in a private Belgian collection till the 1960s. Miró created *Birth of the World* nearly two decades before Motherwell's collages. He was also under the influence of Surrealist automatism when he made that remarkably free and poetic painting. It was a metaphor for a world of artistic sensibility emerging from chaos. We will see that the affinities between the young American artist and the older Spanish master grew during the decade.

When Motherwell finished his first two collages, he felt immediately that "I had discovered something that was really me."[7] With this enthusiasm, he took them to Matta who suggested that since he felt so strongly about the medium that he make larger collages.[8] As a result of this suggestion, Motherwell executed three large collages during two months of the late spring and summer of 1943.[9] They are *The Joy of Living, Surprise and Inspiration,* and *Pancho Villa, Dead and Alive* (figs. 25, 26, and 27).

These three collages established Motherwell's interest in the medium, and are among his most expressive works of the decade. In contrast to the lighthearted mood of creative discovery in his first collage, these three works show a preoccupation with violence and communicate his strong sense of personal fear during the years of World War II. *The Joy of Living* is probably the earliest of the three because it exhibits the influence of Matta. Motherwell had consulted Matta for advice about his collages. The paper was originally rubbed with brown and black washes of thin oil paint, a technique which resembles Matta's creation of thin, amorphous paint layers.

This method is like that of the *Untitled* collage, but here the paint is spread in more complex and even deliberately confusing layers. The diagonal lines in the upper right quadrant, as well as the painted trapezoidal plane in the upper center, indicate spatial recession. These Matta-like features are rarely found in Motherwell's art of a later date. The drawn lines also create a kind of web, which threatens to trap both creator and viewer.[10] In any case, these perspective lines, when contrasted with the pieces of paper glued on

the surface of the work, are also deliberately confounding. Are we to look at the tangible surface, or imagine some deep cavernous space?

The pieces of paper that Motherwell pasted onto *The Joy of Living* employ a wide variety of collage techniques, all of which will appear individually in his later works. This variety has two results. First, it shows the early date at which Motherwell experimented in an adventurous manner with different collage methods. Yet, these different modes, all compressed into a single composition, create a discordant and emotionally tense situation. Three rectangular pieces of rice paper, which have been previously splattered or rapidly brushed with paint, were pasted in the left-center and lower left quadrants of *The Joy of Living*.

On the one hand these pieces of paper formally provide areas of spontaneous execution, automatism, that can be moved around the composition in a controlled and willful manner before deciding on their final position and gluing them down. We will see that this technique was also used in more emotionally neutral works like *In Blue with China Ink* (1946). In *The Joy of Living* there were further emotional associations. Motherwell expressed these when discussing his next collage *Surprise and Inspiration,* stating that the paint soaking into rice paper could remind him of "blood stained bandages."[11] This metaphor is most appropriate to the crimson and vermilion colored paint in the two lower pieces of rice paper in *The Joy of Living,* and it certainly suits the overall grim character of the collage.

In fact the large vertical piece of paper to left of center is dominated by a bloodred ink stain and is pierced by a "sharp" triangular piece of paper at the center of that "wound." The suggestion of a symbolic wound occurs in other works by Motherwell, notably his *Emperor of China* (1947). When he discussed that painting, Motherwell observed that the form gave him a "slight feeling of horror."

The Joy of Living also contains three pieces of torn paper, another new collage technique for Motherwell. One has black spots; a small ochre fragment overlaps it; and the third is rice paper with a painted grey oval on it to the right side of the composition. This tearing generally expresses spontaneity and reliance on chance which differs radically from the Cubist collage papers which are usually carefully cut. Like the stained rice paper, the torn collage fragments reappeared frequently in Motherwell's work throughout the decade. The tearing of the paper can also be emotionally neutral as for instance in the collage *In Grey and Tan* of 1948, but at other times it can represent violence. Later in his career Motherwell said, "Tearing the paper is like killing someone."[12] Again this gesture which can be violent suits the overall meaning of *The Joy of Living.*

Given the somber handling of Motherwell's collage, its title might be seen as an ironic commentary on Matisse's famous *Bonheur de vivre* of 1906. In

every way Motherwell's collage is the opposite from Matisse's bright colors, sensuous forms, and arcadian subject. Because *The Joy of Living* explores internal states and because of its title, it is noteworthy that Sigmund Freud, in whose writings Motherwell had been interested since college, studied the psychological motivations for irony. He concluded that those forms of speech often provided protection for the individual against disturbing experiences, an insight which illuminates Motherwell's collage.[13]

The painterly violence and confusion which dominates *The Joy of Living* and several other works of 1943 and 1944 are related to Motherwell's personal feelings of anxiety during World War II. This connection to the war is supported by the last unmentioned collage fragment, a piece of combat map in the upper right corner. In *The Joy of Living* Motherwell first recognized the disjunctive possibilities of the collage medium. The many fragments which could be spontaneously torn and rapidly moved around the dark surface provided a metaphor for the world torn asunder.

The young American artists must have found New York during the war years a place of conflicting emotions. The arrival of the European emigrés instantly made it the capital of the art world. On the other hand, artists, like everyone else, felt the tragedy of the war raging around them. The spring and summer of 1943 were marked by the allied invasion of Sicily, during which a total of one hundred and sixty-five thousand casualties occurred on both sides. Motherwell has revealed privately his feeling of "utter horror" as he followed the human losses and tragic events of those years.[14] In his public writings and statements Motherwell has taken a less personal and more circumspect view. In a recent public interview, he characterized New York during the war as, "immigrants and emigrés, establishment and dispossessed, vital and chaotic, innocent and street-wise, in short, a metropolis clouded by war."[15]

For Motherwell and the other Abstract Expressionist artists, World War II destroyed the mood of optimism and rationality which led to such art movements as Neoplasticism, Constructivism, the Bauhaus, and the American Abstract Artists group during the 1920s and 1930s. To the Abstract Expressionists, the war epitomized irrationality and the dark side of man's nature. This awareness encouraged an art that was individualistic, emotional, and often pessimistic. Motherwell was thinking of this state of mind when he wrote that the New York School artists were "rebellious, individualistic, unconventional, irritable. . . . [T]his attitude arose from a feeling of being ill at ease with the universe."[16]

Motherwell's second large collage *Surprise and Inspiration* (43 × 28 inches) contains a much more substantial and heavily painted surface than *The Joy of Living*, and may thus be linked to his later painting mode. Here he has abandoned the perspective lines with their illusion of depth which are

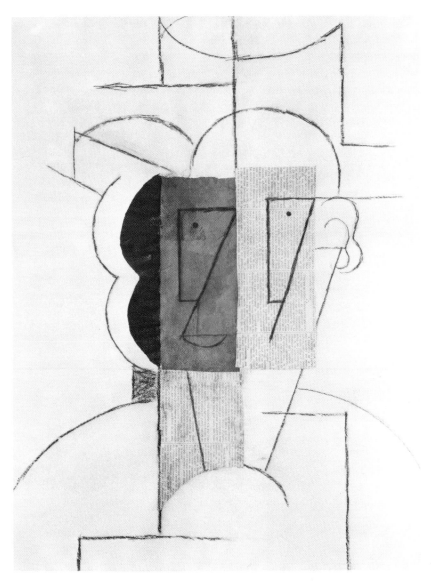

Figure 23. Pablo Picasso, *Man with a Hat,* December 1912
Charcoal, ink and collage on paper, 24 1/2 × 18 5/8″
(Collection, The Museum of Modern Art, New York City)

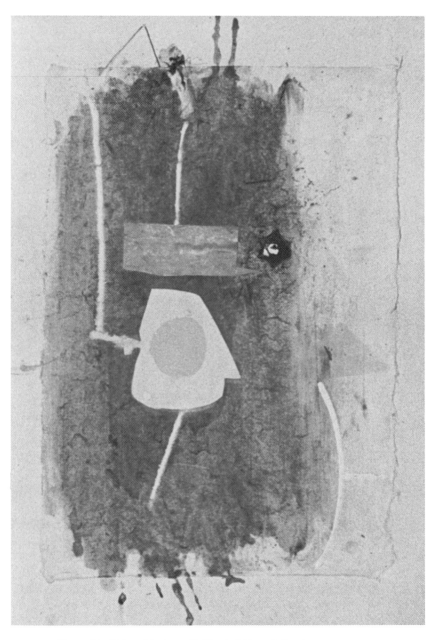

Figure 24. Robert Motherwell, *Untitled* (First Collage), 1943
Oil, ink, rice paper, and a glass button on paper, 20 × 14″
(Collection unknown)

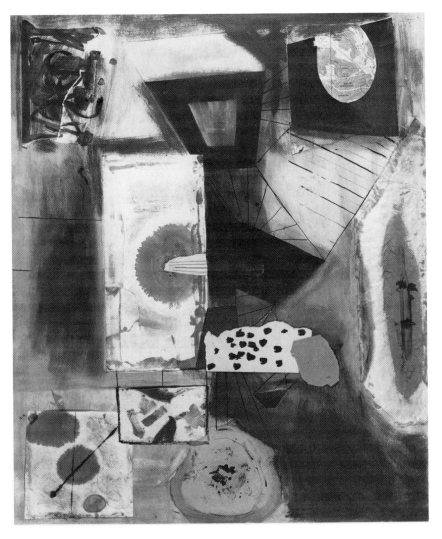

Figure 25. Robert Motherwell, *Joy of Living,* 1943
 Ink, oil, crayon, construction paper and map fragment on cardboard,
 43 1/2 × 33 5/8″
 (Collection The Baltimore Museum of Art. Bequest of Saidie A. May)

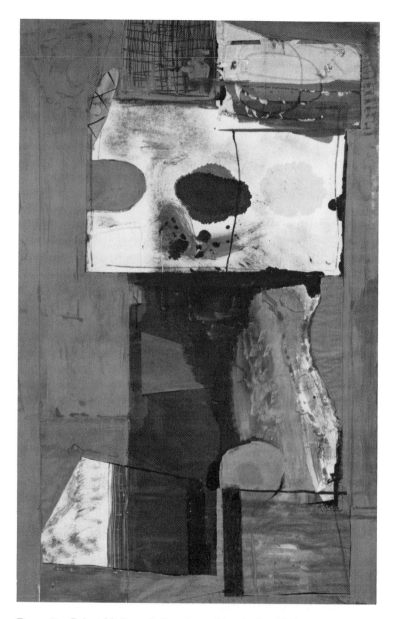

Figure 26. Robert Motherwell, *Surprise and Inspiration*, 1943
Ink, gouache, oil, construction paper and rice paper on cardboard,
40 1/8 × 25 1/4″
*(The Peggy Guggenheim Collection, Venice; The Solomon R.
Guggenheim Foundation, New York City. Photo: Robert E. Mates)*

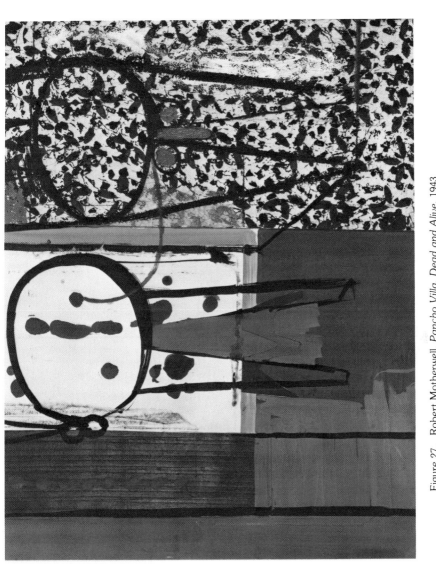

Figure 27. Robert Motherwell, *Pancho Villa, Dead and Alive*, 1943
Oil, gouache, wrapping paper and rice paper on cardboard, 28 × 35 7/8"
(Collection, *The Museum of Modern Art, New York City*)

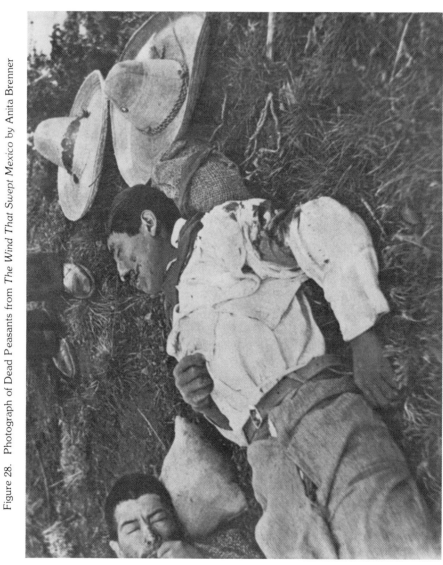

Figure 28. Photograph of Dead Peasants from *The Wind That Swept Mexico* by Anita Brenner

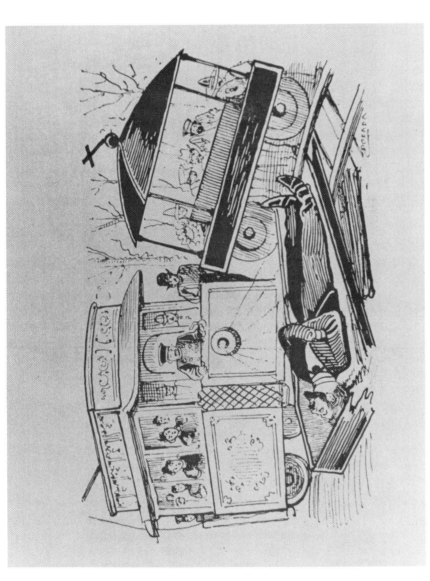

Figure 29. José Posada, *Collision between a Trolley and a Hearse*, 1895–1910
Wood engraving, ink on paper, 7 1/2 × 10 1/2"
(Courtesy Dover Publications)

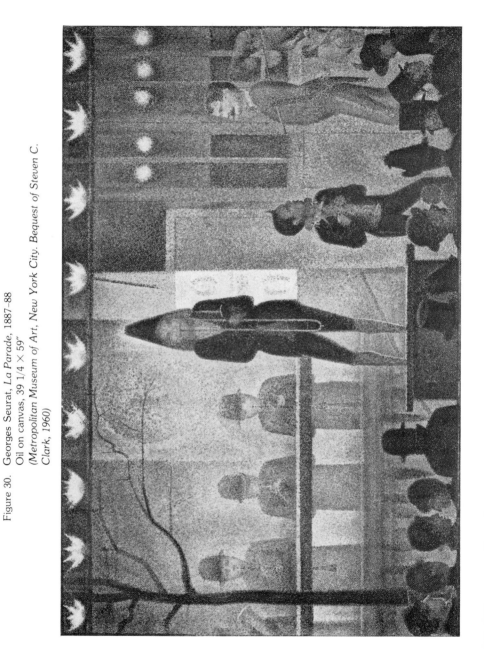

Figure 30. Georges Seurat, *La Parade*, 1887–88
Oil on canvas, 39 1/4 × 59″
*(Metropolitan Museum of Art, New York City. Bequest of Steven C.
Clark, 1960)*

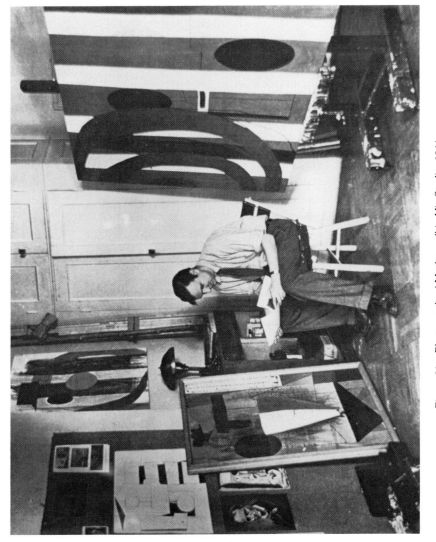

Figure 31. Photograph of Motherwell in His Studio, 1944

seen in *The Joy of Living*. This work is also notable for the variety of painterly methods used on the pasted papers. The fragments attached to the upper areas, over the center, are haphazardly covered with scribbled, crosshatched lines. The large section of rice paper below it has thin stains of red and black ink, while the vertical paper directly below this is painted solid black out to its edges. In contrast, several rectangular pieces which make up the left side of the work are painted over with a heavy layer of ocher paint so that their edges add further texture to the already rugged surface. A torn fragment of paper in the lower right corner is crudely brushed in grey and white, and the colors seem to run together by accident.

In addition to experimenting with a wide variety of rather crude and brutal painting techniques on the attached surfaces, Motherwell suggests a vague analogy to a human presence through the vertical directions of the central shapes. He has said of the work, "I remember I called it 'Wounded Personage.' Meyer Schapiro saw it; we discussed titles; and I still recall the look of revelation on his face when I told him its title. Somehow splashed paint on rice paper reminded me of blood stained bandages."[17] It is through such analogies, an upright form for the human presence and splattered paint for blood, that Motherwell's work attained its associative values without being limited to the depiction of any single scene or narrative scenario. It has not been previously noted that the collage was later retitled by Peggy Guggenheim from Wolfgang Paalen's article "Surprise and Inspiration" before which it appeared on the facing page in Paalen's collected writings, *Form and Sense*.[18] Thus *Surprise and Inspiration* complements the aura of fear and concern with death found in *The Joy of Living*.

Pancho Villa, Dead and Alive is the most powerful of Motherwell's first three collages (fig. 27). In it Motherwell developed a series of emotional and formal possibilities which profoundly influenced his later career. The collage gathers together a wide variety of sources into a confrontation between two opposing forces. These forces can be viewed on a number of different levels, painterly and geometric modes of execution, organic and inorganic shapes, or more broadly in terms of the life force and the death wish, eros and thanatos. *Pancho Villa, Dead and Alive* thus pioneered deeply felt themes that Motherwell has explored throughout his career.

The collage presents two schematic "stick figures" with large oval heads and triangular bodies. Each is flanked by vertical lines. The figure on the left is set before an area of white paper, and has other rectangular divisions around it painted in tan and two tones of grey. The figure on the right is drawn upon a piece of mottled German wrapping paper which was pasted onto the surface of the collage.

Pancho Villa, Dead and Alive marks Motherwell's initial use of the "stick figure" which was suggested in *Surprise and Inspiration*. The stick figure

would appear frequently in his art throughout the decade. For Motherwell these stick figures satisfied two goals. They provided a coherent structural background for the work, counteracting the lack of focus he felt in other works like *Recuerdo de Coyoacan.* The stick figures also suggested a human presence without detail or explicit illustration. One can see through the schematic figure to the painted surface around it, and thus it acted as a structural grid as well as a personage. Because it was a neutral cipher, it could be varied to embody many different types of expression. The stick figure added a tangible note of humanism to Motherwell's work, an issue which had concerned him since his first paintings.[19]

Indicating that he identified personally with these schematic figures, Motherwell has said, "The figure interests me when it fills the picture as in a full length portrait. It never occurs to me to have the figure do anything, its presence is sufficient; and I suppose it rarely occurs to me to do anything except feel my own presence."[20] These stick figures enlarged the content of Motherwell's work with a presence, but communicated that presence primarily through a simple ideogram, paint strokes, texture variations, color, and abstract design.

The images and emotions that generated *Pancho Villa, Dead and Alive* began during Motherwell's Mexican trip. He explained the collage's origins:

> In the summer of 1941 I was in Mexico and beginning to paint full time, having decided not to get a Ph.D. I was seeing Mediterranean culture and peasant art for the first time, in the company of Matta, a Chilean, and a Mexican actress (whom I married in 1941) whose uncle had been a general in Pancho Villa's days. I was fascinated not only with Mexican popular folk art but also with Posada and Anita Brenner's fabulous book of photographs of the Mexican Revolution, called *The Wind Swept over Mexico* [sic]. One pictured showed Pancho Villa after he was shot, spread out—sprawled out, really—in a Model T, covered with blood.[21]

The Mexican Revolution symbolized for Motherwell the struggle of human values against a faceless technology and oppressive ruling class. He also found that the constant reminders of death in Mexico moved him profoundly.[22] With these ideas in mind, it is not surprising that he chose Pancho Villa as a theme for his collage. Villa was the figure in the Mexican Revolution who had risen from the humblest origins. The peasant-rebel gained notoriety by managing to evade a modern American fighting force, complete with aircraft, led by General Pershing. He became a folk hero after the revolution when he was assassinated in 1924. Anita Brenner's book *The Wind that Swept Mexico,* cited by Motherwell, contains some of the most famous pictures of the revolution. It includes several of Villa, although none actually show him shot as Motherwell indicated. In the photographs, Villa appears lively and as a commanding presence yet also vulnerable. He is often

pictured in uncomfortable meetings with competing bandit-patriots and is frequently surrounded by armed bodyguards.

While Brenner's book does not picture Villa assassinated, it has no shortage of blood splattered corpses (fig. 28). As already mentioned in the context of *The Joy of Living* and *Surprise and Inspiration* Motherwell already equated red paint with blood in certain works. Motherwell has specifically identified the automatist paint splashes, the freest gestures in the composition, as Villa "covered with blood spots" in his collage. *Viva Villa*, the romantic book about the bandit-revolutionary's life and which Motherwell owns, describes the assassination. It emphasizes the bullet wounds in the massive head, an image similar to Motherwell's collage. Its author Pinchon wrote:

> "Fire!" Barazas' command is a mere hysterical scream. . . . Pancho Villa, even as the spirit is being driven out of him, swerves the car into the attack as though in death he would still meet the enemy face to face. . . . [Barazas] plants four pistol shots in the bowed massive head. . . . But the highly colored picture postcards of his butchered body are pushed out by the millions. Even so, the pelados remain humbly unconvinced. "No, he is not dead, señor, they only try to trick us." Still they see him riding on the skyline with flaming guns.[23]

The postcards that Pinchon referred to were probably the ones that Motherwell remembered of the assassination.

In his statement about *Pancho Villa, Dead and Alive* Motherwell mentioned the popular Mexican printmaker José Posada as one of his sources. Given his interest in folk art and the direct emotions expressed therein, it is significant that Motherwell would show an interest in the highly expressive works of Mexico's most popular folk artist during the revolutionary period. Posada's prints of skeletons and *danse macabre* subject matter exhibit a raw power despite their morbid concerns (fig. 29). They depict scenes of violent human emotions often involving suffering, assassination, and death. The prints were executed in type-metal cut, and the style consisted of crudely printed black lines that define only the most essential features of the subject. They were often printed on brightly colored Mexican papers for further visual and emotional impact. This rough and simplified style parallels the deliberately bold lines used to define the stick figures in *Pancho Villa, Dead and Alive*. They too are meant to communicate with immediacy and a singular indifference to cultivated artistic style.

While the emotionally charged theme and some of the intentional crudity of *Pancho Villa, Dead and Alive* derived from Motherwell's Mexican experiences, its formal vocabulary was largely based upon the modern masterpieces that Motherwell had so carefully studied in New York collections. His ability to synthesize these two diverse sources is one of the distinctive features of this work. His collage is indebted to both Picasso's

1927-28 *The Studio* at The Museum of Modern Art and his variant *The Studio* of 1928 owned by Peggy Guggenheim (figs. 15 and 18). Both works feature strong two-dimensional design, yet contain personages that are mysterious. From The Museum of Modern Art painting, Motherwell derived the horizontal format, as well as the color scheme of grey, yellow, and red. The stick figure of the painter before his canvas to the left in Picasso's work is the closest source for the oval head and triangular body of Pancho Villa. Picasso's figure is clearly designed, but has two possible readings. One wonders whether he is a painter before the canvas or a line drawing upon the yellow canvas. Motherwell was aiming at a more serious duality, life and death, in his collage.

While *Pancho Villa, Dead and Alive* is horizontal in format, its two figures are pressed together and restrained on either side by vertical lines. This constraining force is similar to the vertical pressures in the version of *The Studio* owned by Peggy Guggenheim. There, the two stick figures are closer together, and the one to the right is tightly held within a picture frame. Again Picasso's figures have a dual meaning. Is he representing an artist and a model, or a sculpture and a linear painting? While the restraining lines in the Picasso are simply a picture frame, Motherwell has identified the vertical lines holding Pancho Villa with a more emotional intent. He has called them a "coffin shape." Figures in coffins are reminiscent of those in Posada prints. Thus, for Motherwell the geometric constraint on the organic figures in this collage is a symbol for death. Interestingly both Pancho Villa dead and Villa alive are placed within schematic coffins. In fact the lines around Pancho Villa alive on the right are closer to the trapezoidal shape of a coffin.

Both Picasso paintings are uniformly dry and austere in comparison to Motherwell's collage. *Pancho Villa, Dead and Alive* presents a contrasting situation. The left side is relatively severe in its geometric design and its cool white and grey coloring. On the right side, the wrapping paper was used to simulate exuberant black and red brushstrokes, or organic growth. The opposition of a figure within a "freely brushed" setting and one within a gray geometric setting is symbolic for Motherwell of the opposition between life and death.

Despite the intended symbolism, the contrasting styles also link *Pancho Villa, Dead and Alive* to Matisse's more hedonistic expression in *Bathers by the River* (1911-17) which Motherwell admired as it hung in the lobby of the Pierre Matisse Gallery during the forties (fig. 16). *Bathers by the River* was executed in two stages six years apart.[24] The left side exhibits schematic figures on a grey ground trapped by a severe geometric design. This first stage of the painting was related to Matisse's initial contact with Cubism. The right side shows Matisse's own taste for the opulent and organic forms of nature at a later date. The contrast of the two creative modes is similar to

elements in Motherwell's collage, although the violent, emotional content of *Pancho Villa, Dead and Alive* has no connection to Matisse's art in any phase.

The right side of *Pancho Villa, Dead and Alive* also recalls Georges Seurat's *La Parade* (fig. 30).[25] Although Motherwell is only willing to say that he admired "the spirit of *La Parade*," I believe there is a strong affinity in the figure of Pancho Villa alive to the simplified silhouettes of figures against a dark pointillist ground. In 1943 Motherwell kept a reproduction of Seurat's painting on the wall of his studio (fig. 31). Seurat was able to create a mysterious and lively interplay of figures and ground with his small color dots, rather than through conventional figural modeling. Motherwell also wished to activate the picture surface around Pancho Villa alive in order to create a feeling of vitality without narration. He found an unexpected method to communicate this emotion in the form of the "painterly," spotted wrapping paper.

Motherwell has commented on the sexual implications and confrontation between death and life in this work: "One of my most celebrated pictures, because it is in The Museum of Modern Art in New York, is called *Pancho Villa, Dead and Alive*. It's rarely observed that one half of it is a figure inside a coffin shape, covered with blood spots; and the other half is a figure with a pink penis—the penis being alive. Two portraits of Pancho Villa, one dead in the coffin, the other standing there alive."[26]

But in the collage the opposition is neither as clear nor as simple as Motherwell made it in his statement. The figure of Pancho Villa alive is also constrained by a schematic coffin, and both figures stand as if alive. While the splashed red paint over Pancho Villa dead symbolized blood for Motherwell, it is also the most lively area of painterly activity in the collage. In fact the color and the shapes of the "blood spots" are very close to those of the "alive" penis. Visually Motherwell supplemented this connection through a single sweeping paint stroke going from the right-most blood spot to the genitalia. One even wonders about the order of the stick figures. Because of our natural tendency to read from left to right, Pancho Villa is first dead then alive again. The order of the words in the title confirms this peculiarity. In this order, death looses its finality; rather it is a condition to be dwelt upon in life. The real power of *Pancho Villa, Dead and Alive* lies in the close interconnection between death and life.

Motherwell has indicated that the sense of death was a constant preoccupation during his life: "All my life, I have been obsessed with death...."[27] The contemplation of mortality aroused his most profound feelings. Although the contemplation of death may be related to Motherwell's introspective, often depressed personality, it is important to note that in his art these anxieties had a creative resolution. For Baudelaire the awareness of

death also gave life its meaning and mystery. Freud found the primary driving forces of existence in the dualism of thanatos (the bleeding spots and the coffin) and eros (the "living" penis).[28] Motherwell's father died in 1943, and this event certainly reinforced his own thoughts about mortality. His concerns about death were later embodied in his "Elegies to the Spanish Republic" series, begun in 1949. These paintings incorporated in their basic expression organic ovals trapped between stiff vertical slabs. Thus, the repertory of forms and the theme of *Pancho Villa, Dead and Alive* found their complete expression in that series.

Four more works by Motherwell are known from 1943. Three of these were executed in oil paint, and they show the artist's attempt to integrate the emotional and formal discoveries made through collage into the paint medium. *Personage* revived some of the conventions of Motherwell's earlier oil paintings (fig. 32). He first spontaneously laid on multiple thin layers of red and grey paint with biomorphic red forms that still appear in the center of the composition. This amorphous paint area and the organic shapes were then partially obscured by heavy layers of ochre, grey and black paint, seen in both the lower half of the painting and its upper right side. Yet due to the increased freedom in mixing shaped areas of color and drawing with paint in his collages, Motherwell has less severely structured these areas than he did in his 1941-42 oils. The left side of the picture is particularly notable for its lively interweaving of line and painterly *passage*.

Like *Surprise and Inspiration* and *Pancho Villa, Dead and Alive, Personage* presents a schematic figure, identified by the central vertical drawing and the upright biomorphic shapes. Also like those collages, the content of *Personage* is somber and even violent. Motherwell has identified the trapezoidal drawing in the center of the composition as a schematic coffin.[29] The red shapes in the upper half of the coffin must then be seen as wounds or as the exposed internal organs of its occupant.

In *Personage*, Motherwell has combined this violent theme with a formal vocabulary derived from an emotionally neutral modern painting. *Personage* is related to Matisse's *Goldfish* (fig. 33), which was then in the Pierre Matisse Gallery. Like *Bathers by the River, Goldfish* was Matisse's structured but vivid response to Cubism, a work far more painterly and dramatically varied in comparison with its Cubist predecessors. Matisse's composition, like Motherwell's, is vertical. The orange, organically shaped goldfish are held within a rectilinear area, as are Motherwell's biomorphic shapes. Matisse has diminished depth by emphasizing the painterly areas of blue, white and black. In the upper right, he has fractured the composition with a web of lines which deliberately shows unresolved layers of paint beneath them. Motherwell used a similar device in the upper left quadrant of *Personage*. This novel synthesis of a morbid theme with the formal language of modernist painting in

Personage is similar to the stratagem used in *Pancho Villa, Dead and Alive,* and exemplifies Motherwell's ability to use the history of modernism in a highly personal manner.

The *Spanish Prison* was executed during 1943 and 1944 (fig. 34).[30] It continued the theme of entrapment, though with less violence, that we have seen in Motherwell's collages. The composition was begun with rapid curvilinear drawing which formed a stick figure whose upright torso and oval head can just be made out in the center of the painting. Most of this improvisational drawing was covered with a variety of geometric shapes in Mexican colors, red, magenta, ochre, and black. The relative freedom with which these shapes were constructed was also influenced by Motherwell's experience in collage.

The organic shapes in the center of the *Spanish Prison* were further covered with loosely drawn vertical bars which echo the "bars" of *The Little Spanish Prison*. These bars at once protect and confine the fragile figure seen beneath them. As noted earlier, Motherwell connected the walls he saw in Mexico with the flat painterly surface of his work. The striped section of the *Spanish Prison* indirectly recalled windows with metal grilling that Motherwell saw amid the stucco walls of Mexico City (fig. 35). Motherwell has recalled thinking that those grilled windows both safeguarded and confined their occupants. This recollection is close to the duality expressed in Motherwell's painting.

It has been suggested throughout this book that many of Motherwell's works are painterly symbols for the artist's state of mind. For instance, we have seen that *Pancho Villa, Dead and Alive* is not so much about an actual death as Motherwell's psychological awareness of mortality. In his 1944 statement about *Spanish Prison,* already quoted in chapter 1, Motherwell made this viewpoint explicitly clear. He identified his preconscious impulses and the sense of anxiety of modern life conveyed to him with the "automatist" and "obscured" shapes of the prisoner. He then associated his conscious intelligence with the "designed shapes" and "weighted color" in the painting.[31] Throughout his career, Motherwell has struggled with this dilemma. On one hand, he wants to reveal the deepest psychological states imprisoned within him. At the same time, he feels the necessity to protect or compartmentalize that vulnerable part of his personality.

The collages and paintings of 1943 provided a springboard for Motherwell's intensified, though less emotional, activity of 1944. During that year he more fully developed his collage method, in works such as *Mallarmé's Swan* (fig. 42). It was also the year when he significantly painted the first of his large, mural-scale paintings *Wall Painting with Stripes* (fig. 44). The austere, simple design of that painting suggested to him a division in his art between a more

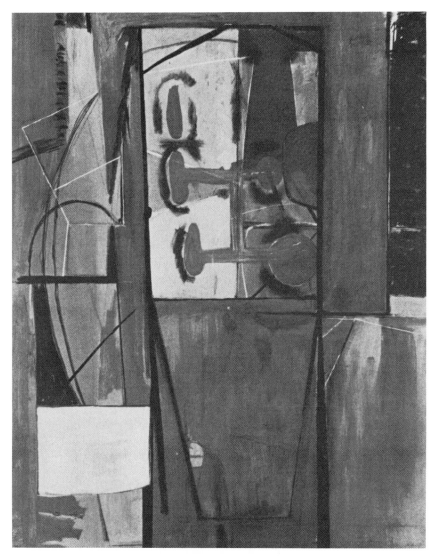

Figure 32. Robert Motherwell, *Personage*, 1943
Oil on canvas, 48 × 38″
(Collection Norton Gallery and School of Art, West Palm Beach, Florida)

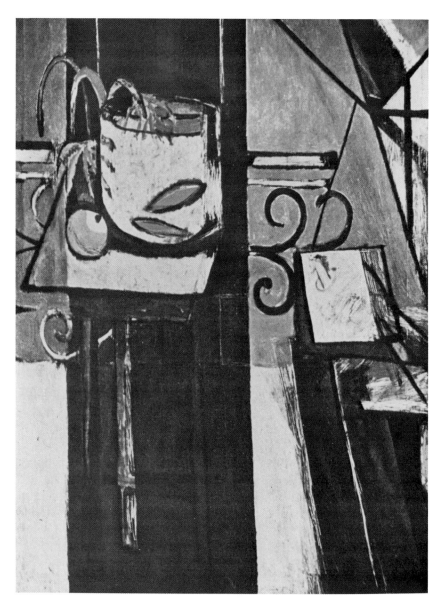

Figure 33. Henri Matisse, *Goldfish*, 1915
Oil on canvas, 57 1/2 × 44″
(Collection unknown)

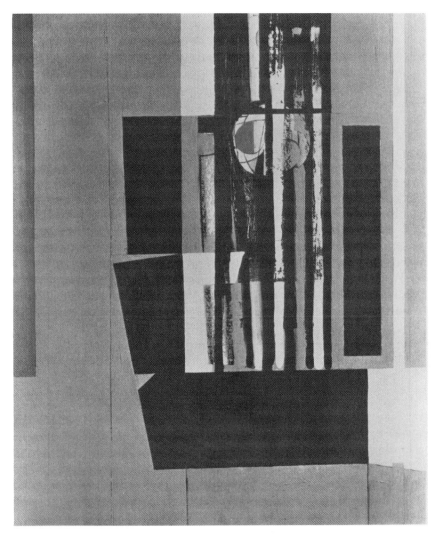

Figure 34. Robert Motherwell, *Spanish Prison*, 1943–44
Oil on canvas, 52 × 42 1/2"
(Collection Mr. H. Gates Lloyd)

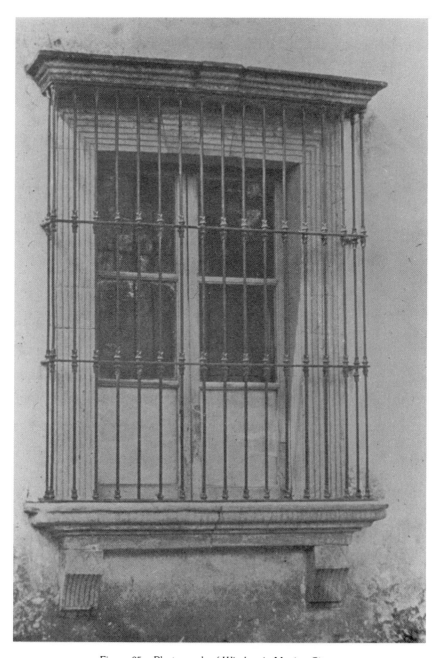

Figure 35. Photograph of Window in Mexico City

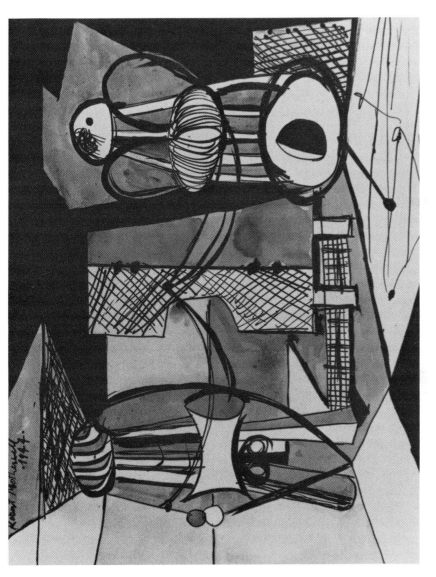

Figure 36. Robert Motherwell, *Three Important Personages*, 1944
Ink and watercolor on paper, 11 × 14"
(Collection Richard E. and Jane M. Lang)

Figure 37. Robert Motherwell, *Untitled*, 1944
Ink and watercolor on paper, 19 × 23 1/2"
(Collection Albright-Knox Art Gallery, Buffalo, New York. The Martha
Jackson Collection, 1974)

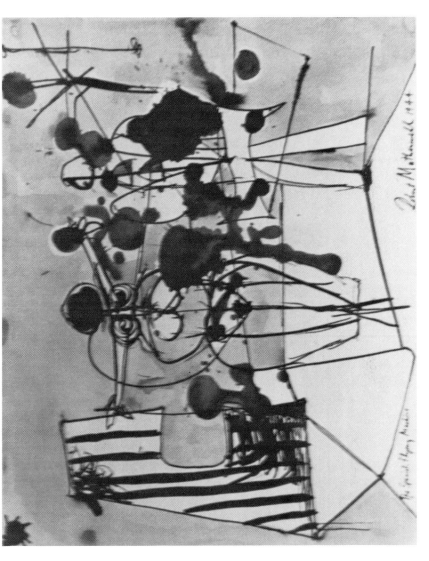

Figure 38. Robert Motherwell, *The Spanish Flying Machine*, 1944
Ink and watercolor on paper, 12 × 14"
(Collection unknown)

Figure 39. Pablo Picasso, *Personages and Cat upon a Chair*, 1937
Ink on paper, 10 1/4 × 16 1/2″
(Collection unknown)

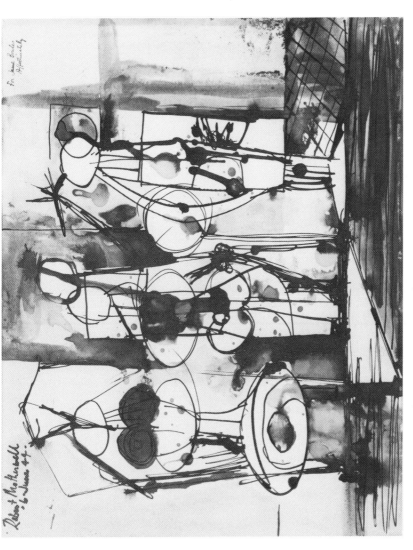

Figure 40. Robert Motherwell, *Three Figures Shot*, January 6, 1944
Ink and watercolor on paper, 11 3/8 × 14 1/2"
*(Collection Whitney Museum of American Art, New York City. Purchase, with funds
from the Burroughs Purchase Fund and the National Endowment for the Arts)*

severe, structural and public mode for painting, in contrast to the more informal collages. Motherwell also executed about thirty pen and ink drawings, loosely based on *Pancho Villa, Dead and Alive,* which exhibit some of the expressive and formal difficulties he had eliminated from his more sophisticated paintings and collages. In a very busy year, Motherwell began editing the extremely important Documents of Modern Art series, and worked at the printmaking studio of Stanley William Hayter.[32] The year culminated in his first one-man exhibition at Art of This Century Gallery.

Of the thirty pen and ink drawings Motherwell created in 1944, eighteen are known.[33] These drawings derive both from the stick figures established already in *Pancho Villa, Dead and Alive,* and from a series of Picasso ink drawings dated 1938. These drawings are not original discoveries on the level of *Pancho Villa, Dead and Alive* or *The Little Spanish Prison.* Yet they do reveal an important characteristic of Motherwell's art. Throughout Motherwell's career, his important images have come to him in what appear to have been flashes of inspiration. He then created variations upon that image. Such was the case with *The Mexican Sketchbook,* and later more extended and sophisticated series include the "Elegies" and "Opens." The drawings are thus a way of affirming the discoveries made in *Pancho Villa, Dead and Alive* and experimenting with various possibilities inherent in that work. In his early phase, however, the variations do not have the conviction of the original collage.

A comparison of *Three Important Personages* with *Pancho Villa, Dead and Alive* highlights the power of his collage and the relative weakness of his drawing (fig. 36). If we were examining traditional artistic methods, such a drawing might be considered a study for the final composition *Pancho Villa, Dead and Alive.* Motherwell, however, worked in a more spontaneous fashion in *Pancho Villa, Dead and Alive.* The drawings were, thus, elaborations of an original idea, and often failed during the forties because they were too studied and self-conscious.

Both works show two stick figures, though in the drawing they appear to be in a studio with a schematic canvas between them. The drawing is thus closer to the emotionally neutral theme of Picasso's two *Studio* paintings than it is to *Pancho Villa, Dead and Alive. Three Important Personages* lacks the poignant investigation of mortality in *Pancho Villa, Dead and Alive.* It is also somewhat formally weaker than the large collage. While the figures in *Pancho Villa, Dead and Alive* are constructed against a resolutely flat ground, *Three Important Personages* is full of spatial contradictions. The black triangle at the bottom can be read on the surface of the work or as a receding plane connected with the grey area above it. The stick figures are vague and ill-defined shapes, and they are not related to the total picture area as are those in *Pancho Villa, Dead and Alive.*

While the figures in *Three Important Personages* do not have a discernible emotional content, Motherwell insisted on their genders by the feminine curved outline of the right figure, and the large tube with circles below it indicating male genitals on the figure to the left. The contact between the two stick figures is a tentative extension of lines from each to the central cross-hatched "canvas," reminiscent of the connecting line in *Pancho Villa, Dead and Alive* but without its meaning. Here, these tentative lines mirror an overall feeling of indecision in the drawing.

When Motherwell's drawings become more descriptively detailed and narrative, their content generally seems to suffer, whereas his more purely painterly and abstract works suggest a wider and richer range of associations. An example of the former is a drawing by Motherwell in the Albright-Knox Gallery, showing male and female figures flanking a monster complete with eye and teeth (fig. 37). This drawing is related to Surrealist fantasies but without the advantage of incongruous juxtapositions that lend power to Surrealist works.

Motherwell's more spontaneous and painterly drawings of 1944 were usually more interesting works. Throughout his career Motherwell has shown himself more skillful in painterly effects than in drawing. *The Spanish Flying Machine*, with its violently splashed areas of red ink (fig. 38), combined simplified and more abstract figures than those found in *Three Important Personages*. The work also contains a notched panel with stripes on it, which Motherwell seemed to use as the cipher for a canvas.[34] While the stick figures and the "canvas" metaphor provided the structural backbone for the work, the freely applied paint embodied the artist's sense of emotional release. This combination of linear drawing and ink spots may also have been inspired by such Picasso drawings as *Personages and Cat upon a Chair* in which linear figurations were combined with splashed ink. This Picasso drawing and several others like it were reproduced in a 1943 issue of *Cahiers d'art* that Motherwell owned.[35] Motherwell has simplified Picasso's linear patterns and increased the areas of splashed ink, creating works that are both more structurally deliberate and more expressively intense than Picasso's.

The Spanish Flying Machine is, of course, directly dependent on Motherwell's own *Pancho Villa, Dead and Alive*. The red ink in the drawing must also signify violence done to the schematic figures. The "canvas" cipher may indicate that the violence, more a fantasy than a physical event perhaps, is taking place in the artist's studio. This reference further reveals the self-referential nature of *Pancho Villa, Dead and Alive*. Like that large collage, the little drawing is at the same time a personal meditation on an outside event. Its strange title, written on the paper by the artist, indicates a continuing fascination with the Spanish Civil War. Motherwell has suggested that the "Flying Machine," perhaps represented by the shapes to the upper right, may

refer to the famous and doomed Spanish Republican Air Force, which was organized by André Malraux.

Motherwell's life from 1940 till 1944 was full of tension, and that anxiety is often reflected in his works of those years. He had scarcely moved to New York, when he made the critical decision to pursue a career in painting. This decision was closely followed by his trip to Mexico, and his intense contact with Surrealism through Matta and Paalen. Upon returning to New York, Motherwell began rapidly to absorb the vast quantity of modern painting there, and soon experienced an increasingly antagonistic relationship with the older and more confident Surrealists. Added to this artistic tension, he married the temperamental and beautiful Mexican actress, Maria. His parents disapproved of the marriage, and his father continued to try to lure him away from the arts.[36] In 1943 Motherwell's father died, which must have caused him a combination of relief and anguish. Besides these personal events, the war which was devastating Europe and killing young American men loomed large in a personal way in Motherwell's mind. It is no wonder that his art during those years was often filled with personal disquiet and symbolic violence.

The year 1944 provided Motherwell with his first breathing space. He was settled happily in New York without the family pressure that had plagued his earlier years. He had shown his first two collages successfully at Art of This Century, and had made many new acquaintances, both inside and outside the Surrealist circle. During 1944, he met André Masson, Hayter, the critic Lionel Abel, the avant-garde architect Pierre Chareau, the novelist Jane Bowles, and Jean Wahl an editor for the *Nouvelle revue française,* among many others. Also in 1944, the allies began to report victories in Europe. Motherwell felt so confident that he went to Amagansett, Long Island, for the summer. There he had a chance to work and exchange ideas with other artists and writers outside the intense pressures of the New York City art world. From Amagansett, he wrote Baziotes, urging him to visit:

> Dear Bill,
>
> I was very pleased to hear from you. We have had a wonderful summer; I have done some of my best work and there have been interesting people all summer, . . . from whom I have taken something and given something and felt very alive. . . . But the best part of the meeting is Masson who is magnificent—simple, sincere, unpretentous, well educated and very strong, in art respects not unlike a French version of you. I like him and Chareau better—much better than any of the other European artists, though Hélion and Hayter have grown on me, too.[37]

Motherwell's growing security in his life was reflected in his art. His large collages and oil paintings from 1944 show the artist confidently stepping back from his art to gain an overview of his means of expression.

View from a High Tower combines with new assurance many discoveries and distinctive elements from Motherwell's previous works (fig. 41). The collage is composed of loosely painted pieces of paper pasted in roughly rectilinear patterns onto a cardboard support. It was executed in several techniques. While the regular center paper, painted tan and brown is a cutout rectangle like those of *Pancho Villa, Dead and Alive,* several other paper fragments have torn edges which appeared for the first time in *The Joy of Living.* The limited number of these roughly torn pieces of paper express greater control over impetuousness and violent feelings. The collage also contains a reference to Motherwell's most important early painting *The Little Spanish Prison* in the yellow and white vertical stripe at its upper center. The use of thick black lines to interweave areas of collage was pioneered in *Pancho Villa, Dead and Alive.* The central image reminds the viewer of a personage, a presence with an emotional charge, even though it is less specifically referential than the figures in *Pancho Villa, Dead and Alive.*

In the center of *View from a High Tower* is a paper fragment with the large letters "V, LA," and part of the word "VIVA." It was the first time Motherwell used words in his paintings. He later expanded the idea in his 1945–46 "Viva" paintings, and made it the focus of his "Je t'aime" series, invented in the mid-fifties (fig. 49). Motherwell was certainly aware of the Cubists' use of painted and pasted letters, as well as Miró's poetic *ecriture.* The availability in New York of Synthetic Cubist collages such as *Lacerbe* and *Man with a Hat,* both containing words, has been mentioned earlier in this chapter. Firsthand examples of Miró's flowing script are found in his *Catalan Landscape* which was at the Museum of Modern Art, and in several Miró paintings shown regularly by the Pierre Matisse Gallery.

In *View from a High Tower,* Motherwell's use of block letters rather than script, as well as placement of the letters on a fragment of paper, resembles Cubist collage in design more than it does Miró's writing. Yet Cubist lettering, when painted, is a neutral reproduction of newspaper print. Motherwell's letters are calligraphic and the powerful meaning of "VIVA," and "V" (for victory) is paralleled by the bold shapes of the letters, enforced further by Motherwell's vigorous brushwork in executing them. Also Motherwell's fragmentation of the letters does not create the sly puns often found in Cubist works (eg., JOURNAL becoming JOU). Rather, Motherwell tore his paper in an assertive and instantaneous gesture, which also parallels the energetic meaning of his words.

There are two additional sources for Motherwell's use of "V" and "VIVA" in his collage. Wolfgang Paalen's article "The New Image," translated by Motherwell for *Dyn,* gave V for victory as a clear example of a symbol that was nonrepresentational, yet understood by everyone. Motherwell also recalls being moved by letters scrawled on rough plaster walls. As mentioned earlier, Motherwell equated the flatness, sensuality, and security of such walls with his paintings.

As *The Joy of Living* expressed Motherwell's feelings of terror about World War II, the sign "VIVA" was his attempt to introduce a personal emotion about the war into his art. Another fragment from the same combat map used in *The Joy of Living* also appears prominently in *View from a High Tower*. Because of the greater allied success in Europe by 1944 and Motherwell's growing artistic confidence, the mood is now one of assurance and even exuberance, rather than the oppressive feelings aroused by the grim and ironically titled *The Joy of Living*. Unlike *The Joy of Living*, the space in *View from a High Tower* is resolutely flat, not confusing. The colors bright red, tans, off white, and sky blue are joyful, not dark. The tans and browns recall warm earth colors. The combination of red, white, and blue may have evoked for Motherwell the French tricolor and even the American flag. However, in *View from a High Tower*, as in the previous collages, one receives primarily an impression of subjective feeling, a personal joy in art partly aroused by events in the exterior world. The collage is not a public summons to political or military action. In this light, Motherwell has frequently compared the battle for modern art to "a military campaign."[38] One might note that the combat map, listing the "Marne" and the "Bois de Malaumont," seems to mark out territory in France, in Motherwell's view the home of modernism.

Like the composition of *View from a High Tower*, its title suggests Motherwell's personal overview of his art. Also it may refer to the flatness of a landscape seen from above, in contrast to the perspectival confusion of Motherwell's first mentor Matta. Motherwell attained some of the composure and peace he needed for his work during the summer in Amagansett. It is likely that he created the collage during that active period. He may have been referring indirectly to its map and its summary of his painting concerns when he wrote Baziotes from there about the need to control one's style:

> I love your instinctiveness and emotionalism, but at the same time you need someone *to make a map* [Motherwell's underlining] for you occasionally and steadily. . . . I was filled with your instinctiveness but now I see the whole terrain, and I beg you to break with the young surrealists. . . . They can only confuse you and they are lyrical, ignorant and sterile. You must make your energy productive and one of the chief ways to do this is to only remain in a milieu which makes you *want* to paint.[39]

In the lecture given that summer at Mount Holyoke College and later published as "The Modern Painter's World," Motherwell also argued that the artist must know himself and exert formal control over his work:

> Painting is a medium in which the mind can actualize itself; it is the medium of thought. Thus painting, like music tends to become its own content. The medium of painting is color and space. Drawing is essentially a division of space. Painting is a reality among realities which has been felt and formed. It is a pattern of choices from the realm of possible choices which gives painting its form.[40]

Motherwell's reflections on the various possibilities of painting and collage, implicit in *View from a High Tower,* affected several other important collages of 1944 including *Mallarmé's Swan* and *Collage in Beige and Black* (figs. 42 and 43). In both works Motherwell enlarged his vocabulary of pictorial forms and simultaneously tightened the syntax between them.

Mallarmé's Swan is one of Motherwell's most important works during the 1940s.[41] In it a variety of formal possibilities was developed which profoundly influenced his later career. Thus, the collage provides a particularly good opportunity to investigate in detail Motherwell's procedure. *Mallarmé's Swan* contains an area where, as a start-up strategy, Motherwell painted automatically according to Surrealist precepts. Thinned oil paint in black, yellow, and red was poured on the surface in puddles and allowed to accidentally run together, as seen in the lower center of the collage. (Only the vertical, pink piece of paper is below those pools of paint and thus preceded them.)

Mallarmé's Swan is characteristic of the manner in which Motherwell's spontaneous paint handling came first and inspired the structure derived from it. Motherwell has said that the yellow vertical stripes on either side of the composition were elicited by the yellow, vertical paint spatters in the center.[42] Similarly he believes that he conceived of the floating irregular oval shape in the upper left in response to the two irregular black paint spills directly below it. He regards allowing the original automatism to remain visible at the center of the composition "as a bold act of asserting the value of painterly instinct."[43]

The more structured areas of *Mallarmé's Swan,* built around that automatism, consist of four vertical slabs of pink, yellow, blue, and beige. They provided a firm compositional scaffolding and affirmed the surface of the work. It is not immediately evident, however, that these stripes parallel to the picture edges are the structural basis for the collage, because of the variations in each. The yellow bars on the left and right are nearly the same width. Nevertheless they appear quite different because the soft white overpainting on the left contrasts with the pasted white paper, on which a linear tracing reminiscent of Miró appears. The central beige stripe of pasted paper does not run the length of the work, but serves to break up the central blue area reducing its chromatic dominance.

The beige stripe changes its shape in response to the suspended oval pressing against it. This is the first time that Motherwell bent one shape against another to this degree. Motherwell believes that the response of one form to another was a product of his intense concentration on the internal workings of the picture surface. This invention should be discussed in general terms.

There are several pictorial devices which, finally, gave his abstract forms an organic rather than rigidly geometric character. The most obvious device

is soft, irregular shapes which, though unspecific, remind us of human anatomies. This method had been applied successfully throughout the 1920s and 1930s by Picasso, Miró, Masson, Arp, and many others. It was adopted by Motherwell as early as 1941 in his *Mexican Sketchbook* drawings and can also be seen in *Mallarmé's Swan*. A second method to infer the biomorphic character of forms is to model them giving the illusion of slight roundness.

While Miró and Picasso had both on occasion depicted this illusionistic swelling, Motherwell had been gradually flattening his shapes. A third method of making abstract shapes seem vital is to change their shape slightly as they press against each other, suggesting the manner in which living, soft shapes alter upon contact. This method had not been fully utilized by either Miró or Picasso, whose shapes interpenetrate but rarely alter each other. The responsiveness of his flat forms to one another gave *Mallarmé's Swan* a liveliness. This device appeared in Motherwell's work throughout the rest of the forties, and then became a key expression for his "Elegies to the Spanish Republic."

There are many other important formal refinements which give *Mallarmé's Swan* its vitality and its compositional unity. The pasted oval to the upper left is echoed in reverse by the "hatchet" shape above it. A drawn oval balances the collage shape at the very bottom of the work, and next to it is a negative shape with the same curvature. The very simple shapes of the ovals thus encompass the fine physical distinctions between negative and positive forms as well as drawing and collage. For Motherwell these distinctions indicated a subtle and refined formalism in which "nothing is spelled out."[44] Throughout *Mallarmé's Swan* tangents are also important. Shapes frequently just touch each other, and for Motherwell provide further evidence of "refined sensibility," and objectivity of the picture surface.[45] Overlapping, which implies depth, was minimalized.

An important touchstone for *Mallarmé's Swan* was Matisse's *The Piano Lesson* (1916), which Motherwell admired at The Museum of Modern Art, and was thinking about when he created his collage. Like *Bathers by the River*, *The Piano Lesson* is a work in which Matisse combined his innate sensuality with the structure he learned from Cubism. *Mallarmé's Swan* and *The Piano Lesson* employ large color areas. (Motherwell's hues are somewhat clearer in this case.) They both organize their surfaces through loosely painted vertical slabs. In the painting and the collage simple ovals, together with these vertical slabs, emphasize the clarity of form and thus the directness of statement. Artistic sensitivity is shown by accenting delicate points of contact. Both artists avoided the overlapping of planes which might suggest a Cubist ambiguity of form.

The Piano Lesson presents a delicately suspended moment of familial and artistic order before Matisse's son went off to World War I, and

Motherwell's collage symbolizes an equally balanced moment during World War II. Although Matisse's painting is more representational, there is a similar feeling of clarity and artistic sensitivity in the two works.

The relationship between *Mallarmé's Swan* and French Symbolist poetry has been discussed in one of the best recent articles on Motherwell by L. Bailey Van Hook.[46] As noted earlier French Symbolist art theory formed a background for Motherwell's work, and he read extensively in Mallarmé by the early 1940s. While Mallarmé did not interest Motherwell as much as Baudelaire or Valéry, he was a paradigm of artistic purity for Motherwell.[47] As stated by Van Hook, Motherwell added elements in his collage "to achieve a plastic sense of composition which parallels Mallarmé's attempts to create a new poetry in which words and images are woven into a total effect." She continued quite perceptively, "Motherwell's composition is in fact close to that of Mallarmé's poetry in this emphasis on the relationship of one form to another, one color to another. Mallarmé strove for a seamless art in the same way that Motherwell attempted to achieve a unified plastic composition."[48]

More specifically Van Hook linked the icy French blue of Motherwell's collage to Mallarmé's preoccupation with that color as a symbol of purity, which he expressed in his poem "L'Azur." The original title for Motherwell's collage was "Mallarmé's Dream." As Van Hook pointed out "dream" had a two-fold meaning for Mallarmé. It represented a higher state of the soul, an alternative to reality, and it was a metaphor for the poet's creativity. Motherwell changed the title for his collage when his friend Joseph Cornell misremembered it as "Mallarmé's Swan." For Mallarmé the swan was also a symbol of artistic purity referred to in his "Sonnet" of 1885.

In that poem, however, the swan also represented creative stasis. It was imprisoned in the ice and about to be lost in the all-consuming whiteness around it. In Motherwell's collage there is no sense of this artistic paralysis suggested in Mallarmé's "Sonnet." Even in a work as elegantly refined as *Mallarmé's Swan,* Motherwell used his artistic instinct (seen most directly in the splashed paint) as a way of vitalizing the work and giving it emotional power. The title of the collage is clearly a homage to Mallarmé, partly in keeping with the delicate sensibility of the work. But the reader must also note Motherwell's long-standing reservations about the overrefinement he found in Mallarmé's poetry.[49]

In addition to the collages, Motherwell experimented with a new painting style in 1944, *Wall Painting with Stripes* (fig. 44). This was Motherwell's most important work in the medium since *The Little Spanish Prison.* Measuring 54 × 67½ inches, *Wall Painting with Stripes* pioneers a new large scale in Motherwell's art. It introduces an important expressive distinction between his large public-scale paintings and more intimate, smaller creations.

Although this division is never rigid, it is epitomized by the "Elegies" and the smaller, more personal collages such as *The French Line* of 1960.

Despite the eventual distinction between oil paintings and collages, *Wall Painting with Stripes* benefits from the carefully considered formal relationships in *Mallarmé's Swan*. Motherwell has said, "*Wall Painting* was one of the few works I made without automatism. I remember that I was consciously experimenting with edge, form, and texture."[50] From the discoveries made in *Mallarmé's Swan*, Motherwell brought to *Wall Painting with Stripes* the expanded vocabulary of ovals and vertical slabs, frontality, tangents, and limited overlapping of forms. Like *Mallarmé's Swan*, the shapes echo and complement each other, providing drama through changes and permutations on the canvas. For instance, the black oval stimulates our curiosity about the half-hidden yellow oval just discernible above it. The crescent shape of that yellow oval provides a startling contrast to its negative, the huge open crescent in black to the left.

In addition to the lessons learned from *Mallarmé's Swan*, the collage also aided Motherwell in further differentiating between the characteristics of that medium and oil painting. This increased understanding may be witnessed in the earlier stages of *Wall Painting with Stripes*, seen in a 1944 photograph of Motherwell's studio (fig. 31). This photograph shows *Wall Painting with Stripes* on the easel behind the artist, and a related oil study on paper tacked to the wall above his head. (*Collage in Beige and Black* is framed at his feet.) The oil sketch, shown above Motherwell, is closer to *Mallarmé's Swan* in its scale, vertical emphasis, wider variety of shapes (including a similar "hatchet" form at its top), and areas of thinned and dripped paint. In the early state of *Wall Painting with Stripes* on the easel, Motherwell has greatly increased the scale of the work (54 × 67½ inches) over the oil study. He has emphasized horizontal expansion, limited and simplified the shapes, and painted in a heavier texture.

The final version of *Wall Painting with Stripes* is a rugged, severe statement, compared to the more intimate and fragile inventions of *Mallarmé's Swan*. Motherwell recognized that while collage dictated small size, oil painting allowed a grander scale. As mentioned earlier, the possibility of expansion of the canvas through repeated vertical stripes was latent in *The Little Spanish Prison*. The more monumental size of *Wall Painting with Stripes* was accompanied by stark shapes. In the final version, Motherwell eliminated the second crescent and the finicky drawing in the lower center of the earlier state of the painting. The large expanse of surface was kept visually alive, however, through the heaviest paint texture that Motherwell had yet employed. The earthlike solidity of the painting is complemented by the ochre color of the alternating stripes.

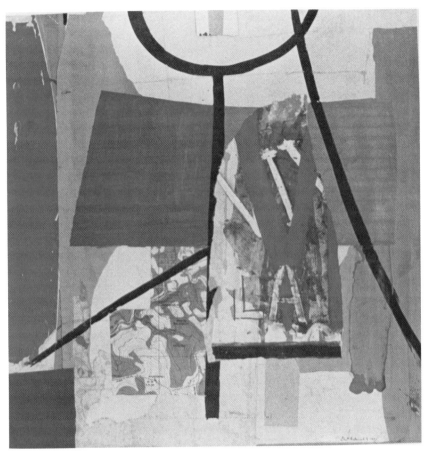

Figure 41. Robert Motherwell, *View from a High Tower*, 1944
Oil, paper and map fragment on cardboard, 29 1/4 × 29 1/4″
(Collection unknown)

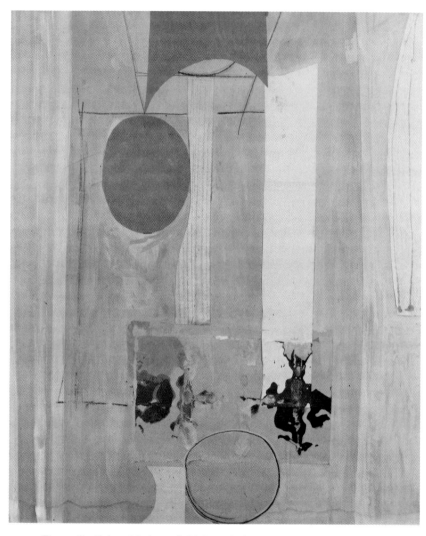

Figure 42. Robert Motherwell, *Mallarmé's Swan*, 1944
Ink, gouache, crayon and paper on cardboard, 43 1/2 × 35 1/2″
(Contemporary Collection of The Cleveland Museum of Art)

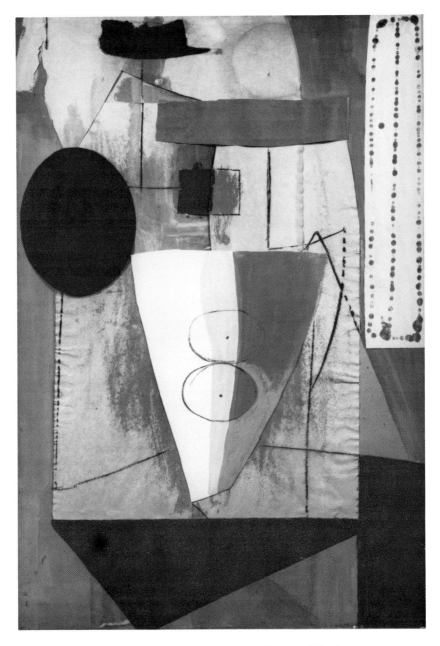

Figure 43. Robert Motherwell, *Collage in Beige and Black*, 1944
Oil and paper on cardboard, 43 × 29 1/2″
(Private collection, Massachusetts)

Figure 44. Robert Motherwell, *Wall Painting with Stripes*, 1944
Oil on canvas, 54 3/16 × 67 3/16"
(Collection The Lannan Foundation, Los Angeles)

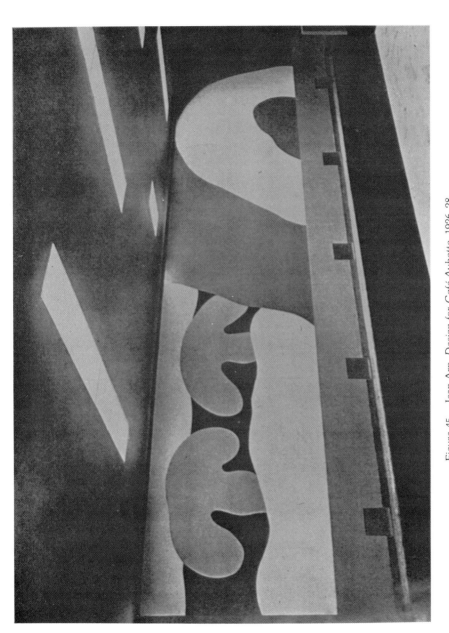

Figure 45. Jean Arp, *Design for Café Aubette*, 1926–28
Oil on canvas, 60 × 240″
(Formerly Strasbourg [destroyed])

Figure 46. Photograph of a Plaza in Mexico City

The basic pictorial tension in the work is between the powerful verticals and the more irregular ovals, the crescent, and the black spiked shape. There is evident tension between the vertical stripes which appear to be trying to absorb or compress the softer curving forms. This impression of pictorial tension is the closest analogy during the mid-1940s to Motherwell's "Elegies to the Spanish Republic." In fact, the black oval at the lower right, compressed between vertical stripes and accented by thinly painted lines above it and to its right is the single motif closest to Motherwell's "Elegies" until 1948 (fig. 81). Thus *Wall Painting with Stripes* expresses controlled and grand emotions which foreshadow the division Motherwell later made between his more severe "Elegies" and more playful collages.

In addition to the internal development of *Wall Painting with Stripes,* Motherwell has indicated that the painting was influenced by three outside sources, all of them *public* art. One was a photograph of Arp's destroyed 1927 mural for the Café Aubette which appeared in the 1944 issue of *transition* magazine (fig. 45).[51] The mural, like Motherwell's painting, depicts large organic forms which overlap in a flattened space. As in Motherwell's painting, the mural exhibits careful control over each shape. It was probably one factor which encouraged Motherwell to increase the scale of his painting to dimensions suitable for a "wall." However, Arp's forms are much more firmly rooted in direct visual experience of nature, suggesting trees or mushrooms, and they are placed amid undulating horizontal lines that suggest landscape. Motherwell's shapes are far more abstract and perhaps universal, expressing a tension between such ideas as containment and expansion, or fragility and power. While Motherwell's painting is organized according to compositional syntax, Arp's mural obeys natural laws such as gravity.

Piet Mondrian's art also influenced the increased scale and construction of *Wall Painting with Stripes.* Shortly after Mondrian's death in 1944, Motherwell and Harry Holtzmann visited the Dutch painter's studio. Holtzmann recalls that Motherwell was particularly interested in Mondrian's creation of an entire environment from his paintings by tacking rectilinear pieces of paper, painted in primary colors, on the white walls of his studio.[52] Motherwell has suggested that his realization of the expansive character of Mondrian's rectilinear paintings stimulated him to increase the scale of his own work, creating more powerful and encompassing images.

Holtzmann also remembers that Motherwell paid careful attention to Mondrian's later, more expressive paintings such as *Victory Boogie Woogie,* which was incomplete and still on the easel, and to Mondrian's experimental charcoal drawings.[53] The visit to Mondrian's studio must have increased Motherwell's awareness of the expressive potential of Mondrian's style. As noted earlier, Motherwell was profoundly influenced by Mondrian at the beginning of his career, but he also found the older master too severe and

reductive. In 1944, Motherwell began editing Mondrian's writings for the Documents of Modern Art series.[54] From his study of these essays, he realized that Mondrian's grids represented a public-directed art and a moral position, as well as reductive formalism. Motherwell thus reexamined his own feelings about Mondrian's art and its relationship to his goals and ambitions.

Finally, the coarse texture, grand scale, and abstract character of *Wall Painting with Stripes* owe something to Motherwell's memory of Mexican plaza designs (fig. 46).[55] In a similar manner Motherwell had already equated the flat surfaces of some of his early oil paintings and collages with the stucco walls he saw in Mexico.[56] Certainly the reference to the stone plazas is appropriate for the large tangible surface of this painting. However, the uniformly repeated stone patterns, which are merely decorative motifs, differ from the subtle variety of shapes, textures, edging, colors, and brushwork in Motherwell's canvas. On the whole, *Wall Painting with Stripes* pioneers feelings of restraint, somber control, and architectonic grandeur which often characterize Motherwell's later and large-scale, public compositions.

In addition to his painting activity during 1944, Motherwell began to edit the Documents of Modern Art series published by Wittenborn, Schultz, Incorporated. (He continues to direct the series with a different publisher today.) Motherwell initially proposed the Documents to George Wittenborn because so few American artists were able to obtain or read major texts by the European founders of modernism in foreign languages.

During the 1940s three volumes of the Documents series were published: Mondrian's *Plastic and Pure Plastic Art* (1945), Arp's *On My Way* (1948), and Max Ernst's *Beyond Painting* (1948). Motherwell wrote the preface for each, and in the case of Mondrian and Arp, the increased attention he paid to their work influenced his own. Motherwell's editorship of the Documents of Modern Art series also manifests the correlation he found between art theory and painting, and thus indicates the importance of his own writings in relationship to his art.

The Documents series is an early example of Motherwell's lifelong role as an educator in modern art. As an editor, author, lecturer, and teacher at Hunter College during the 1950s, he has spent a significant portion of his career disseminating information about modernism. Most of this effort has not been directed toward his own art. Rather, Motherwell believes profoundly in the importance of modern culture as the context for every modern artist. In his own work, Motherwell's complex relationship to other major twentieth-century painters and his willingness to consider modern literature and philosophy in regard to his art reveals this position. In 1951 he wrote, "Every intelligent painter carries the whole culture of modern painting in his head. It is his real subject, of which everything he paints is both an homage and a *critique,* and everything he says a gloss."[57]

Nineteen forty-four ended with Motherwell's first one-man exhibition at Art of This Century Gallery. This exhibition was the third that Guggenheim had held for the young Americans; Jackson Pollock's first one-man exhibition opened in November 1943, and Baziotes's was shown in September of 1944. Motherwell remembers that he did not particularly want to have the exhibition, believing he was too young for his first show. But James Johnson Sweeney, then an advisor to the gallery, and Guggenheim persuaded him to have it from October 15 through November 11.[58] The exhibition consisted of forty-eight works, of which seven were oil paintings, six were collages, thirty-three were drawings and two were etchings. Of these works, we can presently identify fourteen by matching titles from the checklist with known works. More exhibited works may be known, but may have different titles from those given in the checklist, or they do not have distinctive titles.

Motherwell's first one-man exhibition was a popular success, and brought his first museum purchases. Alfred Barr bought *Pancho Villa, Dead and Alive* for The Museum of Modern Art; *The Joy of Living* was purchased by the Baltimore Museum for the Sadie May collection; and *Surprise and Inspiration* was acquired by Peggy Guggenheim. Motherwell also remembers that he sold three more oil paintings and some dozen drawings.[59] These sales indicate the small, but supportive, group of curators and patrons who frequented Art of This Century and created an atmosphere in which experimental American art could be nurtured. Pollock and Baziotes also sold several works from their first one-man exhibitions.

The reviews of Motherwell's exhibition were favorable, although uninformative with the exception of the criticism of Clement Greenberg in *The Nation*. James Sweeney's preface for the exhibition catalogue emphasized Motherwell's concern with materials. However, Sweeney incorrectly concluded that the drawings and collages were preliminary steps leading to "the more exacting medium, oil."[60] We have seen that for Motherwell his collages were expressions largely independent of the oil paintings, although the two media freely influenced each other. They were certainly not studies for the oil paintings. The drawings were mainly elaborations executed *after* the oils and collages.

In his traditional explanation of the progression from studies to the finished work, Sweeney missed the important point that Motherwell made his intuitive pictorial decisions while in the process of creating his larger works, and often these decisions can be read on their surfaces. Sweeney went on to state that Motherwell's art was a combination of observations of nature and independent pictorial construction. He wrote, "And the vitality of his work will depend on the tension he maintains between the logic of pictorial expression and that of visual reality." Sweeney probably wished to differentiate Motherwell's work from the geometric paintings produced by

such groups as the American Abstract Artists. Yet he failed to note that Motherwell had already moved a long way from "visual reality." He was painting expressive abstractions, which communicated profound feelings with few direct references to the natural world.

The anonymous review of Motherwell's show in Art News was brief. It supposed that because he had studied philosophy, his art was esoteric. Yet it found his work to have "spirit, taste and color" of its own.[61] The review in Art Digest by Jon Stroup was more carefully conceived and relevant. It approached a problem that has concerned historians of Abstract Expressionism since the forties. That is how one reconciles nearly abstract handling with fragmentary allusions to recognizable subject matter. Stroup wrote, "Balance is maintained not only with the plastic means themselves, but between subject matter and mode of expression. The indiscriminative might call his work abstract, but it is hardly an adequate definition."[62]

With more acuity than Sweeney's notion of "visual reality," Stroup wrote that the subject matter of Motherwell's work resulted not from "mere physical reality" but from "recreations of aesthetic perceptions generated by the artist's profound intercourse with the world around him." In this brief phrase, Stroup suggested that the subject matter of Motherwell's work was internally generated by emotional and psychological probing. Stroup also commented upon Motherwell's interest in materials and made the important distinction between the "audacious collages" and the "austerity of the paintings." Like Sweeney, he found the oil paintings to be the more important creations. Stroup concluded by emphasizing Motherwell's originality and the fact that he was self-taught. Yet, he simultaneously observed that Motherwell had based his discoveries on the work of Picasso and Mondrian.

The most important reviewer of Motherwell's first one-man show was Clement Greenberg.[63] From 1943 through 1949 Greenberg was the arts editor for The Nation, and in that position he became the most important early champion of the Abstract Expressionists. On several different occasions, Motherwell has observed the importance of Greenberg's critical perceptions for his generation of artists. Motherwell said at one time, "He was the only American critic during the forties with an eye."[64]

Greenberg's criticism during the 1940s is somewhat misunderstood today, and the misperception is partly due to the critic himself. His most famous book Art and Culture, from which most of his writings are popularly known, is not simply a collection of earlier essays. Instead it is a group of very carefully selected essays that promote his formalist viewpoint. Even individual essays have been edited, without the author noting this fact, to eliminate conflicting ideas and self-questioning.[65] Greenberg's criticism was codified during the 1960s by such followers as Michael Fried and Kenworth Moffett.[66]

To understand the speculative breadth of Greenberg's critical faculty,

one must return to his original reviews in *The Nation*. There one finds the young critic eager to understand and interpret a wide variety of artistic expressions. His review of Motherwell is typical of his more tolerant attitude to a variety of moods and expressive devices in art. Greenberg wrote of Motherwell's first exhibition:

> Only in his large oils and collages does Motherwell really lay his cards down. There his constant quality is an ungainliness, an insecurity of placing and drawing which I prefer to his watercolors because it is through this very awkwardness that Motherwell makes his specific contribution.

Greenberg thus perceived that Motherwell's best works were his collages and oils, echoing the painter's judgment. Greenberg did not insist on a sterile review of formal elements exclusively, but took note of Motherwell's "ungainliness" and "insecurity." Interestingly, he saw in this awkwardness of amorphous shape and handling the artist's individuality.

Greenberg continued his review of Motherwell by citing specific examples:

> The big smoky collage "Joy of Living"—which seems to me to hint at the joy of danger and terror, of threats to living—is not half as achieved as the perfect Picasso-ish "Jeune Fille," yet it points Motherwell's only direction: that is the direction he must go to realize his talent—of which he has plenty. Only let him stop watching himself, let him stop thinking instead of painting himself through. Let him find his personal "subject matter" and forget about the order of the day.[67]

Greenberg's sensitive interpretation of Motherwell's art is in keeping with his early discussion of Jackson Pollock and William Baziotes, and is opposed to his later, rigid formalist criticism.[68] Greenberg praised the *Joy of Living* for its disturbing emotions, in opposition to the ironic title, and he applauded the originality of that collage in comparison to the more derivative *Jeune Fille*. Greenberg contrasted that originality even more severely to Motherwell's drawings when he wrote, "Motherwell's water-color drawings are of an astonishing felicity and that felicity is of an astonishing uniformity. But it owes too much to Picasso, pours too directly from post-cubism."

While we have noted that Motherwell based his own art on a wide variety of sources, he converted those sources to an original and personal expression. Greenberg supported this originality and independence from European sources. It was a greater theme in his early writings than formalist truth to the medium, and allowed him to identify with a far wider range of artistic expressions. He advised Motherwell to find his "subject matter." Given the earlier paragraphs, he must have meant by this term both original themes and a personal means of expression, goals toward which Motherwell was already progressing.

Greenberg concluded his review with very encouraging words for Motherwell, singling him out with two other painters as the most advanced and promising artists in this country. "But he has already done enough to make it no exaggeration to say that the future depends on what he, Baziotes, Pollock, and only a comparatively few others do from now on."

All in all Motherwell's first exhibition was a great success. It included an opportunity for him to judge his own work outside of the studio, and gave him public exposure, sales, and favorable reviews. Motherwell has recalled, however, that this sudden popularity was also constricting. He remembers, "Because that exhibition was so successful, it put a tremendous burden on me. Art was no longer play; I felt I had to create 'serious, finished' paintings. That feeling has always produced disastrous results for me."[69]

5

The Transitional Years: 1945–46

After the successes of 1944, one might expect 1945 and 1946 to be highly productive years for Motherwell. Yet several events combined to make those years the most difficult of his early career. Motherwell has recalled the problems that he faced at that time:

> I think the closing up of my work was autobiographical. I became a professional painter; I was earning a living; I had a contract to produce so many pictures. Also I was living in the country for the first time, quite isolated. All of those responsibilities, such as being married, led to a certain playfulness disappearing. I only realized later how important being a non-professional, nobody caring what I did, was to the experimentation in my earliest work. Then sometime in 1947, it began to open up again.[1]

With the success of his exhibition, Motherwell felt pressured to create "finished" works, rather than freely experimenting in collage and oil paint. In 1945 Motherwell moved from New York City to East Hampton. He felt sufficiently established and self-confident to continue his work away from the hectic New York environment.[2] Motherwell rented a small house in East Hampton, which had insufficient studio space. He recalls that this inconvenience broke his work habits. He began to paint less regularly and to think in terms of small, "confined" compositions.[3]

During the summer of 1945, he commissioned his friend, the architect Pierre Chareau, to construct a Quonset hut and to design its interior as a studio and living space for himself and Maria. The interior was divided into a split-level design which bisected the building lengthwise. Large windows, built along the curving wall on the open side, illuminated the living space below and the studio balcony on the second level. Despite the agreeable work space, the new home and studio turned out to be an intolerable financial burden on the young painter. Motherwell remembers worrying constantly for several years about being able to maintain it.[4]

The most distressing aspect of living in East Hampton for Motherwell was the isolation. At that time, the area was not yet an artists' community, but

a conservative rural area. Only Jackson Pollock and his wife Lee Krasner lived in the Hamptons, and despite the early friendship the artists saw each other only a dozen times during the entire period that Motherwell lived there.[5] Motherwell drove to New York City only about once every two weeks to conduct business with his dealer Samuel Kootz. He has spoken at length of his loneliness during this period of his life.[6]

Much of Motherwell's early painting depended upon a dialogue with other artists. Despite his increased independence, it was through such events as interacting with Matta, working with the automatist group, and viewing Mondrian's first American exhibition that Motherwell first defined his own ideas about painting. The difficulties he often had with his paintings in East Hampton reemphasize the importance of those associations.

Motherwell's isolation and unhappiness were compounded by marital problems, which finally resulted in his 1949 divorce. Maria was an aspiring actress, and she had come to New York expecting professional success, an exciting social life, and wealth. Her letters indicate a desperate need for activity and company.[7] The quiet life of East Hampton was particularly unsettling for her.

Even on Motherwell's infrequent trips to New York, he met with a changed and less stimulating and supportive situation there. At the end of the war, Peggy Guggenheim had plans to return to Europe. When she departed in 1946, Motherwell lost a sympathetic patron and a gallery in which he was allowed maximum freedom to show his works. In addition, Peggy Guggenheim's superb collection of modern art, which had been a constant inspiration to him, departed with her. Most of the Surrealists also began to filter back to Europe.[8] Although Motherwell's relationship with the Surrealists had been tempestuous, they clearly provided a needed foil for his own developing ideas.

In retrospect, Motherwell believes that one of the most serious mistakes he made during the mid-1940s was joining the Samuel Kootz Gallery. Kootz put new demands on him for a high quota of paintings per year in return for a monthly advance against sales. This arrangement pressured the artist to create paintings whether or not he felt inclined to do so. Motherwell recalled:

> Kootz arranged my transfer from Peggy Guggenheim to him. He offered the artists two hundred dollars per month for seventy-five works per year. It was very demanding because he had so few artists that each of us had to have many shows. It was really bad for a young artist such as myself to be committed to so much work. He was always desperate for money and drove himself and us very hard.[9]

During 1945 and 1946, Motherwell had four one-man exhibitions with the Kootz gallery. In addition he reluctantly participated in a number of Kootz's thematic shows, which must have offended his independence and made him

feel he was being manipulated. For example in 1946 Kootz arranged the popular shows Big Top, Homage to Jazz, and Modern Paintings for a Country Estate. In 1947, he did the thematic exhibitions, Painters and Poets, and Building a Modern Collection. For the exhibition Big Top, the animosity between Motherwell and Kootz was so open that it was noticed by an anonymous *New York Times* reviewer. He wrote, "Robert Motherwell, like Baziotes, made no concessions and was told right to his face by Mr. Kootz that Mr. Kootz couldn't find a 'Viola and Bareback Rider' on a canvas so titled."[10]

In addition to the difficulties posed by Kootz's exhibition schedule and demands for a large number of works, Motherwell was influenced, though perhaps not consciously, by the other artists who showed with the gallery. In addition to Baziotes who came with Motherwell, Kootz had contracts with Alexander Calder (for gouaches), Byron Browne, Carl Holty, and Ferdinand Léger. Despite quality differences, the stylistic links between these artists were strong. All worked in flat, hard edge and relatively geometric styles featuring bright primary colors. Only Browne was somewhat painterly. Among these artists, Motherwell was most directly influenced by Calder. But together they provided a context for him that was far less painterly and experimental than the work that stimulated him at Art of This Century. We will see that Motherwell's own painting became more geometric at this time, contrasting to the freely painted works made in the early years of the decade.

Early in 1945 Motherwell planned a series of illustrations to Marianne Moore's translation of La Fontaine's *Fables*. Motherwell met Moore at a party given by Kootz early in 1945 and listened to her early plans for the translation; a project she first considered in February of that year.[11] Motherwell did some six illustrations of his own accord after that discussion. They were never included in Moore's translation which she only finished after great labor eight years later.[12] One can hardly imagine a less likely companion for Motherwell's art than La Fontaine's moralistic fables in which animals take on human personalities. Despite the unsuitable character of the project, Motherwell's illustrations were not narrative. While he conceived them in a manner consistent with his abstract inclinations, he also created recognizable imagery.

The Cow is the most successful of these ink and watercolor drawings (fig. 47). In it, the cow is conceptualized as a collection of drooping oval forms, perhaps inspired by the shape of the udder. These shapes epitomize our feelings for an animal laden with human nourishment. The linear design of this cow is reminiscent of such Calder animal drawings and wire constructions as *The Cow* of 1938, which Motherwell would have known through his association with the Kootz Gallery (fig. 48). Because of its exaggerated outline, Calder's work takes on a more comical character than does

Figure 47. Robert Motherwell, *The Cow*, 1945
Ink and watercolor on paper, 8 1/2 × 11 1/2″
(Collection Robert Motherwell)

Figure 48. Alexander Calder, *The Cow*, 1929
Wire, 16 1/2 × 16" long
(Collection, The Museum of Modern Art, New York City. Gift of Edward M.M. Warburg)

Figure 49. Robert Motherwell, *Je t'aime*, 1955
Oil on canvas, 54 × 72"
(*Collection Robert Motherwell*)

Figure 50. Robert Motherwell, *Untitled,* 1945
Ink on paper, 10 1/2 × 8 1/2″
(Collection Mr. and Mrs. Robert A. Rowan)

Figure 51. Robert Motherwell, *Untitled* (The Studio), 1945
Oil on composition board, 12 × 9″
(Collection Robert Motherwell)

Figure 52. Pablo Picasso, *Female Flower*, 1945
Oil on canvas, 57 1/2 × 34 1/2″
(Collection unknown)

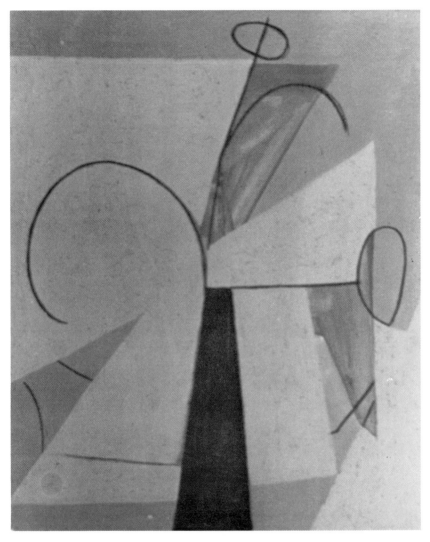

Figure 53. Robert Motherwell, *Line Figure in Green*, 1945
Oil on composition board, 16 × 12″
(Collection Robert Motherwell)

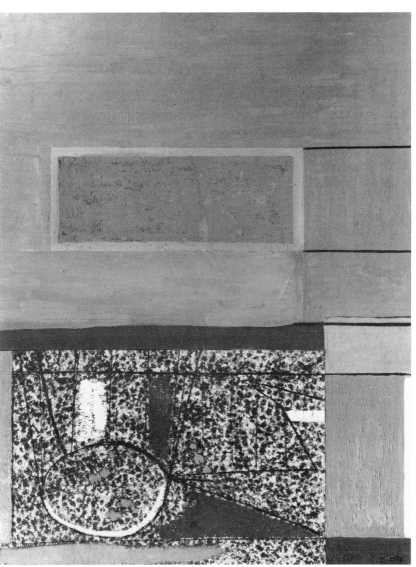

Figure 54. Robert Motherwell, *La Resistance*, 1945
Oil and collage on composition board, 36 × 47 3/4″
(Collection Yale University Art Gallery, New Haven. Gift of Fred Olson)

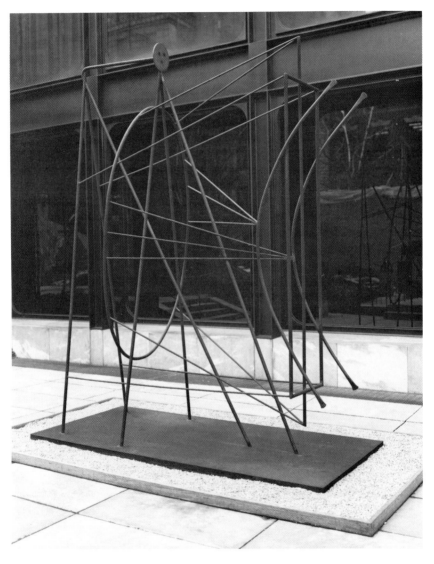

Figure 55. Pablo Picasso, *Monument*, 1972
Constructed after an enlargement, supervised by the artist, of a 20″ wire
maquette from 1928–29 of a monument by Guillaume Apollinaire. Cor-
ten steel, 155 5/8″ high, including base 1 7/8 × 58 3/4 × 125 3/4″
(Collection, The Museum of Modern Art, New York. Gift of the artist)

Motherwell's. In the center of Motherwell's drawing, red and black ovals are pressed within a triangle as if those organic shapes are held firmly and lovingly together. This combination of shapes became the central motif in his "Je t'aime" paintings over a decade later (fig. 49). In those later works, the shapes were placed amid heavy paint and the scrawled phrase which is the title for the series. They evoke the mood of the series which Motherwell has described as "a desperate cry for love."[13]

For the most part, Motherwell's oil paintings during 1945 appear stiffer and more mannered than his drawings. In many of these compositions, we can see the effects of pressure to produce "finished" works. Symptomatic of this problem is the relationship between an untitled drawing and a painting of 1945 (figs. 50 and 51). As can be readily seen, the ink drawing is a precise study for the small oil painting. One of the most important aspects of Motherwell's art is his spontaneity of invention. The immediacy of creative decisions and automatism, made visible on the picture surface, are all elements which have enriched his art. The traditional method of copying in oil paint the design already established in a drawing is inimical to Motherwell's usual working method. These two works comprise the only example I have found of a one-to-one connection between drawing and painting during the forties. Yet, the rigid oil paintings of 1945 suggest the same relationship may have existed for others, but the preliminary drawings are lost.

The untitled oil painting seems to depict two abstracted figures, indicated by their small oval heads and large mauve, curvilinear torsos. These ovoids connected by elegant curving lines form buoyant, rather inexpressive personages. They most nearly recall Picasso's *Female-Flower* paintings which appeared in *Cahiers d'art* during 1945 (fig. 52). Motherwell pursued an expression of this type in a number of small oil paintings which date as late as 1947. They include *Figure in Turquoise* (1945), *Figuration* (1945), *Small Personage* (1945), and *Line Figure in Green* (1947) (fig. 53).

In all of these canvases the flat interlocking forms and curving lines are drawn with a precision that precludes expressive handling of the oil medium. In each Motherwell has attempted to mimic painterly touch by adding sand to the oil paint. This procedure, which produces a grainy but even texture, fails to give the feeling of painterly involvement. Of course, Picasso had used sand in his paint as early as 1925, and, closer to home, both Byron Browne and Carl Holty at the Kootz Gallery added sand to their rigidly designed paintings during the 1940s.

In Motherwell's paintings, the space around the personages varies between relatively complex planar divisions, which resemble Synthetic Cubism, and the uniform background of *Line Figure in Green*. Even the delicate and superficially pleasing pastel colors of these paintings are unlike the strong tonal contrasts and dark earthy colors Motherwell had used in

previous paintings and collages. Recently commenting upon these works, Motherwell noted, "They were rather weak attempts to find an easy solution to painting. Perhaps I was also trying to discover the joy that was missing from my daily life. I really dislike these works, so I have tried to buy back as many of them as possible."[14]

Several collages and oil paintings executed during 1945 are more interesting, though they often refer back closely to Motherwell's most successful works of the previous year. *La Resistance* is closely related to *Pancho Villa, Dead and Alive* (fig. 54). The canvas is constructed with rectangular areas of red and several shades of blue. On the left side, Motherwell attached a piece of the same stippled German wrapping paper that he used in *Pancho Villa, Dead and Alive*. Upon the paper, he drew a stick figure with radiating lines to one side and splattered it with red paint. Like *Pancho Villa, Dead and Alive*, *La Resistance* refers to the violence of the outside world as seen through a personal sensibility. Motherwell has commented, "The title refers to the French underground, among other references to the artist's life."[15] Motherwell saw the violence done to the Resistance in terms of his own struggle between spontaneous and structured painting. In his statement, he may also have been referring to the fact that avant-garde artists still shared a secret existence in relation to the public at large.

As noted with *Pancho Villa, Dead and Alive,* it is the ambiguity between life and death and between spontaneous and structured painting which gives that work its vitality. In *La Resistance*, Motherwell clarified that ambiguity and weakened the work. The contrast between the more organic and more rigid sections of the work are too codified. The stick figure is attached to the edges of the collage and symbolically trapped by its radiating lines. In its conception, Motherwell referred to Picasso's *Wire Construction* of 1928, a version of which was at The Museum of Modern Art (fig. 55). In Picasso's welded sculpture the schematic figure, though derived from an ancient Greek charioteer, might also appear imprisoned in a web of wire lines. It is also worth noting that Picasso's sculpture was originally intended as a funerary monument for the French poet Guillaume Apollinaire, an association which was appropriate to the life and death symbolism of Motherwell's collage.

Motherwell's collage *Figure* (1945) is also somewhat more patterned and mechanical than the works of 1944 such as *Mallarmé's Swan* and *Collage in Beige and Black* (fig. 56). In *Figure*, the personage is defined by the large oval head capping a columnar and triangular torso. Like many of Motherwell's stick figures, it is both trapped and ordered by an interlocking network of rectangular pieces of cut out paper and painted lines. The brown and white vertical bars in the upper left quadrant perform this function. Motherwell cut an oval shape from the mottled wrapping paper and pasted it to the left side of

this collage. In the context of the personage, this oval form placed to one side of the torso might suggest the artist's palette. In any case, the liveliness of that area stands in direct contrast to the relative emptiness of the other oval shape in the work, the personage's head. This head area consists of a tan piece of cardboard and a folded, rectangular piece of sandpaper pasted over that. These elements attempt to give that important area of the personage visual interest. The impression left by the monochrome rectangle is emptiness, however. The mind looks like an open book, and that book is blank.

The heads of Motherwell's personages have always been important. For instance in *Pancho Villa, Dead and Alive* and *La Resistance*, the heads appear oversized, full of energy and vulnerably wounded. Retrospectively Motherwell has suggested that the empty head shape in *Figure* may be a visual symbol for the creative difficulties he was experiencing at that time.[16]

Symbols for the blank mind occur in a drawing and two other collages in 1945. In the drawing, *Charcoal with Green Chalk,* the oval head of the stick figure has heavy black lines scribbled over it. In the collage *For Maria* (1945), a simple torso culminates in an oval head painted grey with sand mixed into the paint. Over this grey paint, Motherwell drew an empty rectangle similar to the sandpaper pasted onto the head in *Figure.*

From January 2 through January 19 of 1946, Kootz held his first large show of Motherwell's art. It included twenty-two works, paintings, collages, and drawings. All except one drawing and one painting were done in 1945. Ten of the works can tentatively be identified through comparing their titles in the exhibition catalogue to known works, and most of those have been mentioned in this chapter.

The exhibition had standard reviews in *Art News* and *Art Digest,* which said very little of importance. Clement Greenberg, whom Motherwell had met only briefly, wrote the most critical and incisive review in *The Nation.* Greenberg immediately pinpointed the lack of turmoil and spontaneity in Motherwell's work which he had highly praised in his 1944 review of Motherwell's first one-man exhibition. Greenberg wrote:

> In concept Motherwell is on the side of violence and disquiet—but his temperament seems to lack the force and sensuousness to carry the concept, while the means he takes from Picasso and Mondrian are treated too hygienically. The richness and complication of color are applied too deliberately and do not accord with the arbitrary, constricted design. Effects are left floating in air, unattached and unnourished by blood vessels, without organic relation to an artist who had to paint thus and not otherwise. The best of Motherwell's work is in his large collages, but even here one feels the constituent elements could be rearranged considerably without altering the final anemic effect.

Greenberg then encouraged Motherwell to recapture and intensify the earlier direction of his art:

Motherwell's gifts—and he has shown he possesses them—deserve better exploitation than this. At times in the past he has produced much better work. Yet he has always suffered from a radical unevenness; there have been too many sudden changes in direction, motivated perhaps by an inability to decide what he wants and by conflicting influences. But the essential is to decide what one is, not what one wants.[17]

Although Motherwell does not now remember the impact of the review at the time, he now feels it may have been one influence on the increasingly powerful works that he began to create in the next year.

In 1946, one begins to see signs of Motherwell's creative vitality returning. This tendency will lead to the artistic breakthroughs of 1947–49. In two heavily painted collages titled *Viva*, Motherwell revived the expressive writing that he employed in *View from a High Tower*. In both these works, as in many of Motherwell's best early collages, the attached paper and expressive paint handling are freely intermixed, not isolated from each other. *Viva* I is probably the earliest of the two collages. In it, a relatively large piece of rice paper has been glued to the center of the composition. Heavy areas of blue paint were applied around nearly all of its edges, visually attaching it to the surface of the composition. Over the piece of rice paper Motherwell spread thin, amorphous areas of brown and burgundy paint. Then he loosely drew a stick figure and finally painted the word "viva." The paint application is more vigorous than in works by Motherwell in the previous year. In this context, the word "viva" may have expressed the artist's own cry of joy at the renewal of his creative energies.

Viva (1946) is more complex in its balance of elements (fig. 57). Although it is a small work (13 × 16¾ inches), its compositional arrangement and large rectilinear space partitions make it seem monumental. Dark brown, heavily textured paint dominates its surface. The active underpainting, found amid this heavy pigment, seems to have fought its way out of a dark gloom. In the later 1950s, Motherwell again used this pictorial expression in his more rugged "Iberia" paintings. There small patches of white have to struggle against overwhelming areas of black paint, evocative of a cave interior.

Viva combines collage and forceful underpainting. The area to the upper left shows raw canvas with free painterly marks upon it, while to the right expressive writing is executed on an attached paper sheet. The use of the interlocked letters "V" and the word "viva," as a way of inspiring painterly invention, preceded Willem de Kooning's use of painterly letters in his compositions by a year.[18] Like the letters in *View from a High Tower*, those in *Viva* are calligraphic. The pattern of interwoven V's to the right side is rigid, though forceful, as it fights its way out of the heavy brown paint around it. The pattern formed (⋁⋌) is the logo for *V.V.V.*, the Surrealist periodical for which Motherwell briefly acted as American editor in 1942. When asked about these letters, Motherwell suggested that the appearance of the insignia,

at once powerful and rigid, might express his dual feelings about the Surrealists.[19] He missed the energy and sophistication they brought to the New York art scene, but he also found a constricting rigidity to their beliefs, especially Breton's pronouncements.

The other writing in *Viva* is freer. In the right side at least three levels of cursive letters overlap. At the bottom level, we can identify a portion of "viva" written in energetic red. Over that, brown paint was used to write "viva" again at a dynamic slant. We also recognize "la" and several letters, "L, F, R, O," which can not be identified with a word. "Viva la" suggests an open-ended cry of joy, and even more than the earlier version of *Viva*, this painted collage signals the renewal of Motherwell's creative enthusiasm. This type of bold, painted letters is reminiscent of graffiti on a wall. As mentioned earlier, Motherwell admired such scribbling for its naive energy and public communication of feelings.

Two other collages from 1946 are noteworthy, *The Pink Mirror* and *In Blue with China Ink* (figs. 58 and 60). These collages are more powerful and assertive than all but a few of Motherwell's previous works in that medium. They herald the forceful figuration and painting style which would dominate his art in 1947 and 1948. For the collage medium, both works are monumental in scale (39 × 29½ inches). The slightly smaller *Pancho Villa, Dead and Alive* is the only earlier collage of comparable size. (In addition to stylistic similarities, the identical size of the two collages is another reason to link them.)

The increased scale of the two collages is accompanied by larger and more assertive shapes within them. *The Pink Mirror* was only named recently by Motherwell and was originally called simply "Composition."[20] Against a neutral background painted in grey, slate blue and olive green, it features the opposition of two distinctive moods and expressive approaches. To the left side, a rectangular piece of paper with evident creases in it has been roughly glued to the surface. It was then painted with thick tan pigment. Another piece of white paper was placed over it while the paint was still wet and then ripped off, leaving irregular fragments behind. Finally, a smaller rectangular fragment of Japanese rice paper splattered with black pigment was glued to the center of that area. The overall feeling of this area of the collage is one of physicality, something earthbound, and even heavy-handed manipulation by the artist.

On the right side, there is a painted polygon suggesting a mirrorlike surface. It is both curvilinear and faired in its edges, and thus seems to float amid the angularities of the rest of the collage. Because the outline shifts from pink to red and to the irregular shape, the polygon is difficult to focus upon clearly. The intense colors, pink and red, further lift it out of the tactile realm so thoroughly expressed by the rectangle on the left.

In *The Pink Mirror,* Motherwell seems to be exploring an opposition between the tangible and ephemeral, with a possible interplay of the physical and psychological. The mirror is often found in the history of art as a symbol of the interior world. Recently Motherwell's spontaneous recognition of the complex pink shape as a mirror is a clue to his original intent. Also, he was certainly aware of one of the most powerful renditions of this theme, Picasso's *Girl before a Mirror* of 1932 at The Museum of Modern Art (fig. 59). From Picasso's mirror, Motherwell adopted the shape, some of the pink and red colors, and location on the picture surface. Perhaps the spotting on the collage to the left side is also derived from Picasso's wallpaper pattern. Picasso's work suggests the opposing forces of the interior and exterior worlds of the girl through subtle changes in shape and color. The mirror view of her is like an X-ray. In *The Pink Mirror,* Motherwell has created an abstract expression of a similar idea. The separate interior and physical presences that Motherwell suggests in *The Pink Mirror* are related to dual imagery and meanings in such works as *Pancho Villa, Dead and Alive.* In paintings of 1947, such as *The Red Skirt* and the *Emperor of China,* Motherwell united the two types of expression into a single image.

In Blue with China Ink is another abstract composition that at the same time suggests a powerful presence (fig. 60). Motherwell glued several pieces of Japanese rice paper and a piece of blue cloth to the work. The rectangular pieces of rice paper to the right have been stained with china ink in black, red, and yellow which are structured and controlled by the rectangles around them. These active, but smaller, areas of the collage are presided over by a large curvilinear presence to the left side. It is composed of paper painted an earthy ochre color. One finds the suggestion of a curved head and more blocky torso. This presence is different from both Motherwell's successful stick figures in a work like *Pancho Villa, Dead and Alive* and from the more superficial figurations of 1945. Its scale, solid earthy color and firm outline make it more of an assertive force than the vulnerable stick figures or the later decorative figures. One finds here the first example of a series of more massive forms which will eventually fill the entire picture surfaces of works like *The Poet,* the *Emperor of China,* and the *Homely Protestant.*

In Blue with China Ink represents an abstracted studio scene, a theme we have found Motherwell personally exploring on so many other occasions, including his 1944 drawings. The powerful ochre presence just described might remind us of the head and torso of a sculptural bust, and the rectangular pieces of rice paper with their splattered ink of automatist paintings. As such *In Blue with China Ink* strongly recalls Matisse's *Still Life with Bust* (1916). Although this Matisse painting was sequestered in the Barnes Foundation, Motherwell visited that collection in 1944.[21] He has also mentioned his admiration for Albert Barnes's book on Matisse which

illustrates this painting.[22] As is the case with Motherwell's earlier uses of the paintings of Matisse as sources, Motherwell's works are more abstract, limit the decorative use of line, and emphasize expressive paint handling.

In Matisse's *Still Life with Bust,* however, one sees the germ of Motherwell's idea. Matisse's severely painted and large-scale bust is not simply another work of art in the studio. Rather, it is a surrogate for the artist's personality presiding over his environment. Likewise, the ochre presence in Motherwell's collage alludes to Motherwell's increasing control of his artistic world. In this light, it is significant that the shape is close to those found in two of Motherwell's most important paintings, the *Emperor of China* and *The Homely Protestant,* both of which Motherwell has described as symbolic self-portraits.[23]

Motherwell's paintings from 1946 also assert a more powerful and expressive means. He continued to produce two closely related types of work. One features freely painted geometric patterns with no recognizable figuration, and the other shows simplified large-scale personages. The paintings of 1946 that employ geometric patterns recall Motherwell's own paintings from 1941 to 1942 such as *Recuerdo de Coyoacan.* The earlier works were more deliberately mysterious in a Surrealist manner, while the latter are more robust, forceful, and immediate in material impact. The mysterious character of the earlier compositions seems to arise from the extensive use of black combined with deep, glowing colors, the unclear transitions between different parts of the paintings, and the "windows" which provide clues to hidden biomorphic shapes just beneath the canvas surface.

Blue Air and *The Red Stripes* exemplify the patterned paintings of 1946 (figs. 61 and 62). In both works the hues are more robust and often related to the colors of nature, sky blue, earth ochre, and green. These colors are offset by intense red. The pigment is applied in a thick, sensuous manner; the free patterning is clearly designed; and the divisions between areas of the canvas are clear. In *The Red Stripes,* the powerful central shape is painted thickly with an ochre core and red halo. It dominates the four different backgrounds around it. When asked about this painting recently, Motherwell replied, "That circle at the center is like a bull's eye. I think I came much closer to hitting the mark, I mean controlling the painting, than I had for several years. My life was also beginning to regain its focus, I think."[24] In this statement Motherwell hints at the integration of impetuosity and structure in his art and personality which is fundamental to his work during the latter part of the 1940s.

Indeed, the circular form in the center of *The Red Stripes* does act as a controlling force by overlapping the diverse background designs. These grounds might express some of the variety of styles Motherwell had explored during the 1940s. In the lower right quadrant a more decorative diamond

pattern is found. Motherwell painted amorphous and deliberately vague areas of brown pigment in the upper right and lower left portions of the compositions. In the upper left quadrant are the red stripes, alternating with black ones, for which the painting was named. These are like the "bars" which have entrapped and enmeshed Motherwell's schematic stick figures since the *Spanish Prison* (1943-44). In *The Red Stripes,* however, the bars are bent by the powerful organic shape at the center of the composition. Like the growing power of Motherwell's art, the central "bull's eye" forces those bars to conform to its will.

Four oil paintings executed in 1946 look directly forward to the expressive discoveries that Motherwell would make in 1947. They are *Figure in Red, The Sailor, Figuration,* and *Starry Personage.* All four paintings feature large, powerful personages at the center of the compositions, which dominate the painterly activity around them. They are much more expressive than the rigidly drawn and lifeless figures of 1945.

Figure in Red is the most dynamic and buoyant of the compositions (fig. 63). In it Motherwell began to replace the duality of the two stick figures in *Pancho Villa, Dead and Alive* with a single integrated, personality image. Motherwell has described *Figure in Red* as an "abstracted portrait bust, perhaps even a self-portrait."[25] An oval at the upper center of the composition is set upon the "shoulders" which are flat on top and become rounded into a torso at the bottom of the painting, as a sculpted portrait bust might be. The shape of the oval "head" is very close to that of the oval in *The Red Stripes.* This similarity reminds us again how close Motherwell's nonrepresentational works are to those with suggested figuration.

In *Figure in Red,* the personage is the largest one in relation to the overall area of the canvas that Motherwell had yet painted. The simple dark grey ground leads us to focus our attention wholly on the presence at the center. This personage is painted in two shades of ochre and dynamically enlivened by a red stripe running through it, as well as five additional short red stripes emanating vertically from its head. The effect of the red vertical stripes, which are also the broadest Motherwell has yet painted in relation to the overall picture surface, is to invest the powerful presence with dynamic energy. They do this through the vertical direction and the hot color. These stripes differ from the bars in Motherwell's earlier paintings. They do not entrap the figure limiting its expression, but rather contribute to that expression. Motherwell was once again dramatically enlarging the expressive possibilities of his pictorial vocabulary.

In contrast to *Figure in Red, The Sailor* is a deliberately awkward painting. The body of the personage is defined by a clumsy, flattened oval suspended on two stick legs. The head is tiny, and is balanced insecurely on an arrowlike shape. The head is also denied formal strength because it has a

confusing dark shadow around a portion of it, and is set against heavily painted horizontal striations. The arms of the figure have become huge black trapezoids which hem it in on either side. In *The Sailor,* paint application is also deliberately heavy and awkward. Layers of ochre pigment have been applied with irregular brushwork. Horizontal brushstrokes often become vertical without transitional passages.

The deliberately inept character of *The Sailor* has a power of its own. It is as though Motherwell were willing to expose his weaknesses with a directness not seen before in his work. The deliberately humble and clumsy work moves us to feelings of empathy somewhat akin to our reaction to the dwarfs that Velázquez painted. *The Sailor* certainly should be considered a symbolic self-portrait in which Motherwell reveals an unflattering self-image and demeaning feelings about himself. The word sailor in the title suggests self-projection; since his youth, Motherwell has loved the sea and imagined himself as a sailor.[26]

Both the aggressive power found in *Figure in Red* and the clumsiness apparent in *The Sailor* are important aspects of Motherwell's internalized view of his personality, and he will further explore these self-images in the paintings of 1947 through 1949. Recently the artist said, "my sense of my images and myself as being at once strong, even monumental, and yet extremely vulnerable...is one of the deepest insights into the ultimate character of my work that I am aware of."[27] Motherwell must have been aware that these two paintings exemplified important expressive statements. They were the only two works from 1940–46 that he included in a major exhibition of his new paintings held at the end of 1947.

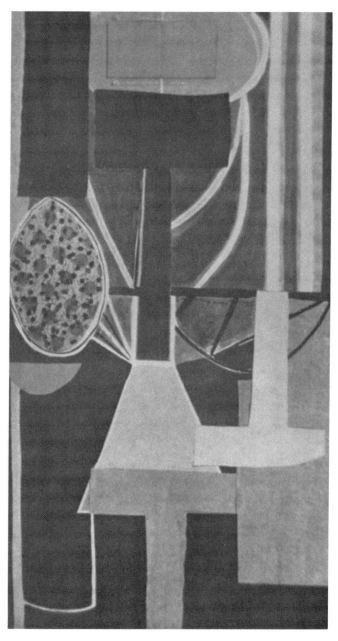

Figure 56. Robert Motherwell, *Figure*, 1945
Oil and collage on paper, 44 3/4 × 24 1/2″
(Private collection)

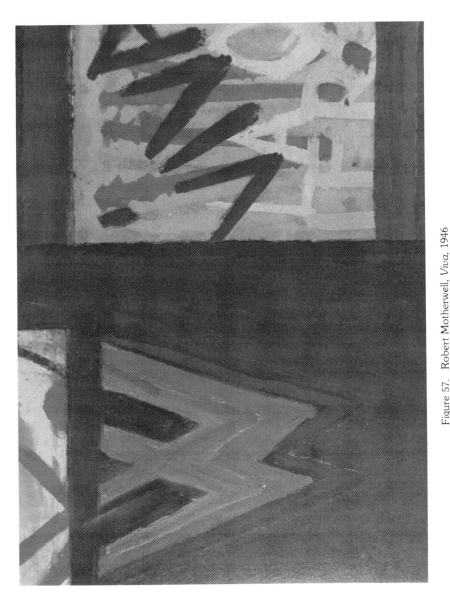

Figure 57. Robert Motherwell, *Viva*, 1946
Oil and collage on canvas, 13 × 16 3/4"
(Collection unknown)

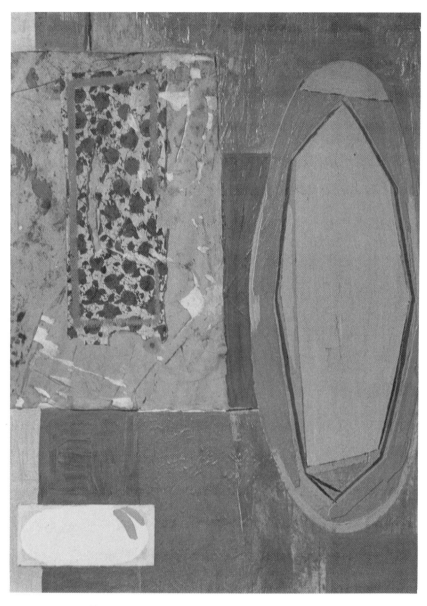

Figure 58. Robert Motherwell, *The Pink Mirror*, 1946
Oil and collage on paper, 39 × 29 1/2″
(Collection Mr. and Mrs. Donald L. Jonas)

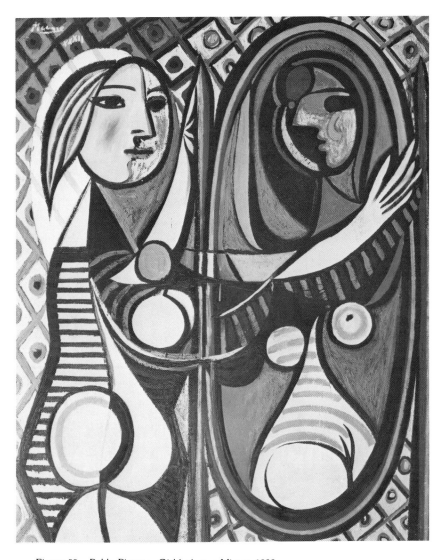

Figure 59. Pablo Picasso, *Girl before a Mirror,* 1932
Oil on canvas, 64 × 51 1/4″
*(Collection, The Museum of Modern Art, New York City. Gift of Mrs.
Simon Guggenheim)*

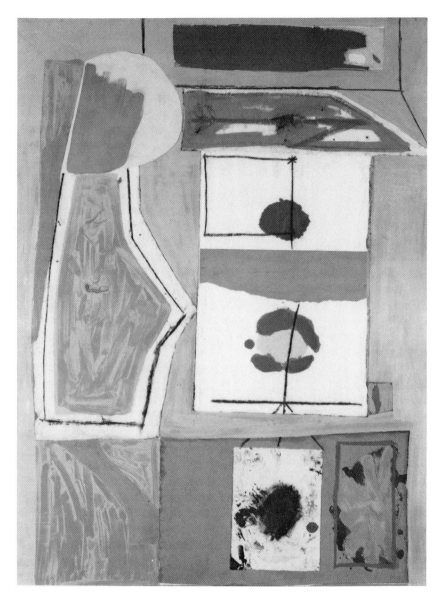

Figure 60. Robert Motherwell, *Blue with China Ink—Homage to John Cage*, 1946
Ink, oil and collage on paper, 40 × 31″
(Collection Richard Brown Baker. Courtesy Yale University Art Gallery, New Haven)

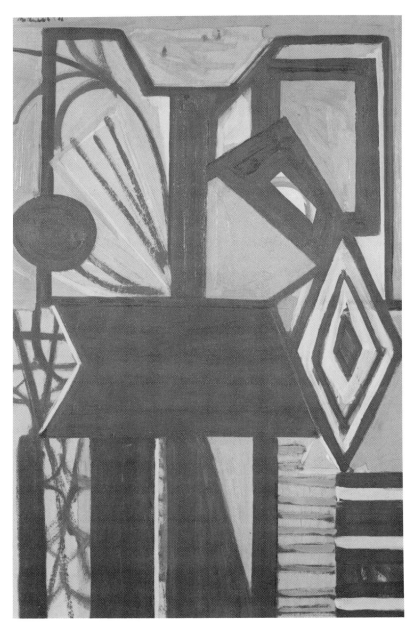

Figure 61. Robert Motherwell, *Blue Air*, 1946
Oil on composition board, 41 1/2 × 28 3/8″
*(Collection Hirshhorn Museum and Sculpture Garden, Smithsonian
Institution. Gift of Joseph H. Hirshhorn, 1966)*

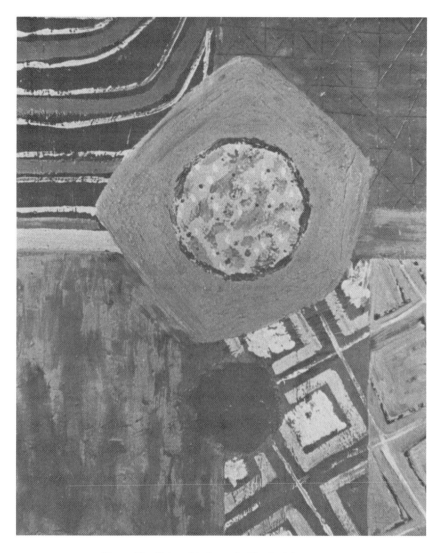

Figure 62. Robert Motherwell, *The Red Stripes*, 1946
Oil on canvas, 37 × 31″
(Collection Robert A. Rowan)

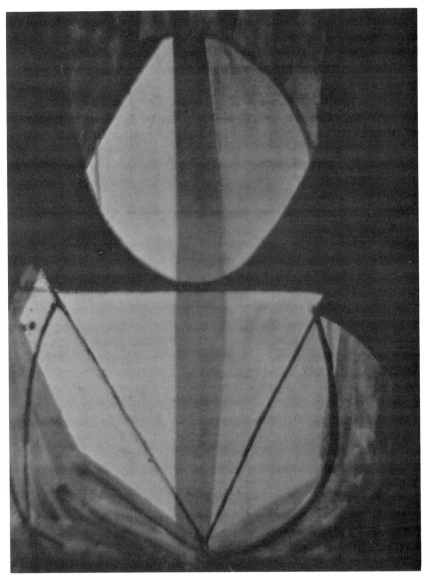

Figure 63. Robert Motherwell, *Figure in Red*, 1946
Oil on composition board, 23 7/8 × 18″
(Collection unknown)

6

Images of Power and Vulnerability: The Years 1947–49

Nineteen forty-seven through 1949 are commonly viewed as the years during which the Abstract Expressionist artists reached their mature individual styles.[1] During that period Pollock executed his first poured paintings, Rothko created his *Multiform* compositions, and de Kooning painted his black and white enamel works. Motherwell also made important discoveries which summarized his first decade as an artist and established the direction for much of his later career. Motherwell painted the powerful *Emperor of China* and *The Homely Protestant* in 1947 and 1948 respectively. Late in 1948 he discovered the motif for his "Elegies to the Spanish Republic," a revelation which would propel him into the 1950s, and in 1949 executed his monumental and summary work, *The Voyage*.

Although Motherwell remained in East Hampton until the fall of 1948, he had more stimulating contacts with the intellectual life in New York City. This situation contrasts with the isolation he felt in 1945 and 1946. First, Motherwell has emphasized that his relationship with the Kootz Gallery became stabilized and more harmonious.[2] He did not participate in the myriad of thematic shows Kootz continued to organize. He had a one-man show of his works from the previous year in 1947, 1948, and 1950. In the last of these shows he first identified his "Elegies" as a generic group. The only group exhibitions that Motherwell participated in during these years were the important show of New York School artists called the Intrasubjectives, Fourteen Americans curated by Dorothy Miller at The Museum of Modern Art, and Introduction to Six American Artists at the Galerie Maeght in Paris.

Motherwell found a stimulating new intellectual climate in his contact with the writers for the *Partisan Review* and then by his friendship with the poet and critic Harold Rosenberg. In Motherwell's own words, "I came to know and like the *Partisan Review* crowd."[3] It was a loose friendship which reinforced Motherwell's own individualism even more than his contact with the Surrealists in the early forties had. Motherwell established a relationship

with the philosopher William Barrett and the poet Delmore Schwartz, whom he recalls were both roughly his age.[4] Between 1946 and 1948, *Partisan Review* brought postwar Existential philosophy to this country. The ideas behind Existentialism had an important effect on Motherwell's art.

Existential articles began to appear in *Partisan Review* after Barrett and Schwartz joined the staff as associate editors in 1946. In the spring of 1946, the magazine published three articles on Sartre and Camus' "Myth of Sisyphus." For the winter issue Barrett wrote two articles on Existential thought and influence, "Writers and Madness," and "Dialogue on Anxiety."[5] Schwartz had a general interest in artists and alienation, while Barrett took a more historical and academic interest in Existential writings. In the winter of 1947, Barrett published *What Is Existentialism?*, which was later expanded into his well-known *Irrational Man*.

What were the premises of Existentialism which might have interested Motherwell and affected his art? The most basic idea in Existential thought is the importance of making individual choices and the need to take action. Through his choices, man creates his sense of his own existence. Existentialism encourages spontaneous thinking. Existential man avoids habitual or standard modes of thought, and lives in a state of expectancy always open to new ideas. In light of the importance placed on choice, action takes on a moral value for each individual. Finally, the Existential man is extremely fragile and often alienated. Yet at the same time he makes himself a hero by his very will to act.[6]

Motherwell's art between 1947 and 1949 was profoundly affected by the Existential spirit. He worked primarily in oil paint in which an expressive choice is required for each brushstroke, rather than collage in which one alters materials already intended for another use in the outside world. One can often trace his painterly decisions through pentimenti beneath multiple layers of paint. The overall construction of the paintings became simpler, and his style was increasingly dominated by a limited number of important decisions. His paintings began to feature large personages which dominated the entire surface. These personages, the offspring of his stick figures, became heroic and monumental presences, as tall as eight feet. Paradoxically, they were also more fragile in their construction than Motherwell's earlier diminutive stick figures.

Existential thought did not conflict with Motherwell's earlier art theory, but rather complemented and intensified its direction. Application of Existentialist emphasis on action differs from the devices of Surrealist automatism in that accident becomes less of a factor. While the Surrealists stressed chance procedures, Motherwell had used automatism to capture and objectify emotional states over which he had greater control. The Existential emphasis on the importance of willed choice confirmed a natural direction in Motherwell's thinking.

One might think that Existential thought would conflict with Empirical philosophy, which was among Motherwell's interests. On the contrary, Barrett found the two outlooks related, "because the Empiricists (pragmatists) put so much emphasis on individual experience."[7] In the *Irrational Man,* he wrote:

> Dewey is moving in the general direction of modern philosophy with his insistence that the modern philosopher must break with the whole classical tradition of thought.... The image of man as an earthbound and timebound creature predominates Dewey's writings as it does the Existentialists up to a point. Beyond that he moves in a direction that is the very opposite of Existentialism.... Dewey places the human being very securely within the biological and social context, but never gets past this context into that deeper center of the human person where fear and trembling start.[8]

Barrett also found Whitehead's emphasis on experience could be related to Existentialism, although he believed that Whitehead's concern with ideal states made him too much a "Platonist" to be "lumped" together with the Existential thinkers.[9] Further Barrett found Symbolism, especially in the writings of Baudelaire, a productive source of Existential thought. In his view, Baudelaire sought out the very essence of the human spirit and, like the Existentialists, finally admitted that "essence was obscure."[10]

During the later 1940s Motherwell's writings exhibit a strong Existential tone. After his initial contact with the *Partisan Review* group, he wrote, "Beyond the Aesthetic" for *Design* magazine. The article discusses one of the primary themes of Existentialism, the need to limit possible choices. For his art Motherwell interpreted this dilemma as the importance of going beyond simply the beautiful in art toward the limited choices which reveal feelings. He wrote:

> But this stage of the creative process, the strictly aesthetic—which is the sensuous aspect of the world ceases to be the chief view.... No wonder the artist is constantly placing and displacing, relating and rupturing relationships: his task is to find a complex of qualities whose feeling is just right—veering toward the unknown and chaos, yet ordered and related in order to be apprehended.[11]

In an even clearer Existential spirit, Motherwell wrote for his 1947 exhibition at the Kootz Gallery about the artistic act as a difficult confrontation with choices, and the painting as a graph of decisions, conscious and unconscious:

> I begin painting with a series of mistakes. The painting comes out of the correction of mistakes by feeling. I begin with shapes and colors which are not related internally nor to the external world; I work without images. Ultimate unifications come about through modulation of the surface by innumerable trials and errors. The final picture is the process arrested at the moment when what I was looking for flashes into view. My pictures have layers of mistakes buried in them—an X-ray would disclose crimes—layers of

consciousness, of willing. They are a succession of humiliations resulting from the realization that only in a state of quickened subjectivity—of freedom from conscious notions, and with what I always suppose to be secondary or accidental colors and shapes, which nevertheless I recognize when I come upon it, for which I am always searching.[12]

In addition to his association with the writers of the *Partisan Review,* Motherwell's other major contact with Existential ideas came through his friendship with Harold Rosenberg and their period of joint editorship of *Possibilities* magazine. The portion of the editorial statement written for the magazine by Motherwell emphasizes individualism, activity and openness to new experiences, all in the Existential spirit:

This is a magazine of artists and writers who "practice" in their work their own experience without seeking to transcend it in academic, group or political formulas. Such a practice implies the belief that through conversion of energy something valid may come out, whatever the situation one is forced to begin with. The question of what will emerge is left open. One functions in an attitude of expectancy. As Juan Gris said: you are lost the instant you know what the result will be.[13]

Motherwell met Rosenberg during the summer of 1946 in East Hampton. He and Rosenberg met frequently until 1948. At that time, Motherwell recalls that Rosenberg was interested primarily in poetry. As was common with many liberal New York intellectuals, Rosenberg became fascinated with Existentialism in the later 1940s. Motherwell remembers Rosenberg's major interests at the time they met:

Harold had a first-rate, eclectic mind, much more than a creative one; we often talked about Kierkegaard in whom Harold was then immersed. I think in many respects Kierkegaard and Karl Marx's analyses of the revolutions of 1848 and 1870 were the deepest influences on Harold at that time, which came out in an Existential attitude and an intense emphasis on individualism.[14]

The major lacuna in Rosenberg's knowledge when he and Motherwell met was twentieth-century visual art. Although Rosenberg had worked in the Arts Division of the WPA during the 1930s, his project had been an encyclopedia of folk art. There is no evidence for Rosenberg's connection with major twentieth-century painters before he met Motherwell. Motherwell remembers that he spent a good deal of time discussing the history of modern painting with Rosenberg "using poetry and in particular Rimbaud and Mallarmé as analogies."[15]

In 1947 Motherwell and Rosenberg embarked on a joint literary project, the founding of *Possibilities,* which was published in a single issue during the winter of 1947/48. The periodical was interdisciplinary and had four editors. Motherwell remembers:

> In those years I was editing slim volumes of writings by classical 20th century artists, published by an art book shop called Wittenborn. . . . The American art magazines were so hopelessly provincial that Wittenborn and his partner Shultz wanted me to edit an avant-garde journal. I felt badly then, as I still do, about the isolation of the various arts from each other in New York, and suggested that as well as art there be literature, music, and architecture in the journal, and appointed Harold as the literary editor, John Cage as music editor and a French emigré, Pierre Chareau as the architecture editor.[16]

As Robert Hobbs has pointed out in his excellent article about *Possibilities,* the periodical was characterized by the "lack of programatic intent," and "openness of inquiry."[17] The entire publication speaks of the strong sense of individualism fostered by Existentialism and taken up by the Abstract Expressionist painters. Each editor was independent and totally responsible for his own discipline. With remarkable foresight, Motherwell chose to illustrate works and printed statements by Pollock, Baziotes, Rothko, and David Smith. *Possibilities* contained the first publication of Pollock's drip paintings and Rothko's transitional *Multiforms.* The statements by the artists were nearly as revealing. They show the individualism of each artist, his freedom of experimentation, and total involvement with his own means of expression. Baziotes wrote about the automatist suggestions with which he began his canvases:

> I cannot evolve any concrete theory about painting. . . . There is no particular system which I follow when I begin painting. Each painting has its own way of evolving. One may start with a few color areas on the canvas; another with a myriad of lines; and perhaps a third with a profusion of colors.[18]

Pollock also wrote one of his most important statements about his art for *Possibilities.* After explaining his method of working on the floor, he expressed the total involvement between self and the creative process:

> When I am *in* a painting, I am not aware of what I am doing. It is only after a sort of "getting acquainted" period that I see what I have been about. I have no fear of making changes, destroying the image, etc., because the painting has a life of its own.[19]

The other selections Motherwell made for *Possibilities* were important both for the spirit of Abstract Expressionism and for his own artistic development. He chose an interview with Miró by Francis Lee. Miró's art was particularly important for Motherwell between 1947 and 1949. In the interview, Miró cited his interest in Symbolist literature, a theme dear to Motherwell. He also spoke of his affinities with primitive art, and we will see that around 1947 Motherwell also was influenced by cave painting. Miró rejected the hard edge abstraction of the Abstraction-Creation group, and concluded "the direction of painting ought to be to discover the sources of human feeling." The statement might

have been made by Motherwell himself. Finally, Miró stated his admiration for the energy and vitality of the younger American painters.

Motherwell also selected an article by Stanley William Hayter on automatism, and illustrated torn paper collages by Jean Arp. Motherwell had stopped using automatic procedures in his 1945 and 1946 paintings, but he would return to them in the later forties most importantly in his first "Elegy" compositions. Arp's collages would influence Motherwell's torn paper collages of 1948.

Although Motherwell's selection of art works and artists' writings was the most important contribution to *Possibilities,* Harold Rosenberg's literary choices also reveal the spirit of Abstract Expressionism.[20] Despite the fact that Rosenberg's background was still primarily literary rather than artistic, he must have made an impression on Motherwell. Motherwell had just gone through a derivative and inexpressive period in his paintings during 1945 and 1946. He was entering a much more powerful and original period. It is likely that Rosenberg's literary and philosophical emphasis on individualism increased Motherwell's confidence in developing an original, forceful style.

During 1947 Motherwell's paintings became more assertive, and assured, yet they also took on a melancholy and even tragic feeling which has been peculiar to much of his work since that time. What were the specific changes evident in these compositions? Oil paintings dominated the year 1947, and Motherwell applied the paint in a particularly heavy and expressive manner. We can see him using the palette knife to carve into the paint for the first time in his career. The distinctly personal style of this paint application differs from the synthetic texture of his 1945 paintings which utilized sand in the pigment. Even though the oil paint is expressively textured, it was applied so that layers of corrections and changes often can be seen beneath the surface. The observer is not simply presented with a finished product, but invited to join in the creative process.

Because of Motherwell's extensive use of oil paint in 1947, he began to separate the expressive power of that medium from collage. At this point in his career, he believed that collage involved construction, while oil paint was more open to expressive feelings. Motherwell wrote about oil paint in his 1947 Kootz exhibition catalogue:

> For me the medium of oil paint resists more strongly than others content cut off from external relations....I attribute my increasing devotion to oil lately, as against the constructionalism of collage, to a greater involvement in the human world.[21]

In this statement we find the germ of Motherwell's eventual separation of oil painting and collage into two modes of expression, one grave and somber, the

other intimate and personal. This new attitude reversed the raw emotional power his earliest collages contained.

In addition to Motherwell's increased emphasis on oil paint, his compositions became larger in scale. This tendency culminated in the 1940s in his heroically proportioned *The Homely Protestant* (96 × 48 inches) of 1947, and *Granada*, the first of his large "Elegies" (47 × 55 inches) of 1949. Motherwell's increased scale parallels that of other Abstract Expressionist painters. In an interview during the 1960s, he commented on the importance of the new large-scale paintings, "What was crucial (and how!) was the development of the large format. The large format at one blow destroyed the century-long tendency of the French to domesticize modern painting, to make it intimate. We replaced the nude girl and the french door with a modern Stonehenge, with a sense of the sublime and the tragic that had not existed since Goya and Turner."[22]

Motherwell's paintings from 1947 onward also exhibited a more intense and focused use of color. The pastel colors of 1945 through 1946 disappeared, and he concentrated on black, white, red, and ochre. None of these colors are superficially sensuous, and all are symbolically charged. Motherwell's use of black and white, which appeared most powerfully in his "Elegies," will be discussed in that context. Suffice to say here that they are probably the most symbolically charged "colors" in our culture. Their symbolism is full of the rich and varied associations upon which Motherwell's art thrives. While black has been associated on many occasions with evil and death, and white with light and purity, Motherwell demonstrated in a 1950 essay that he was fully aware that white could also connote barrenness or even evil as it does in *Moby Dick*. In contrast, black could represent the fertile gesture of the painter on the canvas "like making furrows in my picture."[23]

Red too is one of the most powerfully associative colors of which we know. In his 1946 article "Beyond the Aesthetic," Motherwell chose red when he wanted to illustrate this point: "The 'pure' color of which certain abstractionists speak does not exist, no matter how one shifts its physical contexts. Any red is rooted in blood, glass, wine, hunters' caps, and a thousand other concrete phenomena. Otherwise we would have no feeling toward red or its relations, and it would be useless as an artistic element."[24]

Like black and white, red has richly varying associations. In his 1946 statement, Motherwell deliberately mentioned a wide range from the grave "blood" to the trivial "hunters' cap." Although there are no trivial uses of red in his paintings of 1947, I believe we can find variations which range from expressing a rich interior life in *The Red Skirt* to blood in the *Emperor of China*.

Ochre is the dominant color of the 1947 compositions and plays an important role, second only to black and white, in Motherwell's paintings

after that date. The color is an unusual one to dominate an artist's work. Motherwell views it as a personal hue and relates it back to his childhood in Southern California. He thinks of ochre as a warm color which expresses the direct feeling and sensuality he often seeks in his paintings. Motherwell observed in a conversation with Bryan Robertson, "Yes, certain childhood impressions last a lifetime. What a burden! Sunlit, arid, high blue skies, green on ocean blue, sunbaked yellow ochre island . . . The color I've consistently used throughout my painting life has been yellow ochre, and the hills of California most of the year are yellow ochre. . . . But the color is used concretely, as in a mural, not as in nature."[25]

In his statement Motherwell failed to mention the different effects he obtained with ochre. These uses vary from earthy, tangible feelings obtained through thick pigment application to the atmospheric effects obtained through adding orange to the pigment and painting thinly, as in *The Poet* (1947). They also include the dark, cavelike character in *Emperor of China,* which was arrived at by adding brown and black to the ochre. Motherwell has probably used ochre with more intensity and variety than any other painter in the history of art. He has noted that Miró was the major artistic source for his discovery of that color. A short time ago, Motherwell said, "A writer recently said I am not a colorist. It is true that I do not use color in the classically balanced sense, like Léger. Rather I use one predominant color and then accents around it. I feel Miró, left on his own, would use earth colors reflecting his basic humanity. The public has led him to employ bright colors as he presently does."[26]

In addition to Motherwell's discovery of distinctive colors around 1947, he also began to paint with a simplified and unified ground, rather than the more complex relational structures which had dominated his earlier work. Collage had encouraged him to work out complicated rectangular relationships within the overall rectangle of the work. In 1947, his single hue, painterly grounds were more unified as an artistic statement. Yet, the manner in which he varied paint texture and slight color shifts within the overall hue is full of subtlety.

Coupled with the unified ground were large personages, which often filled the entire surface of the canvas. Their presence became more dominant, as they attained a monumental scale in such works as *The Homely Protestant.* They embody emotions which vary from the flimsy, delicacy of *The Poet* to the deliberately crude and barbarous character of the *Emperor of China.* Around 1947, Motherwell fully came to realize that all of his personages were self-portraits, expressing his feelings. Commenting upon a work called *Autoportrait,* now lost, he wrote:

But if my picture is not abstract, it is imaginative. Its feeling—content—happens to be just how I feel to myself (hence its name "Autoportrait") expressed as directly and clearly and relevantly as I can communicate the felt pattern of my senses. How I feel is not how I look; naturally then I have not represented my visage. This is the justification for the non-representational means employed in the work. Non-representation for its own sake is no more, though no less interesting than representation for itself. There simply happen to be certain problems of expression which representational means cannot solve.[27]

The final point which differentiates Motherwell's paintings of 1947 through 1949 from his earlier work is his use of artistic sources. Motherwell's pantheon of modern artists, Picasso, Miró, and Matisse, remained constant, but he changed his focus. Also these artistic sources were more fully absorbed and transformed into Motherwell's signature style.

Motherwell developed an interest in Picasso's "Seated Women" executed in the late 1930s. These works are among Picasso's most emotionally powerful. They are awkward, melancholy, and almost grotesque figures.[28] They differ extensively from such lean geometric works as Picasso's *The Studio,* which had previously been Motherwell's chief interest. Motherwell became more profoundly affected by Miró. Although he had admired Miró in a limited manner as early as 1941, he became more receptive to the full range of Miró's art by the end of the decade. Miró's ability to embody feelings such as ecstacy, fear, and loneliness through his biomorphic shapes, without literal representation, is close to the range of feelings Motherwell was increasingly developing in his art.

Motherwell's high regard for Matisse also continued, but shifted from the French artist's paintings to his resolutely two-dimensional paper cut outs. Around 1947 Motherwell also became fascinated with prehistoric cave painting. All of these influences, however, are less easily traced amid Motherwell's own powerful and personal expressions.

The Poet, formerly called *Person with Orange,* was executed in January of 1947 (fig. 64). It is one of Motherwell's few collages of that year, and paradoxically it illustrates his increased attention to oil paint. The thin pieces of paper are largely subsumed within layers of oil paint so that the edges of the paper are almost indistinguishable. The commanding scale of the work (55⅝ × 39½ inches) is also related to the size of Motherwell's oil paintings. The artist described it as "the largest collage I had made (until the 1970s), in orange and blue...."[29]

The ground of *The Poet* was painted in a glowing orange/ochre combination. The intense hue and thinly applied paint give the work an almost atmospheric character. One feels a fiery sunset offset by a few patches

of cool sky blue. The vaporous character of this ground is surprising in contrast to the more tangible, murallike surfaces usually found in Motherwell's work. The atmospherically thin paint may have been the result of a temporary influence of Mark Rothko upon Motherwell.

Rothko spent the summer of 1946 in East Hampton and the two artists had become acquainted. Generally, however, Motherwell was acutely aware of the differences between his means of expression and those of Rothko. Mentioning his own involvement with the concrete materiality of paint, he said by contrast that "Mark always loved music. His painting is very much like music in that it is not materialistic, but very ethereal. He never liked the sensual painter's life. Brushes were never lying about his studio, nor was there any sense of the paintings being made, rather just a mysterious and moving presentation."[30] It is not surprising that when Motherwell and Rothko agreed to exchange a painting in 1948 that Rothko chose *The Poet*.

Against the rather intense background of *The Poet*, Motherwell placed a large and schematic figure which barely emerges from that ground. The personage is important in that it is both more abstract than Motherwell's figurations of 1945 and 1946 and also more expressive. The lightly defined and upward rising ovals of the body and the starlike bursts of the head express joyousness or rapture. The shape of this personage, particularly the star configurations, is clearly a homage to some of Miró's joyous little stick figures, such as that in *Amour* (1927). Yet, Motherwell's personage also has a scale and deliberate lack of finish which distinguishes it from Miró's work.

For *The Poet*, we are fortunate to have the most complete contemporary description Motherwell made of any of his works during the 1940s. It is worth quoting extensively:

About *Person with Orange*

The orange background, felt all over, asked for an image. As though ice suddenly said, "Yes, I like my material, but I want a shape." The figuration arose spontaneously, surprising me, though I had used the shape previously.

Medium: flimsy papers painted with oils.

Process: what Yeats called, in describing a class of artists, "simplification through intensity."

Felt Content: ecstatic figure.

Intellectual references: to the traditions of painting.

Derivations from Cubist *papier collé*:

automatic not analytic drawing,

introduction of atmospheric light; chiaroscuro.

Light: reddened and joyous sky at the end of the day.

Colors: matt orange with blacks, and Mediterranean blues.

Types of Paper: butcher, wrapping, Japanese rice.

When Made: late afternoons and nights during a week of snow and ice.

Where Made: in a boarding house on the southeastern coast of Long Island.

Dimensions: about five by three.

Jan '47[31]

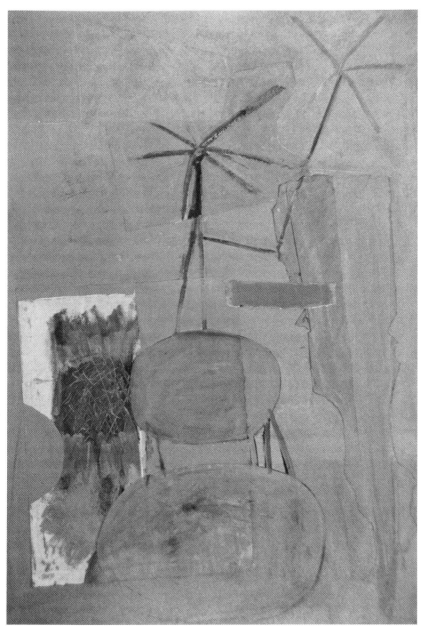

Figure 64. Robert Motherwell, *The Poet*, 1947
Oil and collage on paper, 55 3/8 × 39 1/8″
(Copyright © 1987 Kate Rothko Prizel and Christopher Rothko)

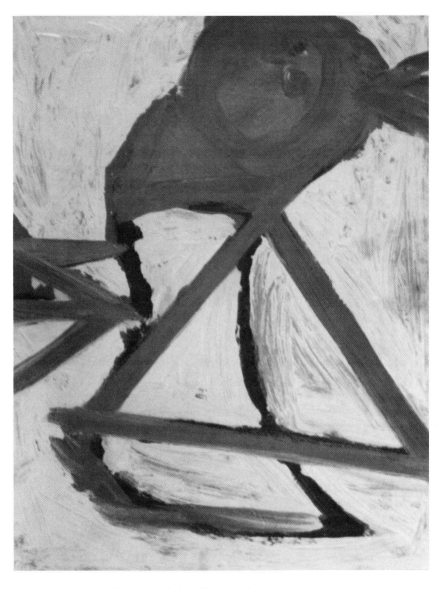

Figure 65. Robert Motherwell, *The Bird*, 1947
Oil on canvas, 25 1/2 × 17″
(Collection Robert Motherwell)

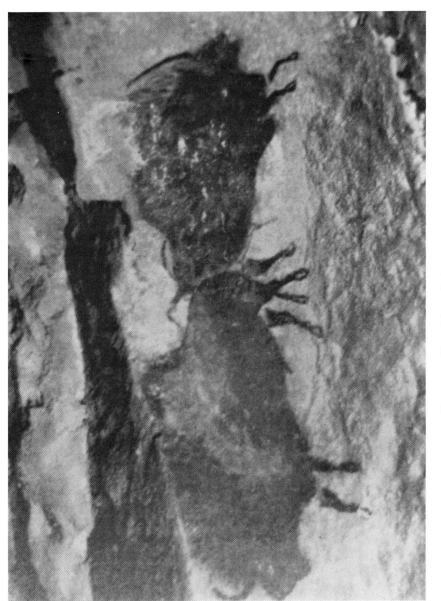

Figure 66. "Bison" from the Lascaux Caves

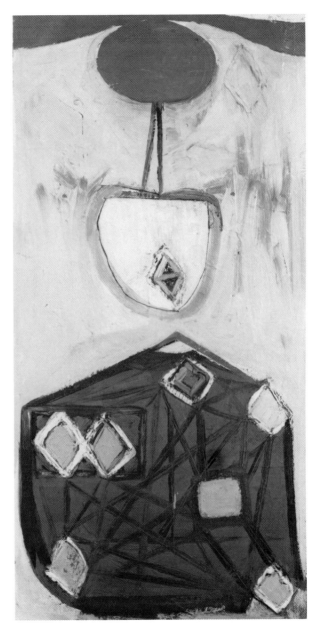

Figure 67. Robert Motherwell, *The Red Skirt*, 1947
Oil on canvas, 48 × 24″
*(Collection Whitney Museum of American Art,
New York City. Purchase)*

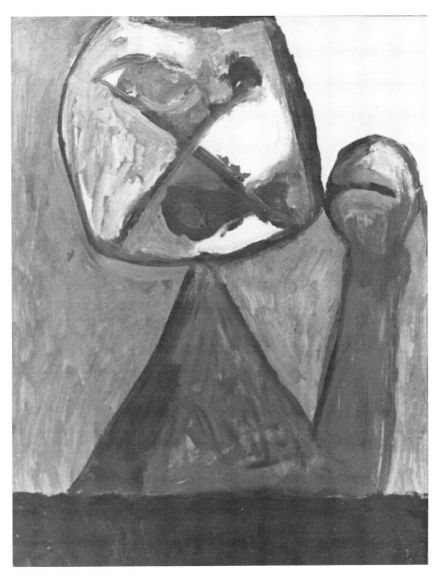

Figure 68. Robert Motherwell, *Ulysses*, 1947
Oil on board, 37 1/2 × 29 1/2"
(Collection The Montclair Art Museum)

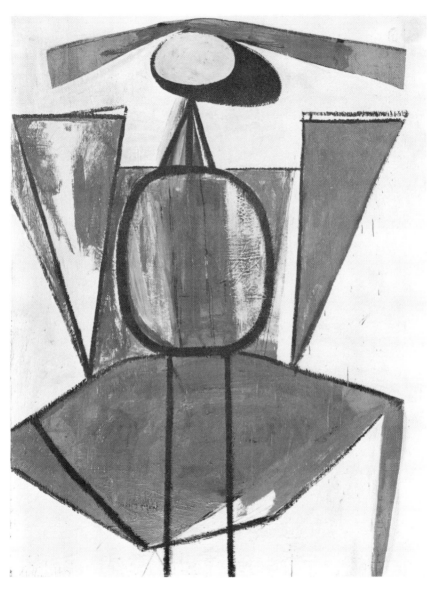

Figure 69. Robert Motherwell, *Personage with Yellow Ochre and White*, 1947
Oil on canvas, 72 × 54"
*(Collection, The Museum of Modern Art, New York City. Gift of Mr.
and Mrs. Samuel M. Kootz)*

In an overly categorized manner, the statement expresses Motherwell's thought process. It joins the surprising discovery of an image with the reassurance that the discovery is part of a continuous train of thought. It emphasizes feelings through forms and colors. In this case the joyous feelings of the ecstatic figure and bright, orange ground are expressed. The statement shows Motherwell's intense concern with his materials, and the relationship of his art to nature which has been transformed into the two-dimensional painterly process. The term "matt orange" reveals this transformation. Motherwell noted his fusion of various modernist idioms, automatism and *papier collé*. Finally, the statement ends with an expression of the concentrated intensity, "afternoons and nights," during which Motherwell executed his art.

One might think that *The Poet* would lead directly to the monumental *The Homely Protestant*. Yet we have seen that characteristically Motherwell will make a discovery and then turn in a slightly different direction, allowing the original idea to germinate over a period of time. In fact Motherwell followed *The Poet* with at least four related studies in oil paint. These are all rather mechanical little works in comparison to the expressive vitality of *The Poet*. He then executed a group of smaller abstract, "still life" compositions in oil paint during the early months of 1947.

The Bird, dated August 1947, is related to Motherwell's still life compositions in scale, forms, color, and rich paint application (fig. 65). The work consists of an open ochre triangle which forms the body. The simplified round head and beak are painted solidly in ochre, and Motherwell painted the bird's plumage in red and ochre brushstrokes to the upper right corner. On the left side of the painting, a schematic arrow invades it. The rough white ground of the work has been painted up to the edges of the ochre triangle. *The Bird* is also related to Motherwell's increased interest in primitive art.

Most of the other Abstract Expressionists had painted works that were personal interpretations of primitive mythology during the 1940s. Examples include Pollock's *She Wolf,* Rothko's *Omen of the Eagle,* Newman's *Pagan Void,* and Gottlieb's *The Eye of Oedipus.*[32] Motherwell has recalled, for instance, that Frazer's *Golden Bough* was almost required reading during the 1940s.[33] Motherwell avoided references to ancient myths in his work. Instead his firm belief in modernism led him to embody more contemporary legends, for instance, that of Pancho Villa and much more extensively the death of Republican Spain in his "Elegies."

Motherwell's involvement with primitive art arose not from mythological tales, but in a more concrete manner. Many of Motherwell's works during 1947 and afterwards are related to prehistoric cave paintings. In those cave paintings, primitive sensibility was translated into tangible form and painterly surfaces. The primitive taboos, fears, and the excitement of the hunt

presented so directly in cave paintings must have struck Motherwell as similar to his own methods of symbolizing emotions in semiabstract paintings.

Motherwell warned recently that his interest in cave painting cannot be attributed to any single source:

> I have been interested in cave painting as long as I can remember. Don't forget I am a book reader, and avidly read anthropology, sociology, psychoanalysis, philosophy as well as things related directly to art. So I may have seen cave paintings in any of a hundred different contexts.[34]

Nevertheless Motherwell still has in his library a February 24, 1947, issue of *Life* magazine which features extensive color reproductions of the Lascaux caves (fig. 66). These illustrations are remarkably similar to Motherwell's paintings as they developed from 1947 through 1949. The prehistoric painters at Lascaux worked in mineral pigments of white, red, brown, and black against ochre walls of the cave. The heavy texture of the cave walls, amplified by photographs, added expressive texture to the paintings. They resemble Motherwell's coarser paint handling. The animals, cows, bison, horses, and deer, shown in these cave paintings form powerful two-dimensional silhouettes contrasting with the lighter walls.

At the same time, these animals appear rather clumsy and fragile. They are often shown being hunted down amid a shower of arrows. Motherwell remembers that he felt "awed by their power and touched by their suffering."[35] Although birds are not depicted in the Lascaux paintings, *The Bird* resembles the colors and schematic drawing style of the cave paintings. The intrusion of the arrow to the left of the work may refer directly to the hunting scenes depicted in the cave paintings.

Motherwell believes that since the 1940s the rugged expressive quality of cave paintings has been naturally part of his artistic sensibility. He wrote recently to me, "Looking at your photostat of the cave paintings at Lascaux, I realized that I 'naturally' draw very much the same way. Since I have seen you, I have made 50 large oil drawings called "Drunk with Turpentine" series, and when you see them you'll see immediately what I mean."[36]

With his increasingly expressive use of oil paint and recent discoveries about cave painting in mind, Motherwell began a series of monumental personages in the latter half of 1947. They are the descendants of *The Poet*. Measuring five by two feet, *The Red Skirt* is the first of these large-scale compositions and was one of Motherwell's first paintings purchased by a museum (fig. 67). It was acquired by the Whitney Museum of American Art in 1948. Recently, Motherwell commented on the painting, "Although the overall image now seems somewhat naive to me, the ideas behind it do not. Parts of it are so

willful, the simple red oval of the head and the heavy ochre paint around it. Yet the skirt reveals the intricacy of art and thought in general."[37]

Indeed *The Red Skirt* was one of the most forceful, even brash, images that Motherwell had yet painted. The narrow vertical shape of the four-foot composition, confronts the viewer. The personage is cramped within the picture frame and seems to want to break out of it. This effect is especially evident in the oval head floating aloft like a balloon and the horizontal pressures of the weightier skirt. Motherwell had used shapes pressed against each other as early as *The Little Spanish Prison,* but until now he had not had those shapes press against the edges of the picture frame with such intensity.

As Motherwell mentioned, *The Red Skirt* is not just a simplified, assertive image. Rather the creative process, and even states of preconscious activity are suggested forthrightly in the painting. The maze pattern of the skirt is an age-old symbol of primitive consciousness and ritualistic communal forms. In Motherwell's work a series of ochre diamond shapes accent the pattern and create a dynamic interaction. They suggest a complex activity which was shown in only limited areas of Motherwell's previous works, for example, the irregular "windows" in *Recuerdo de Coyoacan* or behind vertical bars in *Spanish Prison.* In *The Red Skirt,* this reference to an automatic and preconscious expressive activity is presented more energetically, and thus becomes an increasingly visible part of Motherwell's artistic activity. It is suggested that this maze continues under the entire surface of the composition. Diamond shapes appear in the upper torso of the figure, and the pentimenti of diamonds are found under the ochre ground to the upper right section of the canvas.

The Red Skirt is the only one of these monumental personages whose title and elongated proportions indicate it is a female. In other related versions the titles and bulky shapes suggest the male torso, a sign of Motherwell's closer identification with the image. *The Red Skirt* is related to Picasso's rather grotesque seated females executed in the late 1930s, such as *Seated Woman* (1937). These works were frequently reproduced in *Cahiers d'art* issues that Motherwell still owns. Picasso's paintings express his feelings about Dora Maar's personality, which often varied between aloof arrogance and cruelty.[38] The angular body of the figure and the broad-brimmed hat particularly reveal Motherwell's initial reliance on Picasso's images. Motherwell, however, greatly simplified the image, eliminating the grotesque faces Picasso depicted. Motherwell's works are thus more about types of feelings in general than about a specific individual.

The next major work after *The Red Skirt* was one of Motherwell's most poignant—the *Emperor of China,* dated September 8, 1947 (fig. 70). The *Emperor of China* is among the most powerful images that Motherwell created during the 1940s, and at the same time expresses his personal sense

of vulnerability. Its creation was the end product of a complex variety of sources resolved into a disarmingly simple pictorial statement.

Like *The Red Skirt*, the *Emperor of China* germinated in Motherwell's mind with one of Picasso's seated women. This time the exact source is evident; it is Picasso's ink and crayon drawing *Woman in an Armchair* of 1938 (fig. 71). This drawing was owned by Motherwell's friend, the sculptress Mary Callery, and Motherwell had copied it in his own little ink drawing of 1944. The overall outline of the *Emperor of China* is similar to that of Picasso's little drawing. The floppy, awkward hat was emphasized by Motherwell even more than the one in *The Red Skirt*. The distorted breasts of Picasso's female, pulled one over another, suggest the "buttons" of the Emperor's robe.

The chair back and seat in Picasso's drawing are incorporated into the overall silhouette of Motherwell's Emperor, greatly increasing its scale relative to the picture surface. Motherwell's figure is thus pressed between the confining sides of the picture frame. The Emperor is the largest image Motherwell had yet created relative to the overall size of the picture surface, and the pressure between its swelling form and the surrounding ground is tremendous. The pictorial and emotional expression of this confinement later became a key motif for the "Elegies to the Spanish Republic," where soft ovals are pressed between stiff vertical bars.

At the center of the *Emperor of China* is a red arrow with a triangular base. Such an arrow had already appeared in *The Bird.* Here it is both more central and more threatening. Painted blood red, it is pointed at the narrow and fragile neck of the Emperor. This arrow with a triangular base is also found in Picasso's drawing, only there it is a knife aggressively pointed outward, not threatening the central figure itself. In this context, one wonders if the red circle to the lower right of the Emperor might be read as a wound.

As mentioned earlier, many of Motherwell's works during the 1940s were concerned obliquely with wounding, including *Surprise and Inspiration,* which was originally called *Wounded Personage,* and *Pancho Villa, Dead and Alive.* Motherwell has stated recently, "Wounding in my work is a symbol of psychic tensions."[39] He also mentioned that when he told a psychiatrist about his tendency to show wounded personages in his work, the psychiatrist commented, "It is better to wound yourself than others." While Motherwell has stated that he is not consciously aware of using a dagger schema in the *Emperor of China,* it may be that this association accounts for the "slight feeling of horror" he has when studying the form.[40]

Unlike *The Red Skirt*, the *Emperor of China* does not indicate that the figure is a female, rather its bulk and title strongly suggest that it is male. This fact reinforces Motherwell's personal association with the image. The Emperor is far more abstract than Picasso's figure and even more abstract than *The Red Skirt.* It is reduced to the ochre silhouette contrasted with the

white ground. This simplification makes the form more powerfully massive, yet paradoxically it is also rather awkward. The small head, elongated neck and huge hat brim give this feeling of precariousness.

The *Emperor of China* is further related in both title and sensibility to Paul Goodman's poem "The Emperor of China" which, as mentioned earlier, was published in *Possibilities*. Motherwell commented recently, "I found Goodman's piece deeply moving."[41] Using an emperor as a symbol, the story is about man's attempt to use intellectual constructions and rationalization to hide his instinctive feelings. Both the narrative and style of the story, which features truncated sentences, hypnotic repetitions and grammatic inventions, advocates spontaneity and direct expression. The story acknowledges symbolically that releasing one's feelings might reveal both strengths of character and accompanying weaknesses.[42] In a similar manner, Motherwell's painting also reveals direct feelings through the rapidly formed image and assertive paint handling. He created a work that reveals strengths through the two-dimensional synoptic form. It also reveals weaknesses in the awkward outline of the form and deliberately crude, irregular paint handling. Motherwell wrote in 1947:

> The absolute which lies in the background of all my activites of relating seems to retreat as I get on its track;...the closer one gets to the absolute, the more mercilessly all my weaknesses are revealed.[43]

Goodman's poem may have led Motherwell to associate the *Emperor of China* with imperial Chinese portraiture. Motherwell has acknowledged his familiarity with this type of work and stated his general interest in oriental art beginning with his youth in San Francisco.[44] Motherwell's memory of the imperial portrait image may also have been revived by seeing exhibitions of Chinese portraiture at the Metropolitan Museum of Art in New York. The portrait *Emperor Jen Tsung of the Sung Dynasty* is typical of such ancestral portraits, often simply titled "The Emperor of China" (fig. 72). Some imperial portraits were constantly on display at the museum during the 1940s and two large shows of the Imperial Portraits of 1942 and Costumes of the Forbidden City of 1945 were held there.[45]

The flattened outlines of these portraits are similar to that of Motherwell's Emperor. The robes were often plain and yellow-ochre, as seen in the *Emperor of China,* which was the most common color. Typically the Emperor's head is very small in relation to the massive body. The huge size of the hat brim, which must have had for Motherwell a surprising congruence with the hat of Picasso's female, is an indication of the authority of the sitter.

Why would these imperial portraits act as a catalyst for Motherwell's *Emperor of China?* We have seen that Motherwell was extremely

knowledgeable about the history of art, and often was inspired by a wide variety of art forms from Mexican folk art to modern masters. The shallow space and flattened form of the imperial portraits also would naturally appeal to Motherwell's eye conditioned by modernist abstraction. The artist would be delighted that such "abstract" shapes could be found in a non-Western culture. Most importantly, to the Western eye, these imperial portraits display an interesting combination of grandeur and vulnerability. While the body shape is commanding by its bulk, it lacks the muscular articulation associated in the West with pictorial power. The seated figure with clasped hands closes in upon himself in a seemingly protective gesture. This lack of dramatic gesture is accompanied by an expressionless face. In contrast to the huge body area, the small head and hat brim look particularly awkward. Thus the imperial portrait type is one that appears at once monumental and strangely defenseless. As Lucy Lippard has quite accurately noted, "Motherwell is not a 'tasteful' artist, and perhaps it is this moral sense that has kept him from exploiting elegance and has impelled him towards a 'purity' that often manifests itself in a painfully honest awkwardness touched by grandeur. There is a disturbing factor in much of his art that one can only suppose is an intentional lack of taste."[46]

The paint handling of the *Emperor of China* is as deliberately expressive as its shape. The ground is the most thickly painted of Motherwell's career. Layer after layer of white paint with irregular hints of ochre were layered on with a palette knife. A diamond pattern resembling that of *The Red Skirt* was then cut into the paint with the edge of the palette knife. The Emperor was painted in ochre over a black and white ground. The short aggressive brushstrokes move in every direction and irregular patches of underpaint appear throughout the figure. The painting technique was immediate, powerful, and willfully clumsy; nothing was held back or given a tasteful finish. Both Motherwell's strengths and weaknesses are painfully revealed in the work.

Two other sources ought to be discusssed for the *Emperor of China*. As mentioned earlier one of the underlying influences on Motherwell's art from the late forties onward was cave painting. The simplistic silhouette against a plain ground, the coarse texture as if painted on rock, and the earthen colors all relate the *Emperor of China* to prehistoric painting. As also noted earlier, the Lascaux caves often represented animals being hunted. The powerful creatures were shown amid a shower of arrows. Here we might relate these strong animals under attack to the combination of power and vulnerability in the *Emperor of China*. One way that vulnerability is indicated in that painting is the schematic dagger or arrow pointed at the Emperor's throat.

An influence upon the *Emperor of China,* which does not much affect Motherwell's other contemporary paintings as directly, was Jean Dubuffet's

primitivistic style. Dubuffet had his first American exhibitions at the Pierre Matisse Gallery in 1947 and 1948. Motherwell has commented that at that time he "admired though did not like Dubuffet's paintings."[47] Yet Dubuffet's crude, unlikable art seems particularly close to the brutality and naiveté of the *Emperor of China*. Dubuffet's *Portrait of Gustave Doré* (1945), exhibited at the Pierre Matisse Gallery in January of 1947, resembles the Emperor in its simple, frontal presentation, its raised shoulders, elongated neck and round head with large hat (fig. 73). The most important similarity is the heavy impasto. The pigment is so thick that it can be cut and shaped with the palette knife, a procedure close to that used by Motherwell.

Motherwell, however, rejected the comic and childlike implications of Dubuffet's art. Accordingly his Emperor is without facial features and thus is more sophisticatedly abstract. His paint texture is also somewhat less coarse; and the figure, though awkward, avoids humorous caricature. In Motherwell's art, the search for refreshing naiveté is always tempered by a high degree of sophistication. Thus in 1962, he wrote about naive and primitive art, citing Dubuffet as a source, and continued:

> More simply children love to paint "BOOM BANG." They love to paint directly. . . . But one must remember that when a grown-up is being "childlike" or "primitive" there is nevertheless a much wider background of felt thought and experiences of life and death, so the directness has weight and subtlety a child has not.[48]

Because of his reservations about the simplistic and comical character of Dubuffet's work, Motherwell showed only the temporary interest indicated by the *Emperor of China*. In that painting, nevertheless, Motherwell significantly increased his use of thick and roughly expressive paint handling which would affect his work during the 1950s and particularly the expressionistic "Elegies" executed during the 1960s.

The *Emperor of China* and *The Homely Protestant*, painted during January and February of 1948, may be thought of as pendants (fig. 75). Motherwell hung them side by side in his 1948 exhibition at the Kootz Gallery. They suggested complementary aspects of the artist's personality with great subtlety and sensitivity. Although awkward, the *Emperor of China* is an aggressive and even crude work. Its figure contrasts sharply with the ground and its form is barely compressed by the picture edges. *The Homely Protestant* is fragile and elusive. It suggests Motherwell's lonely search for self-definition, and the ease with which those fleeting images of self can slip away. In fact, Motherwell has described the work as an evocation of solitary existence. When asked who the Homely Protestant is, he responded that it is a self-portrait "concerned with the essential loneliness I feel from time to time."[49]

The Homely Protestant was painted in an earthy ochre color similar to that of the *Emperor of China*. Ochre generally contributes to the rejection of easy sensuality in the two works. Yet the differences in the two effects are great. In place of the thick pigment and contrast of ochre and white in the *Emperor of China*, *The Homely Protestant* is thin and ephemeral. The color is nearly translucent and subtly shifts its tonalities. Also the ochre paint covers the entire surface of the work. Thus Motherwell has identified this work as his first "field" painting.[50] The effect is one of openness and fluidity. One of the few nonochre elements in the painting is a rectangular white patch to the lower right side. Motherwell has suggested that this patch resembles the "windows" in his earlier paintings. Only here the window does not show hidden activity beneath the uppermost paint surface, it shows only the white primed canvas with which Motherwell began. The entire thought process is open and visible on the surface, and the artist has revealed his innermost feelings there. They need not be hinted at in an isolated window.

Painted within the surface of *The Homely Protestant*, the shadowy head, shoulders and hat of the *Emperor of China* appear. The relationship between the two works is thus highlighted. The more assertive, even vulgar, Emperor has been submerged amid the nearly empty surface of the later painting. The Protestant, which replaced him, is a fragile figure indeed. It is the heir to Motherwell's stick figures, but made much more elusive and tentative despite its commanding scale. The red and black drawing is extremely thin, as if the artist could barely execute it. The outline is frequently lost amid glazes of paint or rubbed out. Balanced above an incomplete oval are thin vertical lines which barely support a triangle. Arching lines extending outward, like delicate shoulders, are tenuously poised on the tip of the triangle. Only two buttons, derived from the Emperor's robe, define the center of the figure. But here the buttons appear like a pair of eyes peering out of the mist. The feeling of expressive isolation is present throughout the painting.

The title *The Homely Protestant* reinforces the loneliness and difficulty in defining oneself, which the imagery explores. The title comes from *Finnegans Wake*, James Joyce's masterpiece about the fringes of consciousness. The book "narrates" the mind of an isolated individual exploring itself. Motherwell has written:

> I could not find a title for possibly my single most important "figure" painting. Then I remembered the Surrealist custom, viz, to take a favorite book and place ones' finger at random in it. In either *Ulysses* or *Finnegans Wake* (I forget which), my finger rested on the words "the homely protestant," and I thought, of course, it is a self-portrait.[51]

Motherwell's "accidental" choice of a title was either extremely fortunate, or he may have given chance a little help, as the Surrealists were known to do. In any case, the phrase "homely Protestant" characterizes the isolation

Motherwell has often described. The artists and writers who were his friends in New York City were predominantly Jewish or Catholic. He was an outsider, born a Protestant, reared on the West Coast, and coming from a university rather than studio background. At other times in his career, particularly around 1945, Motherwell had hidden this sense of loneliness. In *The Homely Protestant* he used these feelings as a creative strategy.

In *The Homely Protestant,* there are echoes of Picasso's stick figures and the painterly, often earthen colored grounds that Miró created during the 1920s. But these echoes are faint. Motherwell's own mode of expression has developed quite independently. As with the *Emperor of China,* cave painting remained a reference. *The Homely Protestant* looks less directly like a cave painting, rather it embodies some of our feelings about prehistoric painting. The barely discernible drawing speaks of man's age-old need to record his own existence, and thus make that existence more tangible.

The Homely Protestant is particularly close to Existential ideas. According to Existentialism, the hero is an isolated and fragile figure. For the Existential man, making even the slightest, most frail, record of his existence is an act of supreme courage.

The *Emperor of China* and *The Homely Protestant* define two aspects of Motherwell's personality. The *Emperor of China*'s strong contrast between figure and ground and the compression of its organic shape within the rigid edges of the frame lead to Motherwell's assertive, but also tragic, "Elegies to the Spanish Republic." The spare markings on a nearly uniform ground of *The Homely Protestant* can be traced back to works such as *Spanish Picture with Window* and forward to Motherwell's "Open" compositions begun in 1967. Although also dealing with emptiness, the "Opens" are quite different in meaning. The "Opens" exude meditational confidence. Motherwell was by then absolutely sure of his colors, the canvas surface, and the U-shaped mark after he discovered it. He had been reading Zen philosophy at the time, and its expansiveness and emphasis on restraint affected him.[52] The loneliness and near despair of *The Homely Protestant* had been transformed through his self-assurance at that later date.

The progression from the *Emperor of China* to *The Homely Protestant* was made via two works. One is the *Homely Protestant Bust.* In this relatively small work, the basic shape of the Emperor is retained, but nearly lost amid heavy paint layers. In a work Motherwell now calls *Figure in Interior,* the vertical design of the Protestant, as well as its fragile scaffolding, were created, but the contrasts between form and ground of the Emperor were retained.

Between May 10 and 29 in 1948 Motherwell exhibited his recent work at the Kootz Gallery. The exhibition must have been the most striking and coherent Motherwell had yet assembled. It was dominated by his oil

paintings; only three of the twenty works shown were collages. All of the works which can be identified were from 1947 or early 1948, except *The Sailor* and *Figure in Red* of 1946 which, as mentioned earlier, were predecessors to the 1947 works. The *Emperor of China* and *The Homely Protestant,* which Motherwell recalls were hung across from the entrance, dominated the show. The overall effect of the powerful designs, vigorous paint handling, and ochre color was certainly commanding.

Once again, the most thoughtful review of the show was written by Clement Greenberg. Following Greenberg's criticism of Motherwell's 1945 and 1946 works, his praise of this exhibition represented a dramatic change. Although Greenberg overemphasized the paintings' Cubist underpinnings, a prejudice evident in much of his criticism, he took note of the bold, expressive monumentality of Motherwell's oils and appreciated their novel inventions. He wrote:

> Robert Motherwell's current show at Kootz (through May 29) is another step forward on his part . . . and makes his inclusion among our more important contemporary painters obligatory. Large and middle sized canvases built on figure motifs and showing flat, uninterrupted expanses of ochreous color realize a monumentality such as is rare in art of the moment. The painting is founded on roughly geometrical simplifications and the organization of large elementary shapes with heavy surfaces. It is late cubist in its repertory of forms. At the same time, it exhibits personal "handwriting" and can by no means be classified as "intellectual" or altogether studied—though studiedness is a vice from which Motherwell is not entirely free. [53]

In addition to Greenberg's review, the first extensive article on Motherwell's art was published shortly before the 1948 Kootz exhibition. This was a significant event for the artist, who like other Abstract Expressionists, was still struggling for public acceptance. Weldon Kees, a young poet and friend, wrote the article, which appeared with five illustrations in the *Magazine of Art*.[54] Kees spent the first part of the article making the rather sterile argument that abstract art is only a matter of formal relationships. In contrast we have seen that Motherwell believed that abstract art revealed feelings. Kees wrote, "Motherwell assumes the full consequences of the farthest tendency of abstract art. His circular forms are not oranges or abstractions of oranges, heads or abstractions of heads, his rectangles, blots, blurs and brushstrokes assert nothing but their own existence." Yet, Kees ended the article with a much more sophisticated understanding of the dynamic interaction of ideas and feelings from which Motherwell's art sprang:

> It is division, that schism of mind that comprises so much of our modernity, a rupture from whose conflicts we may make art or by which we may be destroyed. In Motherwell these conflicts define themselves as a declared, full-fledged and recognized war. On one side are ranged reckless savagery, chance taking, the accidental, "quickened subjectivity,"

painting in the words of Miró "as we make love; a total embrace, prudence thrown to the wind, nothing held back;" on the other refinement, discrimination, calculation, taste . . . "layers of consciousness, of willing." It is out of the continual encounters and contests of these opposites that his paintings, marked everywhere on their surfaces with the signs of battle, emerge.

More than thirty years later, Motherwell remembered phrases from this last paragraph by Kees, and cited it as one of the most revealing statements about his art.

Motherwell moved back to New York City in the fall of 1948. His confidence in his art by that date, as well as the self-assurance of the other Abstract Expressionists, was epitomized by the founding of the Subjects of the Artist school. It was a painting school conceived by David Hare, Baziotes, Rothko, Still and Motherwell, who felt they could convey a new and distinctive approach to contemporary creation based on their novel discoveries. Before the school began, Still returned to the West Coast and Barnett Newman joined the other founders. The school was started during the fall of 1948 in an abandoned loft at 35 East Eighth Street. Except for Hans Hofmann's well-established painting school, it was the only modernist program in New York at the time. The project was ambitious, and Motherwell jotted down some notes in 1950 which described the school's technical difficulties.[55] The inexpensive loft was filled with tons of debris. When that was cleared away, the artists spent weeks whitewashing the walls and collecting materials. They were so ill-financed that only a five hundred dollar donation by Bernard Reis allowed them to buy stoves for heat.

Technical difficulties aside, the teaching philosophy of the school was notable for its freedom. Each of the artists had become so confident in his own mode of expression that he felt he could encourage the students to search for their own means of communication without a dogmatic curriculum. The association with a variety of working artists was seen as the basis of intellectual, emotional, and technical development. Motherwell wrote a one-page catalogue for the school in conjunction with the other artists:

> THEORY OF THE SCHOOL: The artists who have formed the school believe that receiving instruction in regularly scheduled courses from a single teacher is not necessarily the best spirit to advance creative work. Those who are in a learning stage benefit most by associating with working artists and developing with them variations on the artistic process (through actually drawing, painting and sculpting). . . . But it is the school's belief that more is to be gained by exposure to the different subjects of all four artists—to what modern artists paint about, as well as how they paint. It will be possible to work with a single artist only in the evening sessions, since the afternoon sessions are the responsibility of the faculty as a whole.[56]

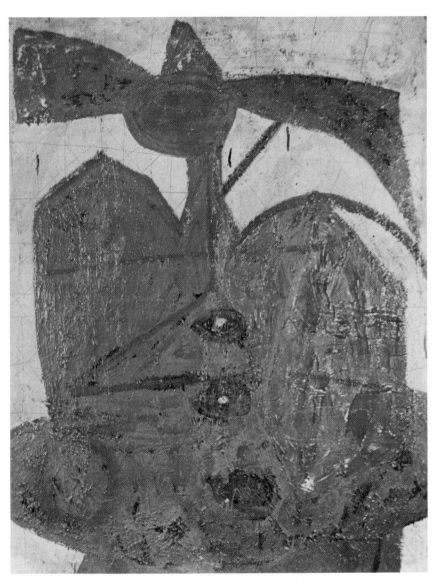

Figure 70. Robert Motherwell, *Emperor of China,* 1947
Oil on canvas, 48 × 36″
(Collection Mr. and Mrs. Maxwell Jospey)

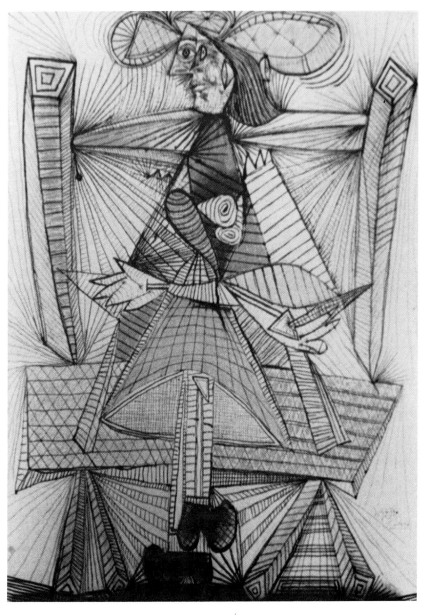

Figure 71. Pablo Picasso, *Woman in an Armchair*, 1938
Ink, crayon and wash on paper, 30 1/8 × 21 3/4″
(Collection unknown)

Figure 72. Unknown, *Emperor Jen Tsung of Sung Dynasty*
Ink and color on silk, 74 1/2 × 53 3/4″
(Collection unknown)

Figure 73. Jean Dubuffet, *Portrait of Doré*, 1945
Oil on canvas, 21 3/4 × 18″
(Collection unknown)

Figure 74. Robert Motherwell, *In Grey with Parasol*, 1947
Oil and collage on canvas, 47 1/2 × 36 1/2″
*(Collection Art Gallery of Ontario, Toronto; Gift of the Women's
Committee Fund)*

Figure 75. Robert Motherwell, *The Homely Protestant*, 1948
Oil on canvas, 96 × 48″
*(The Metropolitan Museum of Art. Gift of
Robert Motherwell, 1987)*

Figure 76. Robert Motherwell, *In Grey and Tan,* 1948
Oil and collage on composition board, 47 × 39″
(Krannert Art Museum, University of Illinois, Champaign)

Figure 77.　Robert Motherwell, *The Elegy,* 1948
　　　　　　Gouache and paper on composition board, 29 1/2 × 24″
　　　　　　(Courtesy of the Harvard University Art Museums [Fogg Art Museum].
　　　　　　Purchase, Louise E. Bettens Fund)

Figure 78. Jean Arp, *Drawing and Torn Colored Papers*, 1946
Ink and collage on paper, 13 3/4 × 9 7/8″
(Collection unknown)

In straightforward language, this little statement expressed a modernist approach. It broke with the artistic tradition of master and pupil, which had developed out of the medieval craft approach to the arts. The freedom and experimental philosophy of Abstract Expressionism was epitomized in it. Appropriately, there were no "technical requirements" for admission, and the school was open to "anyone who wishes to reach beyond the conventional modes of expression." Of course, Motherwell himself had begun to paint, without a studio background, through association with advanced artists.

Motherwell has noted that the name of the school was meant to convey the importance of meaning in abstract art forms, "At this time we hit on our rather awkward name for the school, 'Subjects of the Artist,' which was meant to emphasize that 'abstract' modes of art have subjects, and that the 'curriculum' was to consist of those subjects that interest advanced artists now."[57] Once again his statement underlines the importance of meaning and content for all of the Abstract Expressionist artists. Students have confirmed that the individual development stressed in the catalogue, was followed in practice. Florence Weinstein, a New York painter, recollected her experiences:

> The painters (Rothko, Motherwell, Baziotes, later Newman) walked around us as we worked and made remarks to individuals, often contradictory. The idea was that you didn't get influenced by one artist. Afterwards all the work was displayed and there was a general free for all criticism. Baziotes was the teacher alone on another night; . . . I remember him saying to me, "Yours will always be the irrational way." And I have stuck to that.[58]

This mode of teaching differed from the Surrealist group that Motherwell and Baziotes participated in with Matta during 1941. The distinction tells us of the differences between the more hieratic and doctrinaire Surrealists and the more radical individualism of the Abstract Expressionists. As mentioned earlier, the Surrealist automatist group failed because Matta attempted to lead it by proposing both themes and styles of painting. This more traditional method was eschewed by the Abstract Expressionists.

The second term of Subjects of the Artist began in January of 1949. In addition to the freely organized classes, the school also sponsored Friday evening lectures organized by Motherwell and Newman. The lectures with discussions afterwards featured some of the most advanced cultural figures of the day. They included Joseph Cornell on his films, John Cage on Indian sand painting, Charles Huelsenbeck on Dada, and de Kooning on a "desperate view" of art. The lectures covered the wide range of cultural interests Motherwell and the other Abstract Expressionists had developed. Variety rather than a single viewpoint was espoused.

After a short life, Subjects of the Artist was closed in May of 1949. The closing was not due to disinterest among the painters, nor a lack of students. Rather Motherwell remembers that the financial arrangement was haphazard, and that the teaching responsibilities took too much time away from painting. He, for one, greatly regretted the end of that brief teaching experiment. After the demise of Subjects of the Artist, Tony Smith had the idea to keep the Friday night lectures going, and these lectures and round-table discussions became known as Studio 35. The Studio 35 lectures overlapped during 1950 with the more famous artists' forum of ideas and meeting place, The Club, which was an entirely separate organization founded by Philip Pavia that year.

Because Motherwell was involved with Subjects of the Artist and his own move back to New York, he did not do a large number of works during 1948. The works that he did execute, however, were important for his later career. During the earlier months of 1948, Motherwell completed a number of collages. These included *The Best Toys Are Made of Paper, In Grey and Tan, The Joy of Living II,* and *The Elegy.* Motherwell's renewed interest in collage is surprising in light of his devotion to oil paintings during 1947. Yet these collages provide a different type of expression than the oil paintings, focusing on more intimate and even joyful feelings. None contain the figurative associations of the *Emperor of China* and *The Homely Protestant.* Thus, they perhaps escape the tough self-analysis found in those paintings. *In Grey and Tan* contains mottled blue paper which has been torn into three triangles (fig. 76). These three shapes float in front of the triangular form painted in pastel blue and white stripes upon the paper support. Reviewing this collage, Motherwell commented that understanding the distinction between the painted and pasted triangles requires "a delicate and refined artistic sensibility."[59]

He also noted that the tearing of the paper seemed to reflect the "joy of creativity" rather than the violence found in his earlier collages like *Suprise and Inspiration* (1943).[60] The pastel colors, ascendant character of the triangular shapes, and the graceful manner in which the pieces of paper just touch or are slightly separated also contribute to the lighthearted expression of this work. *The Joy of Living II* is similar in color and design. It contains none of the dark violence or irony found in the 1943 work of the same title.

In *The Best Toys Are Made of Paper,* a wide variety of papers are playfully used, including construction paper, mottled wrapping paper, and rice paper. All are painted with bright colors and pasted on at a lively, even jaunty, angle. *The Elegy* is the first work to which Motherwell gave that somber title (fig. 77). Yet one need only compare it to Motherwell's later painted "Elegies" to see the difference in expression. The collage contains five

organic oval shapes. None are tightly compressed between vertical bars, and a wide, playful variety of textures is used. The colors vary from tan to brown, soft sky blue and pink. The massive, tragic character of the later "Elegy" paintings is not present.

Motherwell's collages of 1948 were partly inspired by Jean Arp's torn paper collages, such as *Drawing and Torn and Colored Papers* of 1946 (fig. 78). Motherwell selected this work for inclusion in *Possibilities* magazine. During 1947 and 1948 Motherwell was also editing the Documents of Modern Art publication of Arp's *On My Way*, which contains illustrations of this torn paper collage and others. In these collages Arp used large, simple, organically shaped pieces of paper often painted in bright colors. They have a creative liveliness similar to Motherwell's works especially *In Grey and Tan*. In his preface for *On My Way*, Motherwell commented specifically on the spontaneity and intimacy of Arp's work.[61]

In fact, Motherwell's 1948 collages hint at the distinction he would later clarify in his works between the monumental character of his paintings and the private, intimate nature of his collages. The 1948 collages are less emotional and brutal than his 1943 works in that medium, such as *The Joy of Living* (1943) and *Pancho Villa, Dead and Alive* (1943). Symptomatic of this rethinking of collage is the fact that after 1948 Motherwell practically gave up the medium, concentrating on his oil paintings especially the "Elegies," until 1952. At that time, he began a series of collages he called his "Easels," which he frankly admitted were intimate works limited to his feelings about the privacy of his studio environment.[62]

The second group of works Motherwell executed during 1948 is centered around a commission given to him by Architects' Collaborative. It was for a mural to be placed in a high school Walter Gropius and his firm built in Attelboro, Massachusetts. Although the mural was never completed, Motherwell remembers some twelve studies, of which I have found only one. Although the studies can not be ranked with Motherwell's finer works during the 1940s, they turned his attention toward wall-size painting. His thinking about public, monumental scale painting influenced *The Voyage* and the development of his "Elegies."

Like several of Motherwell's other most important paintings during the 1940s, the appearance of the "Elegy" motif was an unexpected discovery. Among his projects for the second issue of *Possibilities*, which never appeared, Motherwell decided to illustrate a poem by Harold Rosenberg entitled "The Bird for Every Bird." For this illustration, he created *Ink Sketch (Elegy No. 1)*, 1948 (fig. 79).

Motherwell followed the style that was popular in *Verve* of the artist handwriting as well as illuminating the poet's work. In fact, Motherwell's *Ink*

Sketch (Elegy No. 1) might be loosely compared to Matisse's *de la couleur* (fig. 80). On one page Motherwell wrote the opening lines for the poem and on the facing page its concluding lines framed by a black horizontal slab above and the ink drawing below. As discussed in chapter 1, Motherwell had had a long and profound interest in poetry. He adhered to the Symbolist belief that one medium should not imitate or illustrate the other, but rather provide a parallel set of feelings, or a resonance. When asked about the relationship between his "Elegy" sketch and Rosenberg's poem, Motherwell replied, "It has literally nothing to do with the poem—except for them both having a brutal quality—certainly not its images. Certain critics, for example, have read the phrase 'wire tied in my neck' as being described by the lines between the ovals. No wire or neck is there."[63]

The discovery of the first "Elegy" did not indicate a fundamental change in Motherwell's work. Rather it was a condensation of various currents that had gone before. The "Elegy" format represents increased boldness and directness in his expression.

The black and white contrast of the first "Elegy" sketch was a practical necessity. Motherwell remembers that because they could not afford the cost of reproducing colors in *Possibilities*, he had to restrict his palette.[64] Yet, Motherwell chose black and white as the dominant tone for all later "Elegies." Black and white tonalities had been an integral feature of Motherwell's art throughout the 1940s. But the only time that solid black shapes set against a white ground had previously dominated his works was in his very first creations during the forties, his drawings in the *Mexican Sketchbook*. In some respects the artist had come full circle. Motherwell feels, however, he had forgotten about the sketchbook by the late 1940s.[65]

Black versus white is both the most powerful visual contrast in the arts and the most symbolically loaded color opposition in our culture. The first time that Motherwell wrote anything about black and white, his interest in their formal and symbolic values was evident. The occasion was the 1950 Kootz exhibition *Black or White: Paintings by European and American Artists*, for which Motherwell did the catalogue introduction. He wrote:

> The chemistry of pigments is interesting: ivory black, like bone black, is made from charred bones or horns, carbon black is the result of burnt gas, and the most common whites— apart from cold slimy zinc oxide and recent bright titanium dioxide—are made from lead, and are extremely poisonous on contact with the body. Being soot black is light and fluffy, weighing a twelfth of average pigment.... Sometimes I wonder, laying in a great black stripe on the canvas, what animal bones (or horns) are making the furrows in my picture.... There is a chapter in *Moby Dick* that evokes white's qualities as no painter could except in his medium.... The black grows deeper and deeper, darker and darker before me. It menaces me like a black gullet.... Only love—for painting, in this instance—is able to cover the fearful void. A fresh white canvas is the void, as is the poet's sheet of blank white paper. But look for yourselves, I want to get back to my white washed studio. If the *amounts* of black and white are right, they will have condensed into quality, into feeling.[66]

Since the 1950s, Motherwell has written a great deal about black and white. He also collects statements about those colors found in literature ranging from Cervantes' *Don Quixote* to Theodore Roethke's *The Decision.* The basic points, however, were made in his 1950 statement. By then Motherwell had developed his distinctive formal sensibility regarding which types of black and white images and surfaces he preferred. The paradoxes of the variety of symbolic associations of black and white intrigued him. Like his paintings as a whole, these contrasts were complex and no single meaning contained them. Motherwell has pointed out some of the contradictions in conventional perceptions of these tones. Black, which we often associate with moods of depression and death, is made from animal bones, the very stuff of life. Black, which we often find oppressive in its absence of color, is the lightest pigment in actual weight. White, which sometimes symbolizes light and purity, can also be the "empty void" from which the artist must struggle to create something. Melville's white whale was a symbol of evil, and Mallarmé wrote of the terror of confronting the blank white page. Although Motherwell certainly did not think of all these rich variations in his first sketch, they constantly grew in his mind, enriching the "Elegies" over three decades of creativity.

Like the black and white contrast of the first "Elegy" study, its shapes represent a powerful condensation of previous ideas. Motherwell has recently confirmed that the *Ink Sketch (Elegy No. 1)* began with automatist, underdrawing applied freely.[67] For the recent exhibition catalogue *The Subjects of the Artist,* E.A. Carmean recreated, with Motherwell's approval, the stages of an "Elegy to the Spanish Republic" which illustrate its spontaneous beginning and subsequent structuring. Motherwell has also pointed out to me several works which reveal the underpinnings of the "Elegies" (fig. 81). This method of using rapidly applied and nonsignifying areas of paint as a way of beginning the composition existed in Motherwell's earliest works. He filled in linear drawing with black ink in his *Mexican Sketchbook.* In *Recuerdo de Coyoacan* (1941), splattered paint seen through the "window" suggested the color and compositional design of the final work. In Motherwell's collage *Mallarmé's Swan* (1944), he splashed the surface with unregulated pigment before applying homogeneous large areas of paint and cut out paper to the composition in a more considered manner.

This two-stage method, moving from intuition to intellectual formal organization, disappeared from Motherwell's work around 1945. Although Motherwell began to paint in a more robust manner freely revealing errors and corrections in 1947 works like the *Emperor of China,* he still did not revive the earlier strategy. In the first "Elegy" sketch, these two antithetical stages of creation reappeared. The difference is that they are much more closely united than ever before. Rather than having the underpainting determine some of the shapes and colors, it determined *all* of the shapes and colors.

A new expressive technique appeared at that point in Motherwell's work which has never been emphasized sufficiently. It involves the edges of the "Elegy" bands and ovals. Because of the opacity of the black paint, one can seldom see pentimenti beneath it. Thus the automatist character of the work appears only at the ragged outer edges of the shapes, both ovals, and slabs. While many modern artists before Motherwell created irregular shapes to give them a less geometric character, no artist that I know of has created such solid two-dimensional shapes with rough and spontaneous edges comparable to those of Motherwell. The appearance of the automatist drawing at the edges of the ovals makes clear the new congruence between the automatism and the final image in the work, and the more complex level of expressive coherence.

Although *Ink Sketch (Elegy No. 1)* contained a number of startling discoveries, Motherwell did not immediately recognize its significance for the future. When the second issue of *Possibilities* was cancelled, he put the drawing away in a drawer. It was only many months later that he rediscovered it while unpacking in his new studio in New York City.[68] He was struck by the image, and decided to do a second version in casein on board, which he entitled *At Five in the Afternoon* (fig. 82). Motherwell recalls, "At one moment I was looking around for a generating idea and thought well, I'll try another version, only larger and eliminating the written script. It was one of those times I just wanted to paint for the act of painting."[69] With these two works the "Elegy" format was established. It is thus appropriate to discuss possible meanings for the oval and vertical slab configuration that Motherwell created.

The most persistent art historical debate about Motherwell's work has surrounded possible meanings of the "Elegy" shapes. The recent protagonists in the debate have been Robert Hobbs and E.A. Carmean. In his doctoral dissertation on the "Elegies," Hobbs has identified them with three sources: genitalia, fruit hanging from a tree, and an enlargement of the artist's signature.[70] In the following discussion of *Elegy No. 34*, he stated the first two of these interpretations and suggested the third:

> In the organic *Elegies* genitalia, or an abstraction of it, and shapes reminiscent of fruit hanging on a branch are conceived in gargantuan terms, creating a fascinating interplay between what seems public and private, bringing the private into the open and making it part of a public event. With these paintings the problem is that they monumentalize an autographic technique of drips and sketchy brushwork as well as intimate subject matter, genitalia, not that they are conceived as a picayune manner that is enlarged.[71]

Motherwell has gone out of his way to refute several of these interpretations because of their specificity. Discussing *Elegy No. 34*, 1953–54 (fig. 85), he noted, "Not long after this was painted someone pointed out that it looked phallic. It was of course unintentional." Motherwell continued, "I

subsequently made one that was intended to be phallic, and it was unsuccessful. My intention in altering the shapes in *Elegy 34* was to make them more moving."[72] When asked in a recent interview if the letter "M" from his name appeared in his work, Motherwell replied:

> It is possible that it could be so, but if so, it is unconscious. I would not consciously do it. Again an art historian Professor Robert Hobbs has written about that. Hobbs asked me, and "Certainly," I said, "I *never* think of it, that is, that the gesture is an 'M'." But again it could unconsciously be an "M." I personally see it and think of it as a rhythm, as a rhythmic mark.[73]

In contrast to Hobbs, Carmean accepts few associations for the "Elegies." He has pointed out quite correctly that the "Elegies" began with abstract doodling, which has been discussed in terms of automatism throughout this study. He then analyzed them in formal terms through the interaction of shapes on the two-dimensional surface. The method is derived largely from the critical language codified by Greenberg and his circle during the 1960s. Carmean has written:

> But to a certain extent, the attention to Motherwell's subject matter has obscured his very real formal qualities.... The elements in his final drawing are arranged in a frieze like pattern across the surface. Motherwell had previously preferred this structural order, his compositions aligned to the picture surface. The black forms correspond with the composition, spreading flat on the surface plane and remaining primarily, two dimensional.[74]

Motherwell himself indicates that the "Elegies" fall between these two poles. In fact, he considers neither exclusive. While the paintings do not describe any *particular* object, Motherwell has always insisted that they suggest a number of associations, and thus has referred to them as "similar to a Jungean archetype."[75] The strength of these associations and the overall power of the "Elegies," however, depend upon the formal rhythms between the shapes on the surface of the canvas. Motherwell wrote as early as 1951, "The real content of a painting is the rhythms and the proportions, just as a real person is his own rhythms and proportions, not what he happens to say to you when you meet him on the corner."[76]

When one considers the referential imagery that Motherwell painted during the 1940s, it is clearly impossible to exclude associations from the "Elegies." In fact, the associations Motherwell prefers for the "Elegy" shapes are those largely developed during the 1940s. It is knowledge of his art during that decade which provides a context for the "Elegies."

What associations does Motherwell himself find for the "Elegies to the Spanish Republic"? The contrast of life and death, suggested by black and white and by the ovals being crushed by vertical slabs, is one of the general

meanings Motherwell finds for the "Elegies." He has said, "After a period of painting them, I discovered Black as one of my subjects—and with black, the contrasting white, a sense of life and death which to me is quite Spanish. They are essentially the Spanish black of death contrasted with the dazzle of a Matisse-like sunlight."[77] Throughout his 1940s paintings, Motherwell has confronted personal themes of life and death. These works range from *Surprise and Inspiration* (Wounded Personage) to *Pancho Villa, Dead and Alive* to the *Emperor of China.*

Motherwell also finds an organic presence related to his earlier stick figures in the ovals held aloft and pressed by vertical bars. He has said, "Sometimes I think the ovals *press* against the vertical panels, like my personages pressed against their confining bars in my earlier work. I say press because the automatic drawing gave a sense of energy underneath. They would explode unless something stopped them."[78] Like Motherwell's earlier figurations, the "Elegies" are symbolic self-portraits revealing the way he feels at a given time.

While I see little visual evidence for Hobbs's contention that the "Elegies" refer to Motherwell's signature or fruit upon a tree, the association with genitalia cannot be easily dismissed. Despite Motherwell's clear denial, certain of the "Elegies" contain shapes which look remarkably like a phallus and testicles (fig. 85). The evidence of *Pancho Villa, Dead and Alive* with its "living penis," and related drawings of 1944 reinforces this association. I suspect that the phallic reference which seems to exist in the "Elegies" was not conscious or programmatic on Motherwell's part. The probable reason Motherwell so adamantly denies it is that he fears the public would become fixated on that interpretation and thus not be open to the other suggestive characteristics of the paintings. It is important to note that any one of the associations for the "Elegies" taken singly would focus our attention on one aspect at the expense of the whole.

Spain and particularly the Spanish Civil War is a another reference Motherwell clearly wishes to suggest in the "Elegies." As noted earlier, he linked Spanish cultures with humanity since his first trip to Mexico in 1941. There Motherwell was impressed by the vitality of peasant life and the constant presence of death. Even before that trip, the Spanish Civil War had made a great impression on Motherwell as the death of a great humanistic culture. As a student in California, he had heard André Malraux movingly try to raise American support for the civil war through his speeches.[79]

The Little Spanish Prison (1941) was Motherwell's first consideration of the dual feelings of humanity and entrapment which were related to Spain but also to his own personality and struggle to develop an expressive painting style. He reconsidered these themes more extensively in the "Elegies." Motherwell has never been interested in communicating specific political

events involved with the Spanish Civil War.[80] In a manner similar to his references to World War II in the collages of 1943–44, Motherwell is interested in his personal response and the feelings these events raise in him. These can then be suggested to his audience. It is precisely for this reason that he regarded Picasso's more propagandistic *Guernica* a failure in artistic terms.[81]

The *Elegies to the Spanish Republic* are also related to poetry. We have seen Motherwell's interest since the early 1940s in exploring parallels to poetry in his paintings. *Mallarmé's Swan* is one example. He found affinities between the "Elegies" and Frederico García Lorca's *Llanto por Ignacio Sánchez Mejías*. The title of the second "Elegy," *Five in the Afternoon*, was taken from the refrain in that poem. There is a similar feeling between the death of the bullfighter Lorca describes, which is at once terrible and heroic, and Motherwell's tragic "Elegies." Motherwell was fascinated by the powerful rhythmic repetitions in the poem. "At five in the afternoon" is repeated thirty times. This rolling rhythm is similar to the repetitions and tensions set up between the shapes of the "Elegies."[82] The paintings, of course, do not illustrate any event or object described in the poem.

Another reference point that Motherwell finds for the "Elegies" is architecture. He observed in 1965:

> I think the meaning of the Elegies is deeper than what's obvious and I think it has something to do with the human but also I think it has something to do with architecture. I know a psychoanalyst who I play poker with, who collects German Expressionist painting. He is originally German and sent me from Greece one summer a photograph of some Greek columns, three columns with a pediment across the top that had been taken at twilight so that the columns and the bar across the top appeared black against the twilight whiteness and it looked very much like my pictures.[83]

Since his earliest paintings, Motherwell has shown an interest in architecture. For instance, *Spanish Picture with Window* (1941) had as one inspiration the walls he saw in Mexico. Also Motherwell refers to the areas where automatist underpainting is revealed in his early works as "windows." Motherwell simultaneously found those walls secure and confining. During the 1940s Motherwell utilized a variety of human responses to architectural surroundings. These ranged from the sensuous character of *Spanish Picture with Window*, to the entrapment of the *Spanish Prison* (1943–44), to the nightmarish confusion of his little ink study *Kafka's Room* (1944).

Motherwell's "Elegies," as well as his earlier work, do not describe architecture, rather they evoke similar feelings. The architectural qualities in his "Elegies" are partly the result of large scale, which makes them tower over the viewer. In many of the "Elegies," there is a sense of clear structure, through balancing carefully articulated parts, which is also architectural in

sensibility. The isolation of curved and straight elements makes them appear constructed. Of course the "Elegies" have nothing to do with the two main characteristics of architecture, actual shelter, and three-dimensional space. Instead, they utilize our personal feelings for overwhelming megalithic structures. Motherwell has compared them to Stonehenge as well as to the photograph of a Greek temple, all to the goal of increasing their emotional character as two-dimensional, painterly expressions.

Although *Ink Sketch (Elegy No. 1)* and *At Five in the Afternoon* establish the "Elegy" format through their similarity, the differences between them must have led Motherwell to think about the possibilities of a series. In *At Five in the Afternoon,* the sense of compression between shapes and expressive paint handling is far greater. The adjoining ovals to the right side of the composition are put under more pressure flattening one against the other. To the left side, the oval is larger and more elongated by the pressure of the bars around it than that in *Ink Sketch.*

All the forms of *At Five in the Afternoon* have rougher edges and expressive paint drips, making it a dramatic and rawly expressive work. Motherwell has spoken of the expressive power of these slight changes in the "Elegies," "For me the question is still a mystery of how they can change—the slightest touch will produce a whole, new felt tone—and yet they still remain "Elegies." To me this raises a profound question . . . are the colors and shapes an iconography or a tone of voice. I'd argue that the subject matter of all the "Elegies"—of all Abstract Expressionism—is a tone of voice."[84]

The theme of the "Elegies" was firmly hammered home in Motherwell's mind by the events surrounding the creation of the third "Elegy," entitled *Granada* and his monumental painting *The Voyage* (figs. 83 and 84). *Granada* and *The Voyage* were painted in two eighteen-hour sessions during a blizzard in December of 1948. Motherwell's wife Maria had left him earlier in the winter. She took his car and departed with another man who had lived near them in East Hampton. Motherwell remembers that his feelings that winter were "abandonment, desperation and helplessness." He recalled, "I had never felt so utterly alone in my whole life."[85] Cloistered in his studio by the blizzard, Motherwell painted intensely. He remembers that when he finished the works, "I felt like commiting suicide, but I had a drink and collected myself." Motherwell considered destroying *Granada* because the memories of that day were so strongly linked to it. He was finally dissuaded from that action by Bradley Walker Tomlin.

Neither *The Voyage* nor *Granada* is an anxiety ridden work, revealing self-pity or morbid states in the manner of German Expressionist painting. The works are somber but structured. The paintings seem to represent a powerful and successful attempt by Motherwell to gain control of his

emotions in the midst of a serious life crisis. Motherwell's "Elegies" thus transcend his personal life, but they are also linked intimately to it, and he still recalls the time during which he painted *Granada* as impressing the "Elegy" image indelibly upon his mind.

The Voyage was created in the first of the two eighteen-hour painting sessions. Motherwell named the painting after Baudelaire's famous poem "The Voyage," and has confirmed that he was thinking of the poem while he painted it.[86] As noted earlier, Motherwell found parallels between Baudelaire's evocative poetry and his own creative process. The poem reminded Motherwell of his own difficult journey through the forties toward goals that could not be clearly forseen. He wrote recently:

> The title refers to the sense we had in the 1940s of voyaging on unknown seas (however conventional the work may seem now) and, of course, refers to Baudelaire's famous poem *The Voyage,* the last line of which is: "Au fond de l'inconnu pour trouver du nouveau!" [87]

None of Baudelaire's poem is about the present; it contains only memories of the past and dreams of the future. Like Baudelaire's poem, Motherwell's painting attempts to gather together many of the artist's past resources, and to project them into a future mode of expression. In the large-scale work (48 × 94 inches), Motherwell tried to combine collage and oil painting. The flat, hard-edged shapes overlap and interlock in a collagelike manner. Yet expressive paint texture was utilized and one can see pentimenti through layers of paint. In addition, Motherwell has carved two letters "A" into the ochre paint surface. The device recalls the letters in *Viva* and the carving of paint in *The Emperor of China*. Like *Viva*, the letters make suggestions without providing answers. One asks, "A what?" or if one is thinking in French "to where?"

The wide variety of shapes in *The Voyage* further recalls Motherwell's earlier works. The white egg trapped within a black vertical stripe is the obverse of shapes found in the early "Elegy" studies. The black starlike figure pressed between the black and ochre stripes recalls the figural shape and rough edges of the *Emperor of China* and other works. The overall configuration of the work is like Motherwell's largest painting before 1947, *Wall Painting with Stripes* (1944). The heart shape to the far left side in *The Voyage* is reminiscent of Matisse's paper cutouts, especially "The Heart" from the "Jazz" series and may be a cipher for feelings. While *The Voyage* summarizes a number of influences in Motherwell's career, *Granada* focuses intently on the "Elegy" format and the future.

Granada, the third of Motherwell's "Elegies," is much larger than *At Five in the Afternoon.* The size (47 × 55½ inches) was partially determined by the material used for a support. Motherwell executed the work on a piece of brown stencil paper; the ripped edge of the paper can be seen at the right side

of the painting. The work has a more vertical orientation than the previous "Elegies." The three black panels are longer and thinner, and the ovals are reduced in scale relative to the white ground. *Granada* is also painted less freely. All of the shapes have firm edges. Motherwell might have used this more controlled style because of the new experience in scale, or as a symbolic control of his emotions. In either case, the effect is to increase the architectonic qualities of the work. The painting thus seems even more monumental. Motherwell recalls, "Although it is now easel sized when placed in comparison with the later 'Elegies,' I remember it looked enormous in my studio at that time. The monumental conception started with this picture."[88]

These two monumental paintings act as a fulcrum in Motherwell's career. *The Voyage* summarizes many of the concerns of the forties and suggests the need to move forward, and *Granada* firmly establishes the "Elegy" theme which would be Motherwell's dominant concern during the 1950s.

In retrospect the years 1947 through 1950 were a period of flowering for gestural and color-field painting among the Abstract Expressionists. In addition to Motherwell's painterly discoveries, Pollock elaborated his mature drip style after 1947 in such paintings as *Cathedral*. In the same year Rothko made the transition from his Surrealist-inspired watercolors to his *Multiform* compositions, which were then progressively simplified into his field paintings of 1950. During 1948 and 1949, de Kooning painted such black paintings as *Dark Pond* and a series of large gestural abstractions culminating in *Attic* of 1949. Despite the enormous differences in individual styles, the other artists shared with Motherwell his preoccupation with monumental-scale, and public-oriented, art. Each artist was concerned with expressing, through the abstract mode, his personal feelings about himself and the world around him.

Several galleries, particularly Betty Parsons and Samuel Kootz, continued actively to show the Abstract Expressionists. In 1949, Kootz gathered the major artists, including Baziotes, de Kooning, Gottlieb, Pollock, Rothko and Motherwell showing *The Voyage,* into an exhibition titled The Intrasubjectives. Some museums were also becoming more receptive. Dorothy Miller showed Motherwell and Gorky in Fourteen Americans at the Museum of Modern Art in 1946. But the public and museum world continued to be largely hostile, and here Motherwell's talents as an educator and spokesman proved advantageous.

The Abstract Expressionists organized group activities such as Subjects of the Artist, discussed earlier, which included Baziotes, Hare, Motherwell, Rothko, and Newman. After the collapse of Subjects of the Artist in 1949, Studio 35 was founded. Its final activity was its most important, a three-day conference among the vanguard artists held in the Spring of 1950. The

participants included de Kooning, Gottlieb, Hofmann, Newman, Reinhardt, and twenty other important contemporary artists. Alfred Barr, the only nonartist participant, and Motherwell acted as moderators for the discussions. Later Motherwell and the others participated in the Eighth Street Club.

In May 1950, eighteen Abstract Expressionist painters, including Motherwell, sent an open letter to Roland Redmond, president of the Metropolitan Museum of Art. They attacked him for organizing juried exhibitions that were "notoriously hostile to advanced art."[89] The *New York Times* published the story on its front page and the *Herald Tribune* ran an editorial calling the group "The Irascible Eighteen." The name stuck in the public mind, and the next month *Life* magazine published its famous photograph of the artists. The event contributed greatly to the widespread public interest in the Abstract Expressionists, and launched them into public notoriety, recognition and, finally, the honors of the late fifties.

Figure 79. Motherwell, *Ink Sketch* (Elegy No. 1), 1948
Ink on paper, 10 1/2 × 8 1/2″
(Collection Robert Motherwell)

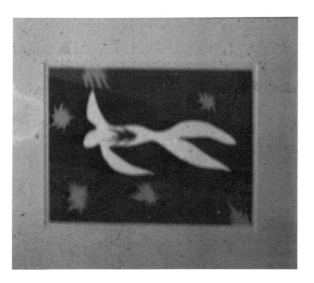

Figure 80. Robert Henri Matisse, "Icarus" and "de la couleur"
Ink on paper
(From Verve magazine, vol. 4, no. 3, 1943)

Figure 81. Robert Motherwell, *Elegy Study*, 1976
Ink on paper, 8 1/2 × 12"
(*Collection Robert Motherwell*)

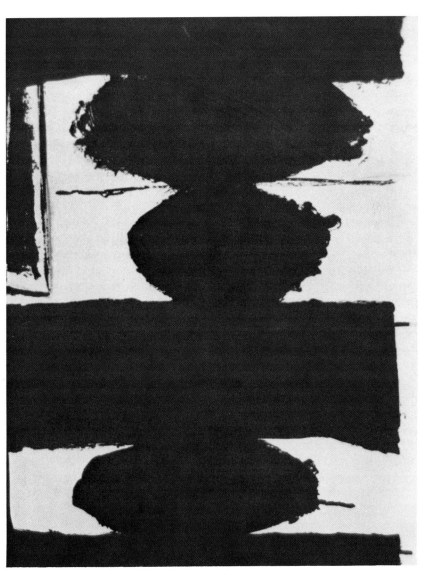

Figure 82. Robert Motherwell, *At Five in the Afternoon*, 1949
Casein on board, 15 × 20″
(Collection Helen Frankenthaler)

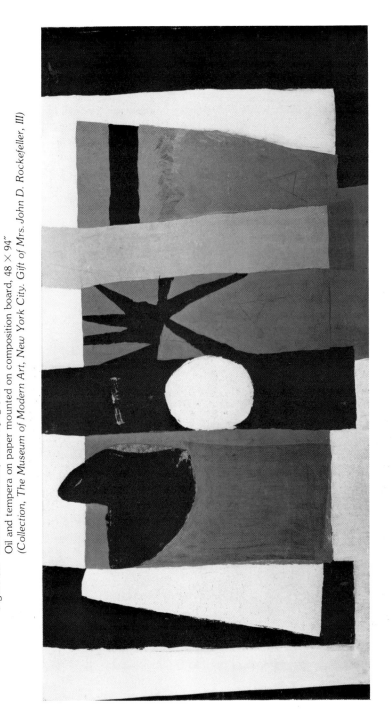

Figure 83. Robert Motherwell, *The Voyage*, 1949
Oil and tempera on paper mounted on composition board, 48 × 94″
(Collection, The Museum of Modern Art, New York City. Gift of Mrs. John D. Rockefeller, III)

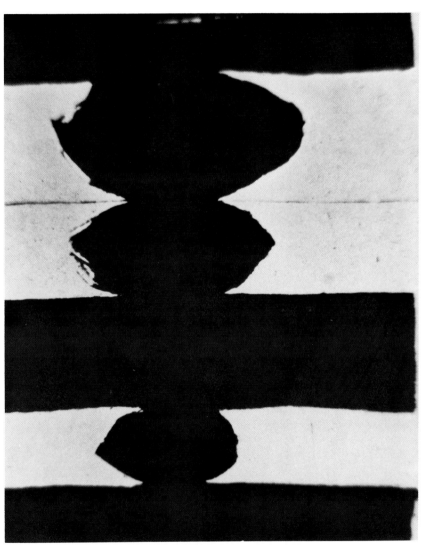

Figure 84.　Robert Motherwell, *Granada*, 1949
Oil on paper on composition board, 47 × 55 1/2"
(The National Trust for Historic Preservation, Nelson A. Rockefeller Collection)

Figure 85. Robert Motherwell, *Elegy to the Spanish Republic No. 34*, 1953-54
Oil on canvas, 80 × 100"
(Collection Albright-Knox Art Gallery, Buffalo, New York. Gift of
Seymour H. Knox, 1957)

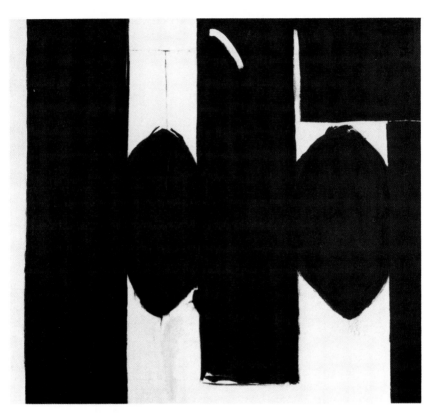

Figure 86. Robert Motherwell, *Elegy to the Spanish Republic No. 55*, 1955–60
Oil on canvas, 70 × 76 1/8″
(Contemporary Collection of The Cleveland Museum of Art)

Conclusion

The 1940s was at once the most experimental and also the most uneven decade of Motherwell's long and productive career. Many paintings were prophetic of his later oeuvre, while others were quite immature and later abandoned as unsatisfactory experiments. Yet during the decade, Motherwell arrived at the mature visual statement of his fundamental artistic concerns.

Motherwell's intellectual roots have been traced to philosophy and Symbolist literature which led him to think about such abstract concepts as spontaneity, structure, process, and correspondences early in his life. His interest in Freudian psychology also directed him towards an art which revealed interior states rather than mimicked the external world. Contact with the Surrealists after 1941 provided Motherwell with his first examples of working artists and introduced him to the idea of "automatism," or free visual association and spontaneous plastic invention. Motherwell translated this Surrealist notion into concrete strategies for beginning his paintings. He typically started his works with a series of painterly marks which were not preconceived. He then utilized these abstract doodles to precipitate a process of editing, refinement, and synthesis. It is remarkable how quickly Motherwell divorced his "plastic automatism" from the more illusionistic Surrealism used even by Matta, who was his most pronounced early influence.

After a trip to Mexico with Matta, Motherwell had his first extensive contact with the wide variety of avant-garde paintings assembled in New York, and especially at Peggy Guggenheim's Art of This Century Gallery. From these works, he chose his pantheon of cultural heroes: Mondrian, Picasso, Matisse, and Miró. From the first, Motherwell was quite specific about the periods, styles, and images that he admired in each artist, and which he assimilated to his own purposes. These include Picasso's collages and his paintings from the late 1920s and early 1930s, Matisse's Cubist 1914–17 works, and Miró's paintings of the late 1920s. In each case, Motherwell showed a preference for the more spare and structural examples

of these artists' works, and himself developed a quasi-geometric framework to contain and order his more instinctive and chaotic painterly effects. In the forties, Motherwell repeatedly pulled apart and resynthesized examples of irrational Surrealist and Constructivist art in order to develop a unique set of symbols and pictorial language.

Motherwell's admiring assimilation of forms and ideas from these modern masters, which can be traced throughout his art, indicates his belief that he is but one link in the cultural chain of modernism. His emulation of the great twentieth-century pioneers is in the spirit of Gorky, de Kooning and Hofmann. His acknowledgment of sources contrasts to the virtual sublimation of influences in the works of Pollock, Rothko, and Clyfford Still.

At the same time that he was discovering modern art, Motherwell had his first contact with the other advanced American painters through the "automatist group" meetings which he and Matta organized. These sessions helped Motherwell differentiate himself from the Surrealists, and their fantastic imagery and illusionistic space. The meetings with Pollock, Baziotes, and Matta were also an early instance of group contact between the nascent Abstract Expressionist painters. These meetings were the predecessors for such later organizations as Subjects of the Artist and group publications such as *Possibilities*. Despite the difficulties and short life of each of these ventures, they did provide a feeling of common interest and support among the struggling young New York vanguard. Motherwell emerged as a spokesman and coordinator for these group efforts.

The years 1943 through 1944 were occupied by Motherwell's discovery of collage, in which he has become one of the preeminent masters since Picasso. Motherwell's use of collage allowed a more complex interplay between spontaneity and structure in his work. The fragments of paper provided large, clearly defined surface areas, yet they could be moved readily and even torn spontaneously. Revision was much easier to achieve than in oil paint. The paper could also be splattered with paint or used to cover up areas of splashed pigment.

Motherwell's expressive freedom through collaging methods coincided with the growth of emotional content in his works. He began to paint stick figures on the collages, which must be seen as both humanist and self-referential. He was also more profoundly affected by feelings of loneliness and personal despair during World War II than is commonly known. In works of this period, Motherwell clearly did not yet make distinctions between collage as a vehicle of intimate, often joyous sentiments and the frequently somber character of his large-scale oil paintings. In fact, the collage *Pancho Villa, Dead and Alive* pioneers the expressive oval and vertical shapes which later became the basis of his "Elegies." However, at the same time Motherwell did

experiment with a large-scale and stoic mode of oil painting in an isolated work, *Wall Painting with Stripes.*

The years 1945 and 1946 were not particularly rich or resolved in terms of Motherwell's oeuvre. He was plagued by personal problems, including excessive pressure from his dealer, his isolation in East Hampton, and his troubled marriage. The oil paintings from that time are mostly small, mechanical in execution, and decorative in color. Motherwell later bought back and destroyed a number of those paintings, and expressed his desire to do the same with several I discovered amid his things at the studio.

Motherwell condensed and strengthened his art in the years 1947 to 1949, the point of maturation for several of the Abstract Expressionists. In part his increased expressive power was due to his contact with Existential ideas. His powerful new imagery and formal decisions seem linked to the Existential rationale of "action." Motherwell focused on a series of large-scale oil paintings. In the *Emperor of China* and *The Homely Protestant,* personages appear which he has specifically identified with feelings about himself. These images are not set in a larger spatial context, as were the stick figures in *Pancho Villa, Dead and Alive.* They dominate the entire canvas, and are at once monumental and self-consciously awkward in design. Sensuously pleasing colors were deliberately avoided. In Motherwell's earlier works, spontaneous and structured paint handling could be viewed in separate areas of the canvas or collage. The two painting modes were closely integrated in these later works.

In *The Voyage* and especially the "Elegy" series, Motherwell was able to symbolize the interplay between feelings of power and vulnerability with less specific figural and more universally suggestive shapes. Yet, the character of the forms, tensions between them, assertive paint handling, scale and restricted palette all grew directly out of Motherwell's earlier experiments. Through the discoveries made in the forties, Motherwell developed a set of original pictorial signs and gave meaning to an essentially abstract mode of expression.

Although the discoveries made during the forties provided touchstones for Motherwell, the many years of creativity afterwards did not follow effortlessly. The transitions from the somber *Iberia Suite* of the late 1950s, to the violent "Elegies" of the 1960s, to the lyrical and relaxed "Opens" show that Motherwell has been involved in a constant process of reexamining and expanding his art to find appropriate pictorial means and visual symbols to express his deepest feelings.

Notes

Introduction

1. The monographic dissertations are among the most complete and informative studies. See Harry F. Gaugh, *The Art of Franz Kline: 1930-1950: Figurative to Mature Abstractions* (Indiana University, 1972); Mary R. Davis, *The Paintings of Adolph Gottlieb* (Columbia University, 1977); Mona Hadler, *The Art of William Baziotes* (Columbia University, 1977); and Sally Yard, *Willem de Kooning: The First Twenty-Six Years in New York 1927-1952* (Princeton University, 1980).

2. Some aspect of Motherwell's art during the 1940s are covered in Robert C. Hobbs's 1975 doctoral dissertation on Motherwell's "Elegies." See bibliography for full citation.

3. For information on Motherwell's life prior to 1940, see H.H. Arnason, "On Robert Motherwell and His Early Work," *Art International* (January 1966), pp. 17-21.

4. Robert Motherwell, "On Form and Content," 1950s, unpublished.

Chapter 1

1. Robert Motherwell, letter to William Carlos Williams, 1941. For a thorough discussion of Motherwell's youth, before 1940, see H.H. Arnason, "On Robert Motherwell and His Early Work," *Art International* (January 1966), pp. 17-19.

2. Robert Motherwell, interview with the author in Greenwich, Connecticut, June 6, 1979. Further references to interviews will be indicated by the artist's initials and date.

3. Robert D. Mack, *The Appeal of Immediate Experience: The Philosophic Method of Bradley, Whitehead and Dewey* (Freeport: Books for Libraries Press, 1945), p. 16.

4. R.M., June 6, 1979.

5. John Dewey, *Art as Experience* (New York: Paragon Books, 1934), p. 48.

6. For instance, Motherwell uses the term in "The Modern Painter's World," *Dyn* (November 1944), p. 11; "Beyond the Aesthetic," *Design* (April 1948), p. 15, and a statement in "Robert Motherwell," Kootz Gallery, April 28—May 17, 1947. For Dewey's frequent use of the term, see chapters 2 and 3 of *Art as Experience*.

7. Robert Motherwell, "The Rise and Continuity of Abstract Art," a lecture given at Harvard University, April 12, 1951.

8. Dewey, *Art as Experience*, pp. 93-94.

9. R.M., December 11, 1979.

10. Motherwell, interview with Arthur Cohen, 1969. The influence of Prall and Whitehead upon Motherwell is also discussed with different conclusions by Robert C. Hobbs, *Motherwell's Concern with Death in Painting: An Investigation of His Elegies to the Spanish Republic* (Chapel Hill: University of North Carolina, Ph.D. dissertation, 1975), pp. 23-33.

11. R.M., December 15, 1979.

12. D.W. Prall, *Aesthetic Analysis* (New York: Thomas Y. Crowell Company, Publishers, 1936), p. 20.

13. Motherwell statement, "On Form and Content," 1950s.

14. Prall, *Aesthetic Analysis,* p. 9.

15. Prall, *Aesthetic Analysis,* p. 34.

16. For instance, see "Notes on Mondrian and De Chirico," *V.V.V.* (June 1942), p. 59; "Beyond the Aesthetic," p. 14; "A Letter from Robert Motherwell to Frank O'Hara" in *Robert Motherwell* (New York: The Museum of Modern Art, 1965), p. 58.

17. Motherwell, interview with Bryan Robertson, 1965.

18. Alfred North Whitehead, *Adventures in Ideas* (New York: The Macmillan Company, 1952; original edition, 1933), p. 104.

19. Motherwell, "Symbolism," a lecture at Hunter College, February 24, 1954.

20. Alfred North Whitehead, *Modes of Thought* (New York: The Macmillan Company, 1938), p. 127.

21. Motherwell, "The Rise and Continuity of Abstract Art," April 12, 1951.

22. R.M., December 11, 1979.

23. Motherwell quoted in Mona Hadler, "William Baziotes: A Contemporary Poet-Painter," *Arts* (June 1977), p. 103.

24. R.M., April 27, 1980.

25. Ibid.

26. Ibid.

27. Ibid.

28. Motherwell, "The Ideas of Art—A Tour of the Sublime," *Tiger's Eye* (December 1948), p. 46.

29. David Sylvester, "Painting as Existence: An Interview with Robert Motherwell," *Metro* (1962), p. 95.

30. Jackson Mathews, ed. *The Collected Works of Paul Valéry* (Princeton: Princeton University Press, 1972), p. 207.

31. Marcel Raymond, *From Baudelaire to Surrealism,* with Preliminary Notice by Robert Motherwell (New York: Wittenborn, Schultz, Inc., 1949), p. 13.

32. Ibid., p. 32.

33. Charles Baudelaire, "The Voyage," James Laver, ed., *Charles Baudelaire: Flowers of Evil* (New York: Heritage Press, 1971), p. 166.

34. Raymond, *From Baudelaire to Surrealism,* p. 13.

35. Motherwell, "Beyond the Aesthetic," p. 15.

36. Hadler, "William Baziotes," p. 103.

37. Ibid., p. 104.

38. R.M., April 27, 1980.

39. R.M., June 6, 1979. The copy in Motherwell's library is inscribed, "to Bob, Maria, Christmas '44."

40. Charles Baudelaire, *Intimate Journals,* translated by T.S. Eliot (New York: Blackmore Press, 1930), p. 21.

41. Ibid.

42. Motherwell, "The Modern Painter's World," p. 10.

43. See, for instance, Sidney Simon, "Concerning the Beginnings of the New York School: 1939-1943. An Interview with Robert Motherwell," *Art International* (Summer 1967), p. 21.

44. Robertson, "Interview with Motherwell," 1965.

45. Paul Cummings, "Interview with Robert Motherwell," Archives of American Art, November 24, 1971.

46. R.M., December 15, 1979.

47. Motherwell, "The Modern Painter's World," p. 13.

48. R.M., November 1, 1979.

49. Mathews, *Paul Valéry,* p. 47.

50. Ibid., p. 120.

51. Ibid., p. 127.

52. Ibid., p. 138.

53. Ibid., p. 160.

54. Motherwell, "Preliminary Notice," in Raymond, *Baudelaire to Surrealism,* p. iv.

55. R.M., August 21, 1979.

56. Motherwell, Statement on *The Spanish Prison,* in Sidney Janis, *Abstract and Surreal Painting in America* (New York: Reynal and Hitchcock, 1944), p. 65.

57. Dore Ashton, *The New York School: A Cultural Reckoning* (Middlesex: Penguin Books, 1979), pp. 124-25.

58. Ibid., pp. 122-23. The scholarly interest in Jung and the Abstract Expressionists has recently been carried to an improbable extreme by Elizabeth Langhorne in her articles on Jackson Pollock. Langhorne has attempted to prove that much of the imagery in Pollock's forties painting is drawn directly from Jungian textbooks. See Elizabeth Langhorne's, "Jackson Pollock's 'The Moon Woman Cuts a Circle,'" *Arts* (March 1979), pp. 28-38.

59. R.M., August 21, 1979.

60. Morris Philipson, *An Outline of Jungian Aesthetics* (Northwestern University Press, 1963), p. 52. "The Collective Unconscious is universal; it not only binds individuals together into a nation or a race, but unites them with the men of the past and their psychology. This is the reason of its supraindividual universality, the unconscious is the prime object of any real psychology that claims to be more than psychoanalyis."

61. Motherwell, "The Modern Painter's World," p. 13.

62. Ibid., p. 13

63. Motherwell, "The Creative Use of the Unconscious by the Artist and the Psychotherapist," in Jules Baron, ed., *Annals of Psychotherapy no. 8* (1964), p. 47.

64. Motherwell, "The Modern Painter's World," p. 13.

65. Robertson, "Interview with Motherwell," 1965.

66. R.M., November 13, 1979.

67. Ashton, *The New York School*, p. 57.

68. Motherwell's copy of Alfred Barr, *Cubism and Abstract Art* (New York: The Museum of Modern Art, 1936) is inscribed "Gift of Peggy Guggenheim 1942."

69. Meyer Schapiro, "The Nature of Abstract Art" originally published in *Marxist Quarterly* (1937), reprinted in Meyer Schapiro, *Modern Art: 19th and 20th Centuries* (New York: George Braziller, 1978), pp. 187-89.

70. Ibid., p. 204.

71. Motherwell in Simon, "Concerning the Beginnings of the New York School: An Interview with Motherwell," p. 20.

Chapter 2

1. R.M., December 15, 1979.

2. Meyer Schapiro, letter to the author, January 21, 1980.

3. R.M., December 15, 1979.

4. For statements regarding the isolation of the Surrealists in America, see André Masson, "A Crisis in Imagery," *Horizon* (July 1945), p. 43; and Sidney Simon, "Concerning the Beginnings of the New York School: An Interview with Peter Busa and Matta," *Art International* (September 1967), p. 17.

5. André Breton, "Manifesto of Surrealism, 1924," reprinted in *Manifestos of Surrealism* translated by Richard Seaver and Helen R. Lane (Ann Arbor: University of Michigan Press, 1969), p. 26.

6. Miró quoted in James Johnson Sweeney, *Joan Miró* (New York: The Museum of Modern Art, 1941), p. 212.

7. André Masson, "Interviews with Eleven Europeans in America," *The Museum of Modern Art Bulletin* (Spring 1945), p. 4.

8. Matta, letter to the author, September 24, 1979.

9. R.M., December 15, 1979.

10. Matta, "Matta's Third Surrealist Manifesto," *Art News* (February 1944), p. 18.

11. Max Kozloff, "Interview with Matta," *Artforum* (September 1965), p. 24.

12. James Thrall Soby, "Matta Echaurren," *Magazine of Art* (March 1947), p. 103.

13. Matta, letter to the author, September 24, 1979.

14. Kozloff, "Interview with Matta," p. 24.

15. R.M., December 15, 1979.

16. R.M., November 8, 1979.

17. Simon, "Concerning the Beginnings of the New York School: An Interview with Robert Motherwell," p. 21.

18. See Gustav Regler, *Wolfgang Paalen* (New York: Nierendorf Editions, 1946), pp. 36–42.

19. Paalen made this statement in his "Biographical Note," in Wolfgang Paalen, *Form and Sense* (New York: Wittenborn and Company, 1945), n.p.

20. Wolfgang Paalen, "The New Image," translated by Robert Motherwell, *Dyn* (April–May 1942), p. 12.

21. Paalen, "The New Image," p. 9.

22. R.M., November 8, 1979.

23. Wolfgang Paalen, letter to Motherwell, February 16, 1945.

24. Paalen, "The New Image," p. 8.

25. Lee Krasner, letter to the author, June 28, 1979, indicated that both she and Pollock were aware of Paalen's works and *Dyn* magazine.

26. Robertson, "Interview with Motherwell," 1965.

27. R.M., March 21, 1980.

28. Robertson, "Interview with Motherwell," 1965.

29. Ibid.

30. Ibid.

31. R.M., December 15, 1979.

32. Robertson, "Interview with Motherwell," 1965.

33. R.M., March 9, 1980.

34. R.M., December 15, 1979.

35. Robertson, "Interview with Motherwell," 1965.

36. The major exception is the concrete example of prehistoric cave painting which influenced Motherwell in the later 1940s. It is discussed in chapter 6.

37. Robertson, "Interview with Motherwell," 1965.

Chapter 3

1. R.M., April 2, 1980.

2. Files of the Pierre Matisse Gallery, New York City.

3. Ibid.

4. Peggy Guggenheim, *Confessions of an Art Addict* (New York: Macmillan, 1960), pp. 69–70.

5. [Unsigned], "Peggy Guggenheim Opens Modern Museum," *Art Digest* (November 1942), p. 8.

6. R.M., April 2, 1980.

7. Robertson, "Interview with Motherwell," 1965.

8. R.M., June 4, 1980.

9. Robert Motherwell, "Notes on Mondrian and De Chirico," p. 59.

10. R.M., June 4, 1980.

11. Tony Smith, interview with the author, November 18, 1980.

12. Susan C. Larsen, *The American Abstract Artists Group* (Northwestern University; Ph.D. dissertation, 1975), pp. 312–18.

13. Harry Holtzmann, interview with the author, March 4, 1981.

14. Adolph Gottlieb, interview with Dorothy Seckler, Archives of American Art, October 25, 1967.

15. R.M., June 4, 1980.

16. Robertson, "Interview with Motherwell," 1965.

17. R.M., March 10, 1980.

18. Ibid.

19. R.M., March 9, 1980.

20. Paul Cummings, "Interview with Robert Motherwell," Archives of American Art, November 24, 1971.

21. R.M., March 10, 1980.

22. Ibid.

23. Arnason, *Robert Motherwell* (1977 ed.). Statement to accompany illustration 58.

24. R.M., March 10, 1980.

25. Carmean, "Robert Motherwell: The Elegies to the Spanish Republic," p. 101.

26. Robert Motherwell, "The Modern Painter's World," p. 12.

27. Dore Ashton, *The New York School*, p. 102.

28. André Malraux, *Man's Hope* (New York: Random House, 1938), chapters 3 and 4.

29. Simon, "Concerning the Beginnings of the New York School: An Interview with Motherwell," p. 21.

30. Ibid.

31. Ibid.

32. Peter Busa, interview with the author, August 30, 1979.

33. Ibid.

34. R.M., October 23, 1980.

35. Ethel Baziotes, interview with the author, August 6, 1979.

36. Ibid.

37. Busa, interview with the author, August 30, 1979.

38. Roberto Sebastian Matta, letter to the author, September 24, 1979.

39. Busa, interview with the author, August 30, 1980.

40. David Rubin, interview with Robert Motherwell cited in "A Case for Content: Jackson Pollock's Subject Was the Automatic Gesture," *Arts* (March 1979), p. 105.

41. William Baziotes, statement in *Possibilities* (New York: Wittenborn and Schultz, Inc., 1947), p. 2.

42. Rubin, "A Case for Content," p. 107.

43. R.M., October 23, 1980.

44. Simon, "Concerning the Beginnings of the New York School: An Interview with Peter Busa and Matta," pp. 18–19.

45. See William S. Rubin, *Dada Surrealism and Their Heritage* (New York: The Museum of Modern Art, 1968), p. 164, illus. 252. Motherwell's painting is in the foreground on the right side of this photograph.

46. R.M., March 9, 1980.

47. Robert Motherwell, letter to William Carlos Williams, 1942.

48. Files of the Pierre Matisse Gallery, New York City.

Chapter 4

1. R.M., June 5, 1980.

2. Ibid.

3. Ibid.

4. Arnason, "On Motherwell and His Early Work," p. 22.

5. R.M., June 5, 1980.

6. Ibid.

7. R.M., June 6, 1980.

8. Ibid.

9. Ibid.

10. Ibid.

11. R.M., April 2, 1980.

12. Robertson, "Interview with Motherwell," 1965.

13. Sigmund Freud, *The Basic Writings of Sigmund Freud*, A.A. Brill, ed. (New York: Modern Library, 1938), pp. 33–39.

14. R.M., June 6, 1980.

15. Motherwell, "Interview with Diamondstein," p. 228.

16. Motherwell, "Symposium: What Abstract Art Means to Me," *Museum of Modern Art Bulletin* (Spring 1951), p. 12.

17. R.M., June 6, 1980.

18. Wolfgang Paalen, *Form and Sense*, p. 43.

19. R.M., May 27, 1980.

20. Robertson, "Interview with Motherwell," 1965.

21. Arnason, *Robert Motherwell* (1982 ed.), p. 105.

22. Robertson, "Interview with Motherwell," 1965.

23. Edgcumb Pinchon, *Viva Villa* (New York: Grosset and Dunlap, 1933), pp. 374–76.

24. Alfred Barr, *Matisse: His Art and Public* (New York: The Museum of Modern Art, 1951), p. 190.

25. E.A. Carmean, Jr., *The Collages of Robert Motherwell: A Retrospective Exhibition* (Houston: Museum of Fine Arts, 1973), p. 48.

26. Robertson, "Interview with Motherwell," 1965.

27. R.M., March 2, 1980.

28. Sigmund Freud, "Thoughts on War and Death" (orig. 1915), in *On Creativity and the Unconscious* (New York: Harper and Row, 1958).

29. Robertson, "Interview with Motherwell," 1965.

30. As indicated by the dating on the canvas "1943/4."

31. Motherwell, statement on *Spanish Prison*, in Sidney Janis, *Abstract and Surrealist Painting in America*, p. 65.

32. Motherwell suggested the idea of a collection of volumes of the theoretical writings of artists to George Wittenborn because of his realization that these writings were often untranslated and difficult to obtain. He has acted as the editor of the series since that time. Motherwell's interest in the series tells indirectly of his own firm belief in the relationship between painting and art theory.

33. Motherwell remembers roughly thirty works. R.M., October 23, 1980.

34. R.M., April 2, 1980.

35. *Cahiers d'art*, vol. 13, nos. 3–10.

36. R.M., April 2,1980.

37. Motherwell, letter to William Baziotes, September 6, 1944, "Baziotes File," Archives of American Art.

38. R.M., December 15, 1979, and May 27, 1980.

39. Motherwell, letter to Baziotes, September 6, 1944.

40. Motherwell, "The Modern Painter's World" (lecture of August 10, 1944), published in *Dyn* (November 1944), p. 12.

41. R.M., April 2, 1980. *Mallarmé's Swan* is traditionally dated 1944–47. Motherwell has pointed out to the author that the 1947 date only indicates the year he changed its title from "Mallarmé's Dream," after Joseph Cornell misremembered the title. Thus, the collage is dated 1944 in this paper.

42. R.M., April 2, 1980.

43. Ibid.

44. Ibid.

45. Ibid.

46. L. Bailey Van Hook, "Robert Motherwell's *Mallarmé's Swan*," *Arts Magazine* (January 1983), pp. 102–6.

47. R.M., April 2, 1980. Motherwell associated Mallarmé's purity with Mondrian's in his 1944 article "The Modern Painter's World," p. 105.

48. Van Hook, "Mallarmé's Swan," p. 105.

49. R.M., April 2, 1980. In Mallarmé's famous poem "Un Coup de Dés," he admits that he will never abolish chance, and that it will always prevent his dream of purity. In contrast, Motherwell *embraces* chance as a necessary factor in artistic creativity.

50. R.M., January 23, 1980.

51. *transition* (April 1944). Motherwell still has this issue of *transition* in his library.

52. Harry Holtzmann, interview with the author, March 4, 1981.

53. Ibid.

54. Piet Mondrian, *Plastic Art and Pure Plastic Art* (New York: Wittenborn and Schultz, Inc., 1945). Preface by Robert Motherwell. Introduction by Harry Holtzmann.

55. R.M., January 23, 1980.

56. Ibid.

57. Motherwell, "The New York School," an exhibition at the Perls Gallery, Beverly Hills, January 1951.

58. R.M., March 21, 1980.

59. Ibid.

60. James Johnson Sweeney, "Preface," *Robert Motherwell,* an exhibition at Art of This Century, 1944.

61. [Unsigned], *Art News* (November 1944), p. 26.

62. Jon Stroup, "Motherwell Modern," *Art Digest* (November 1944), p. 16.

63. Clement Greenberg, "Art," *The Nation* (November 1944), p. 599.

64. R.M., June 4, 1980.

65. As far as I know, a detailed comparison of Greenberg's original articles and the edited version in *Art and Culture* has never been undertaken. Such a project would provide valuable clues about the evolution of his ideas between the 1940s and 1960s.

66. The methodology was codified by Michael Fried, *Three American Painters: Kenneth Noland, Jules Olitski, Frank Stella* (Cambridge: Fogg Art Museum, 1965).

67. Clement Greenberg, "Art," *The Nation* (November 11, 1944), p. 599.

68. For instance, see Greenberg, "Art," *The Nation* (November 11, 1944), p. 958, and (January 24, 1948), p. 108.

69. R.M., April 2, 1980.

Chapter 5

1. R.M., June 5, 1980.

2. Ibid.

3. Ibid.

4. Ibid.

5. Ibid., confirmed in a letter from Lee Krasner to the author, June 28, 1979.

6. Ibid.

7. "Baziotes File," Archives of American Art, letter to Ethel Baziotes from Maria Motherwell, December 5, 1945.

8. Sandler, *Triumph of American Painting,* p. 211.

9. Paul Cummings, "Interview with Motherwell," Archives of American Art, November 24, 1971.

10. [Unsigned], *The New York Times,* March 10, 1946, section 2, p. 11.

11. Lawrence Stapleton, *Marianne Moore* (Princeton: Princeton University Press, 1978), p. 185.

12. Ibid., p. 160.

13. Arnason, *Robert Motherwell* (1982 ed.), p. 38.

14. R.M., April 27, 1984.

15. Carmean, *The Collages of Robert Motherwell,* p. 50.

16. R.M., June 5, 1980.

17. Clement Greenberg, "Art," *The Nation* (January 26, 1946), p. 110.

18. Thomas B. Hess, *Willem de Kooning* (New York: The Museum of Modern Art, 1968), p. 50.

19. R.M., April 2, 1980.

20. The collage was owned until the 1970s by Robert Elkon who acquired it from the Kootz Gallery with the title "Composition." When Motherwell was sent a photograph of it by its present owners in 1981, he titled it "Pink Mirror."

21. R.M., March 19, 1980.

22. Ibid.

23. R.M., April 2, 1980.

24. R.M., April 3, 1980.

25. Ibid.

26. Robertson, "Interview with Motherwell," 1965.

27. Motherwell, letter to the author, August 20, 1979.

Chapter 6

1. For instance, see Sandler, *The Triumph of American Painting*, pp. 211–14.

2. R.M., April 27, 1980.

3. Diamondstein, "Interview with Robert Motherwell," November 17, 1977.

4. Ibid.

5. *Partisan Review*, vol. 24, no. 1 (Winter 1947).

6. William Barrett, *Irrational Man: A Study in Existential Philosophy* (Garden City: Doubleday, reprint 1958), p. 8.

7. Ibid., p. 16.

8. Ibid., p. 17.

9. Ibid., p. 16.

10. Ibid., p. 130.

11. Robert Motherwell, "Beyond the Aesthetic," p. 14.

12. Robert Motherwell, "Statement," for exhibition at Kootz Gallery, April 28–May 17, 1947.

13. Robert Motherwell, "Editorial Statement," *Possibilities* (Winter 1947–48).

14. Robert Motherwell, letter to Brandon Taylor, February 20, 1980.

15. R.M., June 5, 1980.

16. Robert Motherwell, letter to Brandon Taylor, February 20, 1980.

17. Robert C. Hobbs, "Possibilities," *Art Criticism* (1979), p. 97.

18. William Baziotes, statement in *Possibilities* (Winter 1947–48).

19. Jackson Pollock, statement in *Possibilities* (Winter 1947–48).

20. Rosenberg's choices include Huelsenbeck's "En avant dada," which relates to the idea of action and art, Paul Caffi's "On Mythology," which discusses myth in contemporary society, and Paul Goodman's "The Emperor of China," which will be discussed later in the context of Motherwell's painting of the same title.

21. Robert Motherwell, "Statement," Kootz Gallery, April–May 1947.

22. Kozloff, "An Interview with Robert Motherwell," p. 37.

23. R.M., December 15, 1979.

24. Robert Motherwell, "Beyond the Aesthetic," p. 16.

25. Robertson, "Interview with Robert Motherwell," 1965.

26. R.M., October 23, 1979.

27. Robert Motherwell, "Personal Statement," *A Painting Prophecy: 1950,* David Porter Gallery, February 1945.

28. Picasso's content in these works is partly due to his relationship with the oppressive Dora Maar. See Mary Mathews Gedo, *Picasso: Art as Autobiography* (Chicago: University of Chicago Press, 1980), p. 179.

29. Arnason, *Robert Motherwell* (1982, ed.), p. 109.

30. R.M., April 27, 1980.

31. Robert Motherwell, statement on *Person with Orange,* January 1947.

32. See Sandler, *The Triumph of American Painting,* p. 175.

33. Maloon, "Interview with Robert Motherwell," p. 38.

34. Robert Motherwell, letter to the author, September 5, 1979.

35. Ibid.

36. Ibid.

37. R.M., March 2, 1980.

38. Gedo, *Picasso,* chapter 9.

39. Robert Motherwell, telephone conversation with the author, June 6, 1979.

40. Motherwell, letter to the author, September 5, 1979.

41. Ibid.

42. Robert S. Mattison, "The *Emperor of China:* Symbols of Power and Vulnerability in the Art of Robert Motherwell during the 1940s," *Art International* (November–December 1982), p. 11.

43. Robert Motherwell, "Statement," Kootz Gallery, April–May 1947.

44. Robert Motherwell, letter to the author, September 5, 1979.

45. Alan Priest, *Costumes of the Forbidden City* (New York: Metropolitan Museum of Art, March–May 1945).

46. Lucy R. Lippard, "New York Letter: Miró and Motherwell," *Art International* (December 1965), p. 34.

47. Robert Motherwell, letter to the author, September 5, 1979.

48. Robert Motherwell, "A Conversation at Lunch" (an interview with Margaret Paul, November 1962), published in *An Exhibition of the Work of Robert Motherwell,* Smith College Museum of Art, 1963.

49. Hobbs, interview with Motherwell, cited in *Abstract Expressionism: The Formative Years,* p. 92.

50. Cummings, interview with Motherwell, Archives of American Art, November 24, 1971.

51. Arnason, *Robert Motherwell* (1977 ed.), statement accompanying figure 70.

52. Robert C. Hobbs, "Robert Motherwell's *Open* Series," in *Robert Motherwell* (Dusseldorf: Stadtlische Kunsthalle, September 3–October 10, 1976).

53. Clement Greenberg, "Art," *The Nation* (May 31, 1947), p. 665.

54. Weldon Kees, "Robert Motherwell," *Magazine of Art* (March 1948), pp. 86–88.

55. Robert Motherwell, "Concerning the Subjects of the Artist," ca. 1950.

56. Robert Motherwell, "Subjects of the Artist, Catalogue for 1948–49."

57. Robert Motherwell, "Concerning the Subjects of the Artist."

58. Barbara Cavaliere and Robert C. Hobbs, "Against a Newer Laocoon," *Arts* (April 1977), p. 110.

59. R.M., April 2, 1980.

60. Ibid.

61. Robert Motherwell, "Prefatory Note," in Jean Arp, *On My Way* (New York: Wittenborn and Schultz, 1946), p. 6.

62. R.M., April 2, 1980.

63. Carmean, "Robert Motherwell: The Elegies to the Spanish Republic," p. 96.

64. R.M., March 10, 1980.

65. Ibid.

66. Robert Motherwell, statement for the exhibition *Black or White: Paintings by European and American Artists* (New York: Kootz Gallery, February 28–March 20, 1950).

67. Carmean, "Robert Motherwell: The Elegies to the Spanish Republic," p. 96.

68. R.M., March 10, 1980.

69. Carmean, "Robert Motherwell: The Elegies to the Spanish Republic," p. 96.

70. Hobbs, *Motherwell's Concern with Death in Painting,* chapter 5.

71. Ibid., pp. 238–39.

72. Barbara Catior, "The Artist as a Walking Eye," *Pantheon* (July–September 1980), p. 285.

73. Ibid.

74. E.A. Carmean, Jr., "Robert Motherwell's Spanish Elegies," *Arts Magazine* (June 1976), p. 94.

75. Catior, "The Artist as a Walking Eye," p. 284.

76. Robert Motherwell, "The Rise and Continuity of Abstract Art," 1950.

77. Carmean, "Robert Motherwell: The Elegies to the Spanish Republic," p. 102.

78. R.M., March 10, 1980.

79. R.M., December 9, 1979.

80. Except for Malraux's novels, Motherwell has no histories of the Spanish Civil War in his library.

81. Motherwell discussed the "failure" of the *Guernica* in his 1944 "The Modern Painter's World," p. 10. He reiterated this belief to E.A. Carmean in 1979. See "Robert Motherwell: The Elegies to the Spanish Republic," p. 101.

82. Hobbs, *Motherwell's Concern with Death in Painting*, p. 182.

83. Carmean, "Robert Motherwell: The Elegies to the Spanish Republic," p. 104.

84. Ibid.

85. R.M., March 10, 1980.

86. Hobbs, *Motherwell's Concern with Death in Painting*, p. 107.

87. Arnason, *Robert Motherwell* (1982 ed.), p. 115.

88. Carmean, "Robert Motherwell: The Elegies to the Spanish Republic," p. 100.

89. Open letter to Roland Redmond, June 27, 1952, signed by Newman, Still, Reinhardt, Rothko, Gottlieb, Ferber, and Motherwell.

Bibliography

Writings and Interviews by Motherwell (in chronological order)

Letter to William Carlos Williams, 3 December 1941.

"Notes: On Mondrian and De Chirico." *V.V.V.* no. 1 (June 1942): 59-61.

Statement on *The Spanish Prison,* in Sidney Janis, *Abstract and Surrealist Painting in America* (New York: Reynal and Hitchcock, 1944), p. 65.

"Painters' Objects." *Partisan Review* 2 (Winter 1944): 93-97.

"The Modern Painter's World." *Dyn* 1, no. 6 (November 1944): 9-14.

Preface to Piet Mondrian, *Plastic and Pure Plastic Art.* Documents in Modern Art Series (New York: Wittenborn, 1945): 5-6.

"Personal Statement." *A Painting Prophesy—1950.* David Porter Gallery, February 1945.

Statement in *Fourteen Americans,* ed. Dorothy C. Miller (New York: Museum of Modern Art, 1946), pp. 34-36.

"Beyond the Aesthetic." *Design* 47, no. 8 (April 1946): 14-15.

Statement on *Person with Orange,* January 1947.

Catalogue foreword to Motherwell Exhibition (New York: Kootz Gallery, April 28-May 17, 1947).

————, with Harold Rosenberg. "Problems of Contemporary Art" (editorial preface). *Possibilities* 1, no. 1 (Winter 1947-48): 1.

Preface to Hans Arp, *On My Way: Poetry and Essays 1912-1947.* Documents of Modern Art Series (New York: Wittenborn, 1948): 6.

Preface to Max Ernst, *Beyond Painting and Other Writings by the Artist and His Friends.* Documents of Modern Art Series (New York: Wittenborn and Schultz, 1948): v-vi.

"A Tour of the Sublime." *Tiger's Eye* 1, no. 6 (December 15, 1948): 46-48.

"Catalogue Statement" for *Subjects of the Artist: A New School, 1948-49.*

Preliminary notice in Marcel Raymond, *From Baudelaire to Surrealism.* Documents of Modern Art Series (New York: Wittenborn and Schultz, 1950 [1949]), pp. vii-viii.

Statements in *Black or White: Paintings by European and American Artists* (New York: Samuel Kootz Gallery, 1950).

"Artists' Sessions at *Studio 35* (1950)." *Modern Artists in America,* no. 1 ([1951]), pp. 8-24. A symposium.

Preface and introduction to Robert Motherwell (ed.), *The Dada Painters and Poets: An Anthology.* Documents of Modern Art Series (New York: Wittenborn and Schultz, 1951), pp. xv-xxxviii.

"The Rise and Continuity of Abstract Art." Lecture at the Fogg Art Museum, Harvard University, Cambridge, Mass., 1951.

"The School of New York." Preface in *Seventeen Modern American Painters* (Beverly Hills: Frank Perls Gallery, 1951).

"What Abstract Art Means to Me." *Museum of Modern Art Bulletin* 18, no. 3 (Spring 1951): 12–13. Robert Motherwell's statements at the symposium "What Modern Art Means to Me," Museum of Modern Art, New York, February 5, 1951.

"Science and the Modern Artist." Oreon E. Scott Symposium, Washington University, St. Louis, 1952. A lecture.

"A Painting Must Make Human Contact." In *New Decade* (New York: Whitney Museum of American Art and Macmillan, 1955).

"The Signifigance of Miró." *Art News* 58, no. 4 (May 1959): 32–33, 65–67.

David Sylvester. "Painting as Existence: An Interview with Robert Motherwell." *Metro* (Milan) 7 (1962): 94–97.

"A Conversation at Lunch." In *An Exhibition of the Work of Robert Motherwell* (Northampton, Mass.: Smith College Museum of Art, 1963).

"The Creative Use of the Unconscious by the Artist and by the Psychotherapist." Symposium at the Eighth Annual Conference of the American Academy of Psychotherapists, New York, 1963. Statement published in "The Creative Use of the Unconscious by the Artist and by the Psychotherapist," Jules Barron and Renee Nell eds., monograph no. 8 in *Annals of Psychotherapy: Journal of the American Academy of Psychotherapists* 5, no. 1 (1964): 46–49.

"A Letter from Robert Motherwell to Frank O'Hara Dated August 18, 1965." In *Robert Motherwell* (New York: Museum of Modern Art, 1965), pp. 58–59, 67–68, 70.

Bryan Robertson. "Interview with Robert Motherwell," 1965. Unpublished.

Max Kozloff. "An Interview with Robert Motherwell." *Artforum* 4, no. 1 (September 1965), pp. 33–37.

"Jackson Pollock: An Artists' Symposium, Part 1," *Art News* 66, no. 2 (April 1967), pp. 29–30, 64–67.

Sidney Simon. "Concerning the Beginnings of the New York School: 1939–1943. An Interview with Robert Motherwell." *Art International* 11, no. 6 (Summer 1967): 20–23.

"The Universal Language of Children's Art, and Modernism." Address at opening session of a conference on International Exchange in the Arts, April 29, 1970. Published in *American Scholar* 40, no. 1 (Winter 1970): 24–27.

Paul Cummings. "Interview with Robert Motherwell." Archives of American Art, November 24, 1971.

"The Humanism of Abstraction." Lecture at St. Paul's School, Concord, New Hampshire, 1970. Published in *Tracks: A Journal of Artists' Writings* 1, no. 1 (November 1974): 10–16.

Terence Maloon. "Robert Motherwell: An Interview." *Artscribe* (April 1978), pp. 17–21.

Barbaralee Diamondstein. "Inside New York's Art World: An Interview with Robert Motherwell." *Partisan Review/3* 46, no. 3 (1979): 376–90. This is an abridged and revised version of an interview conducted before an audience at the New School for Social Research, New York, in 1977. Reprinted in Barbaralee Diamondstein, *Inside New York's Art World* (New York: Rizzoli International, 1979), pp. 239–53.

Interviews with Robert S. Mattison, 1979–80. Individual dates are cited in footnotes.

"The International World of the Modern Artist: 1945–1960." *Art Journal* 39, no. 4, (Summer 1980): 270–71.

Books, Articles, and Exhibition Catalogues about Motherwell

Arnason, H.H., "Motherwell: The Wall and the Window." *Art News* 68, no. 4 (Summer 1969): 48–52, 66ff.

———. "On Robert Motherwell and His Early Work." *Art International* 10, no. 1 (January 1966): 17–35

———. *Robert Motherwell.* Preface by Bryan Robertson; notes on the plates by Robert Motherwell. First ed. New York: Harry N. Abrams, 1977. Reprinted in 1982 with different selection of plates by Motherwell.

_____. "Robert Motherwell: 1966-1976." *Art International* 20, nos. 8-9 (October-November 1976): 9-25, 55-56.

_____. "Robert Motherwell: The Years 1948 to 1965." *Art International* 10, no. 4 (April 1966): 19-45.

Ashton, Dore. "Robert Motherwell, Passion and Transfiguration." *Studio* 167, no. 851 (March 1964): 100-105.

Buck, Robert T., ed. *Robert Motherwell*. Albright-Knox Art Gallery, 1983.

Carmean, E.A., Jr. *The Collages of Robert Motherwell: A Retrospective Exhibition.* November 15, 1972–January 14, 1973 (Houston: Museum of Fine Arts).

_____. "Robert Motherwell: The Elegies to the Spanish Republic." *American Art at Mid-Century: The Subjects of the Artist.* June 1, 1978–January 14, 1979 (Washington, D.C.: National Gallery of Art).

_____. "Robert Motherwell's Spanish Elegies." *Arts* 50, no. 10 (June 1976): 94-97.

Cavaliere, Barbara, and Robert C. Hobbs. "Against a Newer Laocoon." *Arts* 51, no. 8 (April 1977): 110-17.

Cuddihy, John Murray, compiler. Scrapbooks on Robert Motherwell containing material from the 1940s until the 1960s. Material partially copied and on deposit at the Museum of Modern Art Library, New York.

Fineberg, Jonathan. "Death and Maternal Love: Psychological Speculations on Robert Motherwell's Art." *Artforum* 17, no. 1 (September 1978): 52-57.

Goossen, Eugene C. "Robert Motherwell and the Seriousness of the Subject." *Art International* 3, nos. 1-2 (January-February 1959): 33-35, 38, 51.

Greenberg, Clement. "Art." *The Nation* (November 11, 1944): 598-99.

_____. "Art." *The Nation* (January 26, 1946): 110.

_____. "Art." *The Nation* (May 31, 1947): 664-65.

Hobbs, Robert C. *Motherwell's Concern with Death in Painting: An Investigation of His Elegies to the Spanish Republic, Including an Examination of His Philosophical and Methodological Considerations.* Ph.D. dissertation, University of North Carolina, Chapel Hill, N.C., 1975.

_____, with Gail Levin. *Abstract Expressionism: the Formative Years.* March 30–May 14, 1978 (Ithaca, N.Y.: Herbert F. Johnson Museum of Art, Cornell University), with an entry on Motherwell by Hobbs, pp. 88-93.

Hunter, Sam, ed. *Robert Motherwell: Recent Work.* January 5–February 17, 1973 (Princeton: Art Museum, Princeton University).

Kees, Weldon. "Robert Motherwell." *Magazine of Art* 41, no. 3 (March 1948): 86-88.

Lippard, Lucy R. "New York Letter: Miró and Motherwell." *Art International* 9, nos. 9-10 (December 1965): 33-35.

Mattison, Robert S. "The Emperor of China: Symbols of Power and Vulnerability in the Art of Robert Motherwell during the 1940s." *Art International* 25, nos. 9-10 (November-December 1982): 8-14.

_____. "Two Decades of Graphic Art by Robert Motherwell." *Print Collector's Newsletter* 11, no. 6 (January-February 1981): 197-201.

_____. "A Voyage: Robert Motherwell's Earliest Works." *Arts Magazine* 59, no. 6 (February 1985): 90-93.

O'Hara, Frank. *Robert Motherwell.* October 1–November 28, 1965. Retrospective exhibition (New York: Museum of Modern Art).

Sandler, Irving H. "New York Letter." *Quadrum*, no. 14 (1963): 116-17

_____. "Robert Motherwell." *Art International* 5, nos. 5-6 (June-August 1961): 43-44.

Stroup, Jon. "Motherwell Modern." *Art Digest* (November 1944): 16.

Sweeney, James Johnson. Preface to *Robert Motherwell*, Art of This Century, 1944. First exhibition.

Van Hook, L. Bailey. "Robert Motherwell's *Mallarmé's Swan.*" *Arts Magazine* 57, no. 5 (January 1983): 102-6.

Sources for Motherwell's Art Theory

Barrett, William. *Irrational Man: A Study in Existentialist Philosophy* (Garden City: Doubleday, reprint 1958).

Baudelaire, Charles. *Charles Baudelaire: The Flowers of Evil.* James Laver, ed. (New York: Heritage Press, 1971).

_____. *Intimate Journals.* T.S. Eliot, trans. (New York: Blackmore Press, 1930).

Dewey, John. *Art as Experience* (New York: Paragon Books, 1934).

Freud, Sigmund. *The Basic Writings of Sigmund Freud.* A.A. Brill, ed. (New York: Modern Library, 1938).

Mack, Robert D. *The Appeal of Immediate Experience: The Philosophic Method of Bradley, Whitehead and Dewey* (Freeport: Books for Libraries Press, 1945).

Philipson, Morris. *An Outline of Jungian Aesthetics* (Evanston: Northwestern University Press, 1963).

Prall, D.W. *Aesthetic Analysis* (New York: Thomas Y. Crowell Company, 1936).

Schapiro, Meyer. "The Nature of Abstract Art." Originally published in the *Marxist Quarterly,* 1937. Reprinted in Meyer Schapiro, *Modern Art, 19th and 20th Centuries* (New York: George Braziller, 1978).

Valéry, Paul. *The Collected Works of Paul Valéry.* Jackson Mathews, ed. (Princeton: Princeton University Press, 1972).

Whitehead, Alfred North. *Adventures in Ideas* (New York: The Macmillan Company, 1952).

Texts on Abstract Expressionism

Ashton, Dore. *The New York School: A Cultural Reckoning* (Middlesex: Penguin Books, 1979).

Guggenheim, Peggy. *Confessions of an Art Addict* (New York: Macmillan, 1960).

Hadler, Mona. "William Baziotes: A Contemporary Poet-Painter." *Arts* 51, no. 10 (June 1977): 102–9.

Hobbs, Robert C. "Possibilities." *Art Criticism* 1, no. 2 (1979): 96–103.

Janis, Sidney. *Abstract and Surreal Painting in New York* (New York: Reynal and Hitchcock, 1944).

Kozloff, Max. "Interview with Matta." *Artforum* 4 (September 1965): 24–26.

Masson, André. "Interviews with Eleven European Artists in America." *The Museum of Modern Art Bulletin* 13, nos. 4–5 (Spring 1946): 4.

Matta, Roberto. "Matta's Third Surrealist Manifesto." *Art News* 43, no. 1 (February 15, 1944): 18.

Motherwell, Robert, et al., eds. *Possibilities: An Occasional Review* 1, no. 1 (New York: Wittenborn, Winter 1947–48).

Paalen, Wolfgang. *Form and Sense: Problems in Contemporary Art* (New York: Wittenborn, 1945).

Rubin, William S. *Dada, Surrealism and Their Heritage* (New York: The Museum of Modern Art, 1968).

Sandler, Irving. *The Triumph of American Painting: A History of Abstract Expressionism* (New York: Praeger Publishers, 1970).

Seitz, William C. *Abstract Expressionist Painting in America* (New York: Viking Press, 1983).

Simon, Sidney. "Concerning the Beginnings of the New York School: An Interview with Peter Busa and Matta." *Art International* 11, no. 6 (September 1967): 17–20.

Index